THE LAST GOOD WAR

J. L. GRANATSTEIN

THE LAST

AN ILLUSTRATED HISTORY OF CANADA

GOOD WAR

IN THE SECOND WORLD WAR | 1939–1945

Douglas & McIntyre

VANCOUVER/TORONTO

For Carole, Eric and Tess

05 06 07 08 09 5 4 3 2 1

Douglas & McIntyre Ltd.
2323 Quebec Street, Suite 201
Vancouver, British Columbia
Canada V5T 4S7
www.douglas-mcintyre.com

Library and Archives Canada Cataloguing in Publication
Granatstein, J. L., 1939–
The last good war : an illustrated history of Canada in the
Second World War, 1939–1945 / J.L. Granatstein. Includes index.

ISBN 1-55054-913-8

1. World War, 1939–1945—Canada.
2. World War, 1939–1945—Canada—Pictorial works. I. Title.
D768.15.G728 2005 940.53′71 C2004-906072-4

Editing by John Eerkes-Medrano
Jacket and text design by Peter Cocking
Typesetting and layout by Jessica Sullivan
Front jacket photograph: National Archives of Canada PA-141306
Back jacket photograph: National Archives of Canada
Frontispiece image: CWM Molly Lamb Bobak 12059 (detail)
p. vi photo: CWM 197000186-023 (detail)
Printed and bound in China by C&C Offset
Printed on acid-free paper

We gratefully acknowledge the financial support of the
Canada Council for the Arts, the British Columbia Arts Council,
and the Government of Canada through the Book Publishing Industry
Development Program (BPIDP) for our publishing activities.

CONTENTS

ACKNOWLEDGEMENTS

HAVE BENEFITED GREATLY from the good work of Gabrielle Nishiguchi in doing photographic and art research. This book makes special use of the largely untapped collections of the Canadian War Museum, where from 1998 to 2000 I was director and CEO. At the museum, I discovered its rich collections, but I hasten to say that my former status won me no privileged access. The publisher paid for the use of the CWM's material in full.

I am indebted to Joe Geurts, Roger Sarty, Dean Oliver, Serge Durflinger and Laura Brandon, all past colleagues with whom I worked at CWM, for their assistance over many years. That this book will be available in time for the opening of the new Canadian War Museum at LeBreton Flats, Ottawa, is a very special satisfaction to me.

Dr. Serge Bernier, the director of history and heritage at National Defence Headquarters, Ottawa, with great kindness allowed me to use the superb maps produced by his directorate. Once again, I am most grateful to him.

J.L.G.
Toronto, 2005

INTRODUCTION

MOST CANADIANS know very little about Canada's role in the world wars of the twentieth century. If they do, they are likely to believe that the country's part in the Great War was more important than that in the Second World War. After all, the number of deaths in battle was greater, Sir Arthur Currie's Canadian Corps developed a huge reputation and Sir Robert Borden, the prime minister, was tough, determined and devoted to the welfare and reinforcement of the troops at the front.

And yet, this belief is incorrect. The Second World War was infinitely more dangerous to the world and to Canada than the 1914–18 conflict. Whereas the First World War was a battle of rival imperialisms, the following world war was genuinely a struggle for survival against a monstrous evil, a just war, the last good war. Canadians seemed to recognize this, as more than 1.1 million men and women joined the armed forces, a much higher number than in the Great War. The Canadian contribution at sea and in the air was far greater in the 1939–45 conflict and critical to the Allied victory in the Battle of the Atlantic and the air war against Nazi Germany. At the same time, the First Canadian Army of two corps, substantially larger than Currie's corps, fought with great distinction in Italy and Northwest Europe. Moreover, Canadian war production—in the First World War largely limited to artillery shells—covered a wide range of the weapons of war and had a vastly greater dollar value in the Second. Similarly, the country's assistance to its allies in dollars, food and war supplies was incomparably larger than in the Great War. In every respect (except, happily, the number of war dead), the Canadian war effort in the Second World War was unparalleled.

This war effort was shaped and directed by Mackenzie King, a reluctant wartime leader if ever there was one. King was cautious and careful, a trimmer by nature and a politician

whose primary task, as he saw it, was to keep himself and his Liberal Party in power. But King could lead, and from 1939 to 1945 he did just that, directing a government of strong men and giving them their heads. He kept the Liberals in office, maintained a high degree of national unity and, despite his desperate desire to avoid conscription for overseas service, mobilized the nation's huge war effort with unparalleled skill. Never particularly popular at home, no Franklin D. Roosevelt or Winston Churchill for charisma or stirring oratory, Mackenzie King nonetheless guided his country into and through the fires of war with consummate finesse. He even won re-election in 1945, one task Churchill could not manage.

For Canadians, the Second World War lasted six long years. Men overseas were separated from their families for years, some forever. The war brought death to many thousands and destroyed countless lives in different ways. It sped the industrialization of Canada, hastened rural depopulation and, surprisingly, despite rationing and controls, greatly improved the lot of the ordinary Canadian. Abroad, the efforts of Canada's war industries and, most especially, of Canada's servicemen and women won the nation a huge reputation as the leader of the middle powers, a standing that the government used skilfully to secure a place at the tables of the Allies and in the United Nations. The Canada that had entered the war in 1939 was a divided country wracked by economic depression. The nation that emerged from the struggle was rich and powerful, confident and secure.

The Second World War was a just war by any definition, canonical or otherwise, so it was only right and proper that Canada, as one of the leading participants among the victors, should benefit. And so it did. Not in territory—Canada wanted no colonies—and not in plunder, of course. Canada benefited because it had fought the good fight for freedom and fought well in a just cause. That the nation changed for the better in the course of the last good war was a bonus.

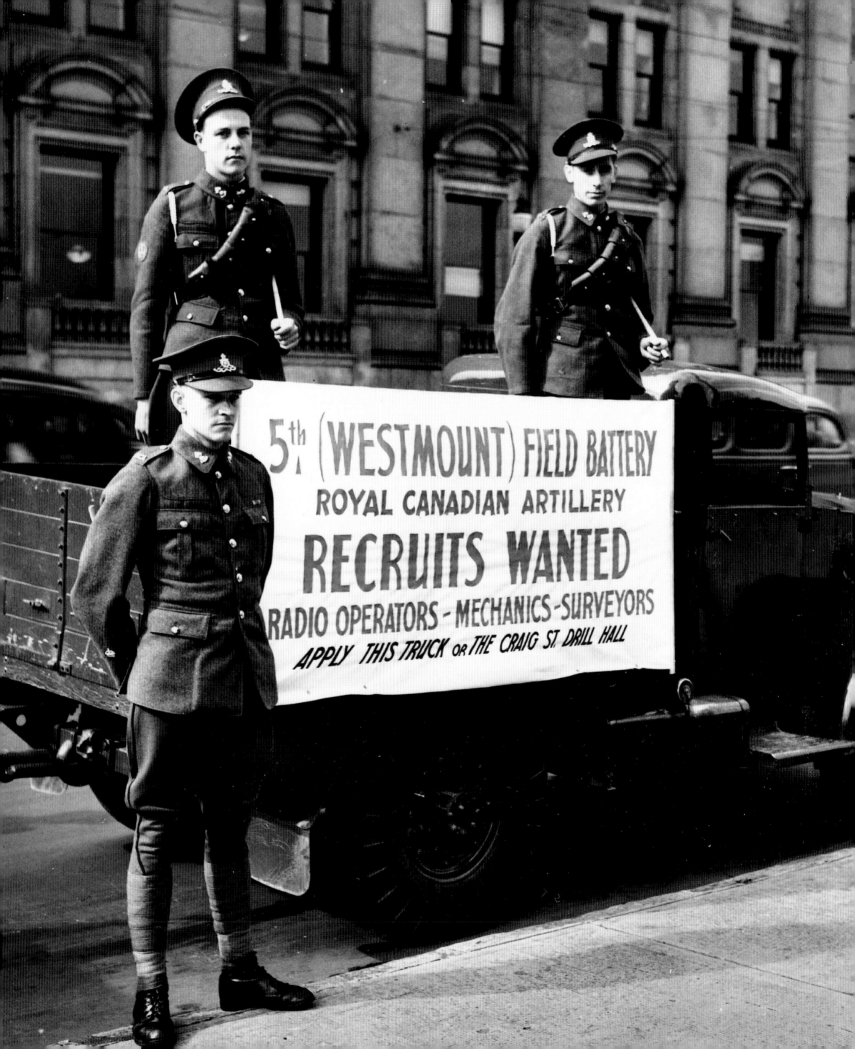

LEFT: Recruiting for the artillery in Montreal in September 1939,

these reservists sported Great War uniforms. But, unlike many units,

they did have a truck! (National Archives of Canada PA-129610)

1 | THE LIMITED LIABILITY WAR

STEPHEN LEACOCK was Canada's greatest humourist, a man beloved for his uncanny ability to poke fun at the foibles of the rich and the poor. But Leacock was at root a serious man, and he was never more so than in June 1939, when he wrote in Boston's *The Atlantic Monthly* on Canada's attitude to the coming war. "If you asked any Canadian, 'Do you have to go to war if England does?,' he'd answer at once, 'Oh, no.' If you then said, 'Would you go to war if England does?,' he'd answer, 'Oh, yes.' And if you asked, 'Why?,' he would say, reflectively, 'Well, you see, we'd have to.'" Leacock had it exactly right.

IN 1939, CANADA'S eleven million people were struggling to survive. The Great Depression, which had begun in the stock market crash in October 1929, still clutched the country. Its effects had been devastating. Industries had reduced their production, if they were lucky, or shut down entirely if they were not. Agricultural exports had shrunken drastically, and the great wheat-growing areas of the Prairies had not yet completely recovered from years of drought and plagues of grasshoppers. Unemployment had soared during the 1930s and in 1939 still numbered 900,000 men and women. Single men roamed the country, bumming meals and looking for work with ever-more-hopeless eyes. The gross national product stood at $5.6 billion, and Canada was a poor country.

Not everyone suffered. John David Eaton, the scion of the department store chain, looked back almost nostalgically at the 1930s. "Nobody thought about money in those days," he said, "because they never saw any. You could take your girl to a supper dance at the hotel for ten dollars, and that included the bottle and a room for you and your friends to drink it in." Ten dollars was two weeks' pay for women in the wool department at

Simpson's, Eaton's competitor across Queen Street in Toronto, and those clerks (my mother was one) never saw a ten-dollar bill. But for the rich, as Eaton said, "I'm glad I grew up then. It was a good time for everybody. People learned what it means to work." If only they could have found work.

It was the bleakest of times, and the federal, provincial and municipal governments had proven almost helpless to cope with an economic disaster on this scale. There was no social welfare safety net in Canada; the unemployed and homeless were forced to depend on

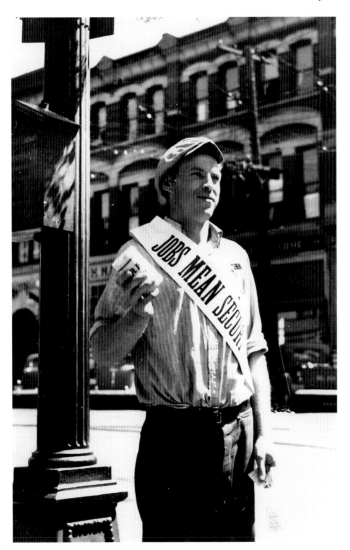

charity or on a small municipal dole of relief food and cash, usually in return for work like shovelling snow or piling logs. The Conservative federal government of Richard Bedford Bennett, coming to power in the autumn of 1930, had appropriated unprecedented sums for relief, but the money was absorbed like water in a desert and made no appreciable impact. Ottawa had more money than the provinces, some of which were on the edge of default, but the Canadian constitution forbade the federal government from interjecting itself into social welfare, a responsibility that belonged to the provinces. Bennett tried in 1935 to circumvent the constitutional limits with an array of legislation, but the courts declared his efforts null and void—and the voters, fed up with Bennett's bluster after five years, tossed him out in the October 1935 elections.

It fell to William Lyon Mackenzie King to try to fix the Depression, revamp the constitution and, as it turned out, prepare Canada for war. King's Liberals had no plan to deal with the Depression except to wait it out. In 1937, the prime minister established the Royal Commission on Dominion–Provincial Relations to examine if and in what ways the constitutional arrangements and federal support for the provinces should be altered. The commission would not report until 1940. King signed a trade treaty with President Franklin Delano Roosevelt's United States in 1935, the first Canada–U.S. trade deal in more than ninety years, but its effects were relatively minor during an era of high tariffs. Further

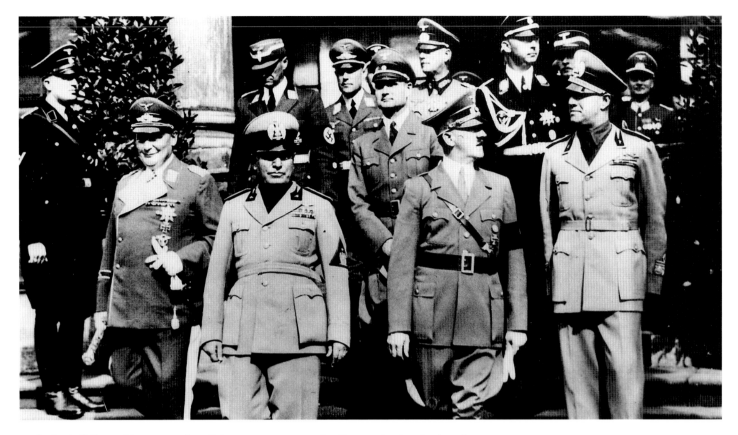

trade deals followed in 1937 and 1938, but so strong was the Depression's grip that they too did not greatly increase exports or imports.

War, however, would not wait. Adolf Hitler and his Nazi Party had taken power in Germany in 1933, and that nation's rearmament had begun at once. The Nazis began the active repression of German Jews, and refugees from Hitlerism tried desperately to get away. Most countries, including Canada, turned a deaf ear to their cries, and most Canadians were indifferent. Jews were not admired in most western countries in the 1930s, and many Canadians, like many Americans and Britons, thought Hitler had the right idea in dealing with them. Although no one in the early 1930s could conceive of the Holocaust, at least one Canadian foreign correspondent—the young and able Matthew Halton of the *Toronto Star*—reported directly and bluntly from early 1933 on the "most fanatical, thoroughgoing and savage philosophy of war ever imposed on any nation." In a 1936 report, Halton added: "Watch for the first signs of Fascism in your community, because in spite of their seductive exterior virility, they are signs of decay . . . signs that we are despairing of reason, despairing of our fine dreams, of a sane world."

Germany was not alone in disturbing careful observers. In Japan, the power of the militarists in government rapidly began to grow, and Japan's expansionist efforts in China continued apace. In Italy, Fascist leader Benito Mussolini had launched an invasion of the almost defenceless African nation of Abyssinia (now Ethiopia) in 1935, and the League of

Nations, the world body established after the Great War, tried to mobilize itself to resist Mussolini's aggression. Oil sanctions were the route, said some, including the Canadian acting delegate at the league's Geneva headquarters. Without oil, Italy's invasion would grind to a halt.

In Ottawa, Mackenzie King, Minister of Justice Ernest Lapointe, his key Quebec lieutenant, and Dr. O.D. Skelton, the powerful undersecretary in the Department of External Affairs, were horrified that a Canadian had taken the lead in such a forum in a global crisis. It was not Canada's place to interfere in the Great Power games; to do so might force Canada into war, and war, as every Canadian understood after the conscription crisis of 1917, threatened Canada's stability and survival. The diplomat was repudiated (and soon dispatched to New Zealand as punishment), and the Great Powers gratefully allowed the suggestion of interfering with dictators' ambitions to disappear. Abyssinia was swallowed whole, and Germany and Japan were emboldened. Mackenzie King, a cautious, careful man who did not want Canada to take the lead, was gratified.

THE LAST GOOD WAR

King was a domestic politician, a leader who had made his career by "never doing by halves what could be done by quarters," as poet Frank Scott once wrote. He had governed Canada from 1921 to 1925 and again from 1926 to 1930, doing little but fitting the attitudes of the age. Now, his country was weakened by an economic depression, regionally divided, linguistically fractious and unsure of its proper role in the world. English-speakers, especially those of British origin, tended to believe that wherever Britain led, Canada should follow. French Canadians, by contrast, remained suspicious of the Empire, fearful of war and desperately afraid that any major conflict again would lead to conscription, as it had in 1917. Some Canadians were League of Nations supporters, devout believers in collective security as the way to enforce peace. A few Canadians were communists, taking their lead from the Soviet Union. Some were pacifists, most notably J.S. Woodsworth, the leader of the Co-operative Commonwealth Federation, or CCF. And atop the pile was Mackenzie King, struggling to keep his countrymen united and afraid that war could only divide them more.

King also knew that his country's military forces were pathetically small and ill-equipped. The Dominion's regular army, navy and air force numbered under ten thousand men all told, and their equipment dated from the Great War. The reserve forces were larger, some fifty thousand in the Non-Permanent Active Militia, for example, but their equipment was even more out of date and their training casual. It was "an amateur performance," remembered Strome Galloway of the Elgin Regiment in southwestern Ontario. "Some of the chaps were in the regiment only for the shooting, others for the bar privileges found in the messes... Among the officers the social aspect—mess dinners, dances, ceremonial parades and garden parties—seemed to be the main appeal." The navy had a few ships, little ammunition and no aircraft. The air force had a handful or two of aircraft of ancient vintage. The army Permanent Force had no tanks, no modern artillery, no anti-aircraft guns, few trucks and only a platoon of staff-trained officers. Still, as George Kitching, a regular British officer who

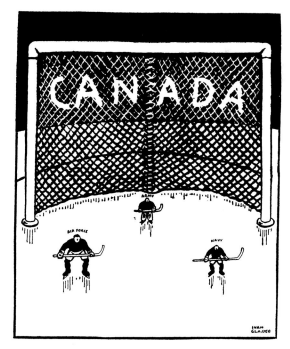

joined the Canadian army at the outbreak of war, noted of the Royal Canadian Regiment's soldiers: "Many were well educated and had joined during the depression." The strength of the company he visited at St. Jean, Quebec, in early 1939 was "about 60 and of those more than 50% were commissioned early in the war."

About all the army had in its stores in quantity was harness, and few expected cavalry to be of much use in another war. The defence budget through the 1920s and especially in the hard times of the 1930s was minimal, in 1935 totalling $27.3 million for all three services, and most of the government members of Parliament did not believe defence was worth a penny more. King, a most unmilitary-minded prime minister, tended to agree, but the British government was beginning to talk about the necessity of rearmament in response to the increasing strength of the dictators. Perhaps even more important to King, President Roosevelt was letting Canada know that its defenceless state was worrisome.

King and Roosevelt were friendly, if not close, and they met with some regularity. Roosevelt also had summered at Campobello, New Brunswick, and he cruised Canadian waters regularly. He understood just how undefended Canada was against a seaward attack, and he let King know this. In 1937, for the first time, the Canadian and American chiefs of staff met for secret discussions, and there was another meeting the next year. In 1938, the president spoke at Kingston and Gananoque, Ontario, and pledged to defend Canada against attack from any other empire. King reciprocated a few days later, promising that Canada would never allow its territory to be used by any power to attack the United States. This at least was a beginning towards co-operation, and King began to speak more frequently about the defence of Canada. "We are not concerned with aggression," he told his caucus on one occasion. "We are concerned with the defence of Canada." His party MPs, most of them suspicious and fearful, did not especially like this, but who could argue with defending the homeland? Defence budgets slowly crept up, reaching $36 million in 1937 and $64 million in 1939. The air force received the lion's share of the increase, the navy the second-largest.

Nonetheless, events overseas continued to drive the issue of war to the fore. Hitler's Germany remilitarized the Rhineland, began to construct submarines and swallowed Austria, incorporating it into the Third Reich in 1938. The Treaty of Versailles lay in tatters, and Hitler began to demand that the Sudeten Germans in Czechoslovakia be incorporated

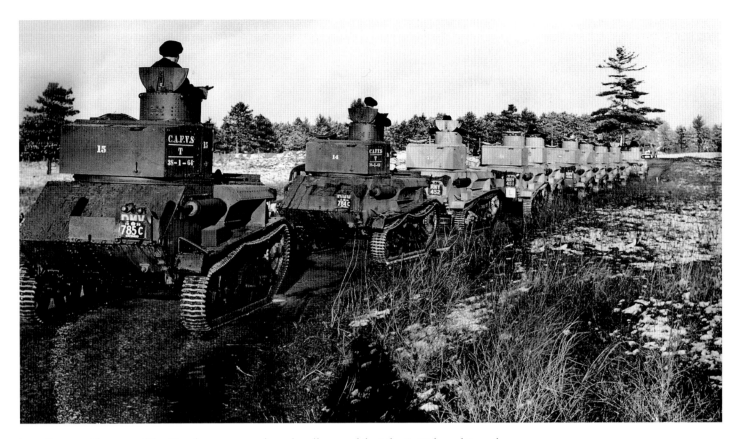

into Greater Germany. The Czechs were tough and well-armed, but the British and French leaders, Neville Chamberlain and Édouard Daladier, had no stomach for a fight. At Munich, in the early autumn of 1938, they agreed that Hitler should have the Sudetenland. People around the globe cheered that "peace" had been preserved, and Mackenzie King and Canadians celebrated with them. Abandoned by their "friends," the Czechs swallowed their pride and gave up the province.

Hitler was far from done, however. Emboldened by the abject cowardice of Britain and France, he took over the remains of Czechoslovakia in March 1939 and turned his gaze on Poland. A fearful London suddenly offered military guarantees to Warsaw—without consulting Ottawa. King was furious that the British still acted as if the Empire ruled the waves, but public opinion clearly had begun a shift to support the necessity of stopping Hitler. In August, the German führer stunned the world by striking an alliance with Joseph Stalin's Soviet Union, hitherto the enemy that he had slandered almost daily. The cynicism of the bargain was obvious, but it did mean that Poland was going to be attacked and likely divided between its historic enemies, Germany and Russia.

In Ottawa, Mackenzie King repeated the mantra he had been using as his all-purpose answer to queries on foreign and defence policy: "Parliament will decide" what Canada would do in the event of war. In fact, he knew at once that Canada had to support the United Kingdom, and he himself wanted to do so. He consulted his Cabinet on August 24

BELOW: In Weyburn, men of the South Saskatchewan Regiment's advance party bade their farewells at the station. (CWM 19830268-004 #15)

RIGHT: By the end of November 1939, the units of the Canadian Division were moving towards Halifax and embarkation for England. Here the 48th Highlanders leave Toronto to form part of the 1st Brigade. (City of Toronto Archives G&M 62782)

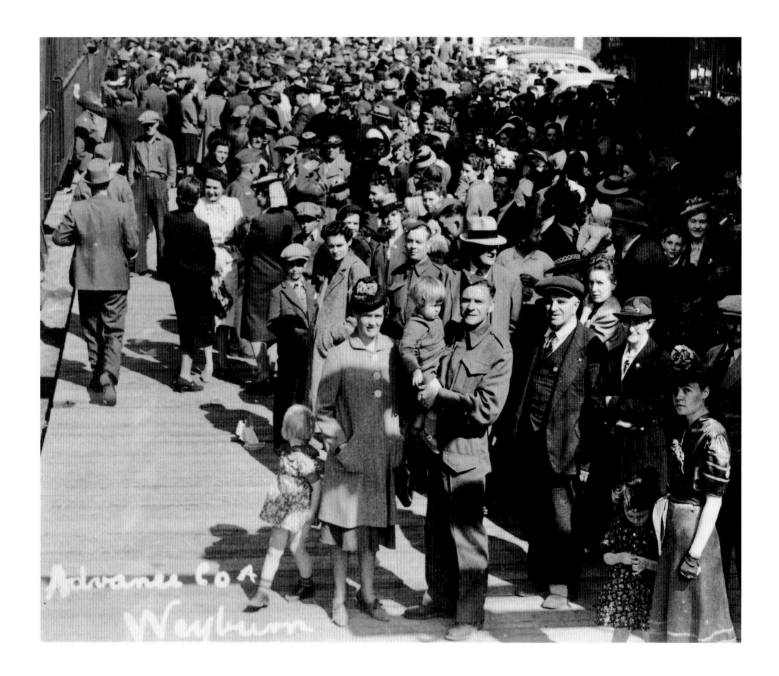

THE LAST GOOD WAR

and, as C.D. Howe, the minister of transport, put it, all agreed that "Canada would have to participate." Meanwhile the military went on alert, and the lights in the Department of National Defence burned late. On September 1, Hitler's Wehrmacht invaded Poland, the panzers racing forward under the air support of dive-bombing Stukas. The Poles fought with great courage but were forced back to the east. The British and French governments reluctantly issued ultimata to Berlin, while Prime Minister Chamberlain sought futilely to find a way to escape his government's guarantee to Poland. On September 3, Britain and France declared war and the Second World War began, just two decades after the armistice that had brought the Great War to an end.

What would Canada do? Hitler had few admirers in Canada, but he did not yet seem to be a monster of unparalleled brutality. As a result, some Canadians favoured neutrality in a war that they perceived to be just as much a struggle of imperialisms as in 1914. Quebec was frightened of all wars, but resigned and only mildly reassured by King's commitment in late March 1939 that no government led by him would ever resort to conscription for overseas service. Most Canadians, however, assumed that, exactly as in 1914, when Britain was at war, Canada was at war. The prime minister, however, did not. He knew, with Stephen Leacock, that Canada had to go to war if Britain went to war. But the Statute of Westminster of 1931, a British law negotiated with the governments of the Commonwealth, had pronounced that the Dominions were independent in their foreign policy. To King, this meant that Canada had the right to choose what to do, and he wanted Parliament to decide on its own to join the struggle.

The government summoned Parliament to meet in a special session and informed the MPs that if the address in reply to the speech from the throne carried the House, Canada would ask George VI as king of Canada to declare the nation at war. There was debate, but only a few members called for neutrality, and on September 9 the message to the king went to London. The next day—September 10, 1939, one symbolic week after Great Britain had declared war—George VI declared that his Dominion of Canada was at war.

Canada's military mobilization was slow.

LEFT: By May 1940, as the possibility of victory was on the verge of slipping away, soldiers in training had time for games. (City of Toronto Archives G&M 65880)

BELOW: Public school cadets marched—in step!—through the streets. (City of Toronto Archives G&M 66374)

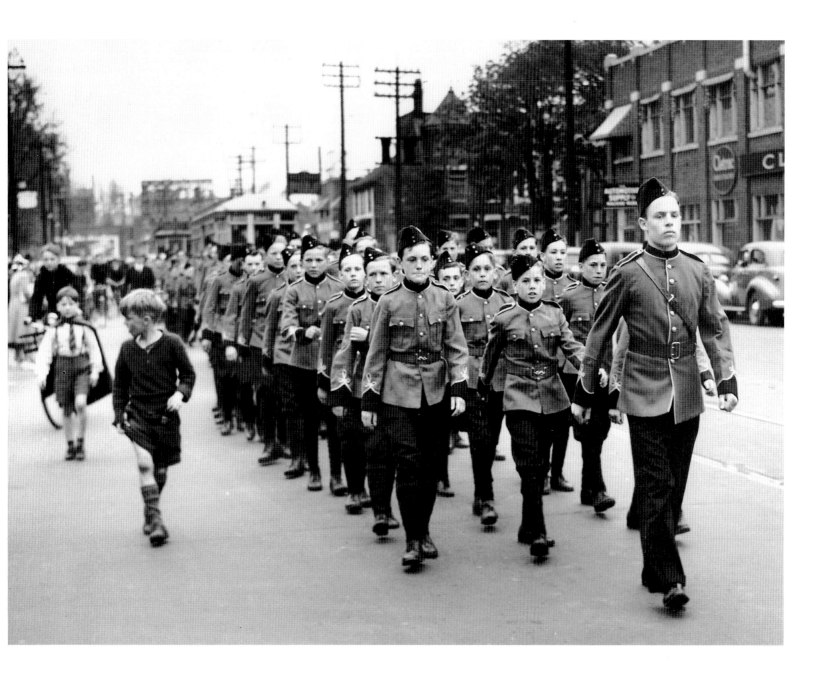

Mackenzie King had brought his nation into the war, almost no one objecting, in part because he had repeated his pledge of March 1939 against conscription for overseas service: "No such measure will be introduced by the present administration." But there was little enthusiasm for the conflict and no crowds cheering, as had been the case in August 1914. Too many Canadians remembered the horror of the trenches for any to cheer.

NOW WHAT WAS CANADA TO DO? The military's chiefs of staff had their plans ready. They wanted Canada to begin buying or making military equipment, and they proposed that an army corps of sixty thousand men be recruited, trained and dispatched to Britain as quickly as possible. The cost of their recommendations was $491 million, a sum almost equal to the entire peacetime federal budget. King was horrified at the fiscal recommendations, which he and his ministers believed insupportable. In his mind, this was not a war like the Great War, not a total war. Instead, this conflict was a limited liability war, one in which Canada would strive to get its economy moving and do the minimum necessary to satisfy the martial ardour of the country—such as it was—and the demands of Great Britain. Indeed, this was not all that different from the war Chamberlain's government was preparing to fight. Above all, King feared casualties: heavy losses at the front meant conscription, and King and many other Canadians were afraid that if the issue of conscription arose a second time, it might tear the nation apart irrevocably.

Thus Mackenzie King initially opposed any expeditionary force at all, maintaining that the defence of Canada was and remained the primary task. Only when his Cabinet favoured the idea did he relent, and even then he authorized the recruiting of only two

divisions and the dispatch overseas of just one. By September 17, he had begun to fear that events were getting out of hand. "Recruiting has already gone too far," King wrote in his diary. "It was decided to stop recruitment," he added, though men could still volunteer. The prime minister still hoped that something might turn up to prevent the need to send an army overseas.

What turned up was air training. For at least three years before the outbreak of war, Britain had been asking Canada to allow the Royal Canadian Air Force (RCAF) to establish training bases in Canada's wide-open spaces for British aircrew candidates. King had flatly refused, arguing that such a move would commit Canada to war. But now that war had come, the idea resurfaced and King was quick to see that the idea had its attractions. It could generate jobs in Canada, in the building, operating and supplying of the bases. The air was the future, and Canadians had proven skilled in flying during the 1914–18 war.

Above all, in 1939 it was completely inconceivable that air warfare could produce huge aircrew casualties, so conscription was simply not a possibility if the air training plan became Canada's number one role in the war. On that basis, King opened negotiations with Britain.

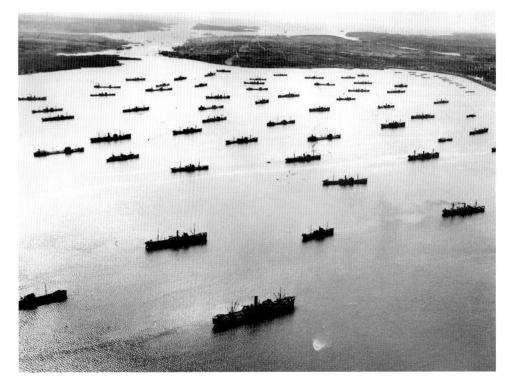

They were difficult indeed. The British expected Canada and the other Dominions to pay the bills, but Canada in 1939 had few financial resources, and the terrifying costs of raising men and equipping them frightened the government. The British hoped to see the air training plan generate twenty thousand to thirty thousand aircrew each year, a staggering total, and they estimated the costs for the necessary ninety or so flying training schools at $880 million. Heated discussions reduced the total to just over $600 million, and in December 1939 King agreed that Canada would provide $353 million,

while the Australians and New Zealanders were to chip in some $68 million and the British $185 million. But King demanded that the RCAF control the training plan and, most important to the prime minister, that London declare that this was Canada's major contribution to the war. Reluctantly, the British agreed, and Mackenzie King was able to announce the establishment of the British Commonwealth Air Training Plan (BCATP) on December 17. That this date was his sixty-fifth birthday mattered greatly to King, a man obsessed with coincidences and portents.

The pattern of Canada's war now seemed set. The country's main effort was to be in the air, the army very much secondary and the navy, scrambling to find the crews to operate the few ships it had, in third place. Financial considerations mattered, and in a limited liability war the nation had no qualms about fighting for its fair share of the economic spoils. Above all, in a gesture to French Canada, there was to be no conscription.

QUEBEC WAS NOT APPEASED and Ontario was disgruntled. The first province to be convulsed by the war was Quebec. The premier, Maurice Duplessis, seized on the excuse of war to dissolve his legislature on September 25 and seek a renewed mandate. Ottawa had always tried to destroy provincial autonomy, the premier said, and now it was using the war to foster a campaign of assimilation and centralization. This was a standard *nationaliste* argument in the province, and most observers concluded that the Union Nationale government's financial situation was so precarious that Duplessis was trying to get re-elected before Quebec could no longer borrow money.

Ottawa, nonetheless, was in a near panic; the carefully crafted agreement that King and Lapointe had created was now jeopardized by the sudden election. Then Lapointe, Charles G. "Chubby" Power, the postmaster-general, and P.J.A. Cardin, the minister of public works, persuaded King that Duplessis was directly challenging them in their role as Quebec federal ministers. They had to fight back, and the way to do it was to announce

that they would resign—and leave French Canada exposed to conscription—if Duplessis was not defeated by the provincial Liberals. Initially horrified at the possibility of losing his key men, King eventually came to see the wisdom of the approach.

Yet few thought Duplessis could lose. He had won 77 of 90 seats in 1936, and some projections gave the Liberals at best 25 seats. But Québécois listened to Lapointe and Company, who campaigned vigorously for a moderate war effort. The justice minister, repeatedly pledging that he and his colleagues were the guarantors of a no-conscription policy, was heard. The voters duly weighed the risks and plumped for Adélard Godbout and his provincial *rouges*. As a result, the Liberals won 53 per cent of the vote and 69 seats in the legislature, a stunning triumph for a united Canada.

Now it was Ontario's turn. If Duplessis believed Ottawa was doing too much, Liberal premier Mitchell Hepburn believed the King government was doing too little in the war. Hepburn was a maverick, perpetually feuding with the federal government, and he told reporters privately that "Mr. King hasn't yet realized there is a war on." He complained about the slow mobilization, the lack of equipment and the government's unwillingness to spend money on the war. When the provincial Conservative leader, George Drew, criticized the federal government's war leadership in a speech at Queen's Park on January 18, 1940, Hepburn promptly moved a resolution condemning the government's war management. Threatening to resign if his members did not back him, Hepburn ensured that his motion passed, with only ten votes cast against it. Ontario now was on record as denouncing the King government.

King was surprised but delighted. He had promised the Opposition that there would be a session of Parliament in early 1940 before he called a general election. Now, King decided, this challenge from the largest province in Canada had to be faced. Parliament met a week after the Ontario resolution had carried, and the stunned MPs, Liberal and Opposition alike, heard the governor general read the speech from the throne

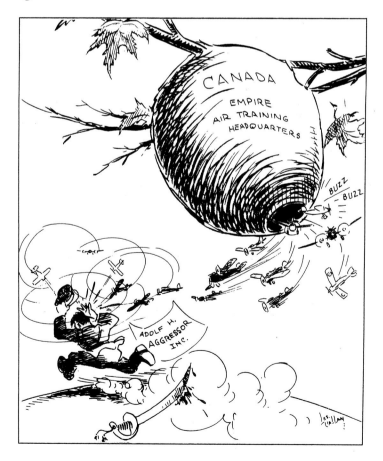

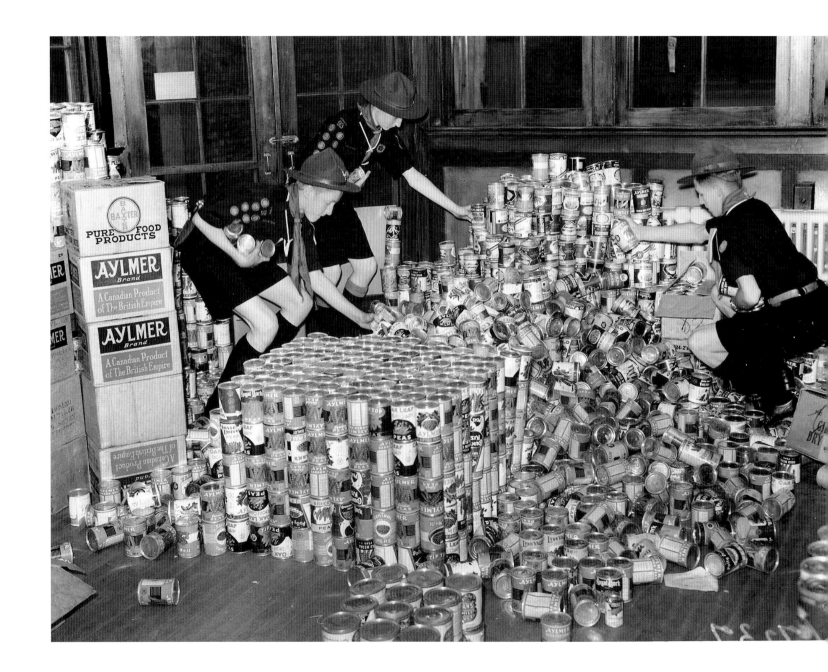

declaring the Parliament dissolved. The Opposition screamed treachery and betrayal, but could do nothing. The election was to take place on March 26.

The campaign was a hallelujah chorus for Mackenzie King. The Opposition Conservatives had a weak leader in Dr. R.J. Manion, who foolishly called for a "national government" but spoke against conscription. No one who opposed conscription, especially those voters in Quebec, believed Manion's pledges against compulsory service if he was calling for a coalition government that aped the Union Government of the Great War. Poor Manion was also unable to produce the names of potential ministers in his coalition, for Liberal after Liberal stated that they would not serve. The CCF, too, was badly divided: J.S. Woodsworth, its former leader, opposed the war, and M.J. Coldwell, its present standard bearer, supported it. For his part, King repeated his pledges against compulsory service, promised a balanced and moderate war effort, and pointed to the able ministers around him.

The Canadian public decided that Mackenzie King was the best choice. He was no one's ideal war leader, but there was not much war as yet. Poland had been defeated by October 1939, but from then through the election campaign, it was a "phony war," with neither ground action nor much fighting at sea or in the air. King and the Grits were their best choice, Canadians decided, giving the Liberals a huge majority of 117 seats. Even in Mitch Hepburn's Ontario, King won a majority of the popular vote and 57 of 82 seats. The government was safe for five more years.

Just as well, for the temper and pace of the war changed within weeks of the vote. The "sitzkrieg," as the press called the long period of inaction that followed the German destruction of Poland, was followed by the sudden blitzkrieg. In April 1940, Hitler's legions invaded Denmark and Norway. In May, they attacked Belgium, Luxembourg, the Netherlands and France, and the world reeled at the savagery and success of the jackbooted armies. It took all of five days to capture Holland and only six days to seize half of Belgium. Bypassing the well-fortified Maginot Line, the Germans struck at France through the forests of the Ardennes, smashing the light French defences and trapping the British Expeditionary Force, which had advanced into Belgium to confront the advancing enemy. The Germans made for the English Channel, their armoured spearheads bypassing pockets of resistance and advancing under air cover that created more panic among soldiers and

civilians than it did destruction. Stuck in the mud of obsolete doctrine, weakly led and without much stomach for the fight, the British and French were outclassed and outfought. The British retreated back to Dunkirk by late May and in a miraculous fashion rescued a large part of their army from the beaches. The French armies, however, collapsed, and the government fled Paris in a panic. The war on the continent was all but over by the first few days of June. The Wehrmacht marched into Paris on June 14, set up shop at the Hotel Crillon, and the swastika flew from the Eiffel Tower. A world had crashed into the dust, and a new world order seemed to be in place.

Canada's part in this cataclysm was minimal, some of its tiny fleet of destroyers assisting in the evacuation of French ports. HMCS *Fraser,* one of these vessels, was on its way back to Plymouth from St. Jean de Luz when it collided with a British cruiser. *Fraser* sank, losing forty-seven of her crew. HMCS *Restigouche* picked up her survivors.

A few Canadian sailors had extraordinary adventures, but none more so than Acting Sub-Lieutenant Robert Timbrell. Training in England in late May 1940, the twenty-year-old Timbrell was given a crew of nine, including six Newfoundlanders just recruited into the Royal Navy, and command of a yacht, *Llanthony,* as well as five trawlers, and he pointed them at Dunkirk. There, 400,000 soldiers—"about half the population of Nova Scotia," Timbrell recollected—awaited evacuation. "We anchored and loaded from the beach using my small rowboat and the power boat with a total carrying capacity of 16 to load the six ships." *Llanthony* could carry a hundred soldiers and the trawlers seventy-five, and Timbrell and his men made three trips. On one trip, a German E-boat, a fast motor torpedo boat, attacked, but some of the soldiers had Bren guns or anti-tank guns. "We held fire

until the last possible moment and then fired with all ten guns." The startled E-boat veered off, and *Llanthony* and its precious cargo made it back to Ramsgate. Timbrell's tiny flotilla rescued nine hundred men, the equivalent of a complete battalion, and Acting Sub-Lieutenant Timbrell won the Distinguished Service Cross.

SO THE WAR SITUATION had dramatically altered. One certainty was that Mackenzie King's electoral timing could not have been better. If he had held his election after the horrific events of May and June, the result might have been very uncertain. The slow pace of Canadian mobilization would likely have been viewed in a very different light.

Certainly that mobilization had been hesitant. King's Cabinet had agreed to raise two infantry divisions in September 1939, and the mobilization plans, prepared by the general staff, were put into effect. This stood in marked contrast to the chaos of August 1914 and demonstrated that some things had been learned. The primary task for the army now was to prepare the 1st Canadian Infantry Division for dispatch to Britain.

This was a major job, for everything was lacking except men. Some units had difficulty filling their ranks; some commanding officers and company commanders were too old to fight a war. But many of the militia regiments could pick the best physical specimens from the many men who besieged their armouries. Significantly, the three regular force infantry regiments—the Princess Patricia's Canadian Light Infantry (PPCLI), the Royal Canadian Regiment, and the Royal 22e Régiment—took their place in the division's ranks, joined by some of the country's great militia units, including Vancouver's Seaforth Highlanders of Canada, the Hastings and Prince Edward Regiment, New Brunswick's Carleton and York Regiment and the West Nova Scotia Regiment.

Strikingly, there was no prejudice against the regulars this time, as had been the case in 1914, and indeed the key staff

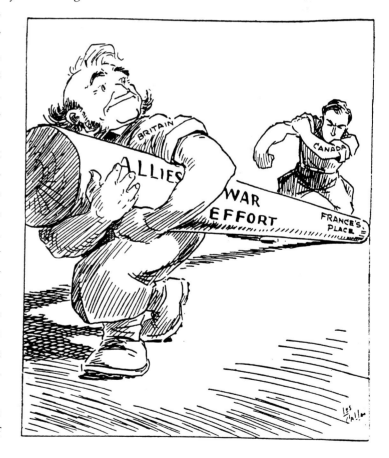

positions in the division went to professional soldiers. The division commander was the Canadian Corps' hugely successful counter-battery staff officer, the former chief of the general staff, A.G.L. McNaughton. Andy McNaughton was a thinking man's soldier, a scientist (he had headed the National Research Council from 1935 to 1939) and a believer in minimizing casualties through use of firepower. This greatly appealed to Mackenzie King and the government.

McNaughton set about organizing his division. When the Royal Montreal Regiment had difficulty getting boots, the general authorized the funds to buy them from Eaton's. That attracted notice, and so did the fact that some units had no transport and only Great War uniforms rather than the new battledress; a few units lacked enough uniforms of any variety to equip all their recruits, so some paraded in civvies for days or weeks. Brigadier George Pearkes in Calgary noted that in Alberta the "rifles, bayonets, Lewis machine guns and signalling equipment" were of Great War vintage, and "there were no mortars or Bren-gun carriers and indeed hardly any Bren guns," the modern light machine gun the Canadians were to employ throughout the war. Worse, beyond basic drill and firearms training, McNaughton's regiments, scattered across the full breadth of the country, did little training. Housed at exhibition grounds, sleeping in rough horse stalls, the volunteers of 1939 learned to roll their puttees and the units tried to carry out minor tactical exercises, but most were playing games and knew it. The men who embarked for Britain at the beginning of December 1939 "were a division of civilians with very little discipline," George Kitching wrote in his memoirs. "We didn't know a thing," another officer remarked—understandable enough, since most of the Canadians' weapons had not yet been issued to the units.

After difficulties in getting into new barracks at Bramshott, near Aldershot—the British contractor insisted on finishing the cricket pavilion before building the huts—training began in earnest in the bitter cold of January 1940, the division essentially preparing for trench warfare and to take its place in the British line in May 1940. Progress was measured but satisfactory, though equipment, in short supply in England as in Canada, only trickled slowly through to the units. The PPCLI, for example, did not receive its transport until the end of March, and some of the trucks were civilian vehicles requisitioned by the British government. Then, in mid-April, part of the division had its training disrupted

when the Germans struck at Norway. One brigade scrambled to get itself ready to move northward, only (and fortunately) to have its orders annulled, the British finally deeming the operation too risky because of the enemy's air superiority.

The 1st Canadian Infantry Division, still awaiting its first division-scale exercises, could only watch the disaster unfold in the Low Countries and France, the miracle occur at Dunkirk and the desperate efforts made to form a new defensive line in Brittany in the west of France. On June 8, at last, the 1st Canadian Infantry Brigade prepared to embark for Brest, part of the contribution to the new British Expeditionary Force. Mercifully, the excursion was brief, if ultimately pointless. The first Canadian soldiers reached France on June 12, the rest close behind. On June 14, the units strung out along the railway to the "front," orders came to return to England, and the Canadians, minus six men and some of their heavy equipment abandoned in the hasty retreat, made their way back safely. It was a fiasco—the "Brest bust," as the men called it—but France was beyond salvation in June 1940. The French capitulation to the Nazis followed immediately. Half-trained as it was, the 1st Canadian Division now was one of the most battle-ready formations left to meet the expected invasion of the British Isles.

Like the army, the Royal Canadian Navy (RCN) also had struggled to ready itself for war. The 1,900 regulars and fewer than 2,000 members of the Royal Canadian Naval Reserve, all members of the seafaring trades or retired regulars, and the Royal Canadian Naval Volunteer Reserve, the naval equivalent of the militia, were all that were on hand in September 1939. The navy had six destroyers, divided between Halifax and Esquimalt, scant training in anti-submarine warfare and badly lagged behind its British counterpart in technology. None of the Canadian ships, for example, had ASDIC, the sound-detection system developed to locate U-boats.

But some lessons had been learned from the Great War experience. From the outset, merchant ships travelled in convoys, escorted by warships. The first convoy, HX1, left Halifax for Britain on September 16, escorted by HMCS Fraser and St. Laurent, which had arrived the day before from Canada's tiny Pacific fleet. The convoy was handed over to the British Royal Navy in the western Atlantic, setting a pattern for much of the rest of the war. Initially at least the U-boats largely confined their patrols to British waters, giving the RCN time to recruit men from the farms and towns and to begin to train them. Anthony

Griffin began his training as a candidate for a commission in late 1939, doing some rudimentary training at HMCS *Star,* the naval reserve unit in Hamilton, Ontario, where he learned Morse code, semaphore, flag signals and the theory of seamanship. "Naval recruitment," he noted later, "had been pretty leisurely during the early 'phony war' period . . ."

The Royal Canadian Air Force (RCAF) had a similar process to go through. Its eight regular and eleven auxiliary or reserve squadrons went on active service in September, and all the RCAF's fifty-three aircraft were made ready for action, or as ready as obsolete aircraft could be. A few Hurricane fighters aside, none were of operational quality. And the need for recruits was not yet understood. Barney Danson, a militiaman in the Queen's Own Rifles in Toronto, was disappointed when his unit was not called for the 1st Division. "I tried to join the air force, but it wasn't easy to get into the RCAF in those days." Farley Mowat had a similar experience. In October 1939 he went to the RCAF in Toronto, only to be told by the sergeant there: "The Air Force don't need no peach-faced kids. Shove off! You're in the way!"

But then the RCAF's task was operating the British Commonwealth Air Training Plan (BCATP). The service scrambled to locate airfields and to get barracks, classrooms and hangars constructed all across the country. Civilian flying schools began to train pilots for the RCAF, and the first Commonwealth aircrew trainees began to arrive in the late spring of 1940. It was a massive effort, one that ultimately might well be judged to have been the greatest Canadian contribution to victory. But it began from nothing, and in the effort to get the BCATP up and running, the RCAF severely hampered its own ability to get into the fray. Initially, three squadrons were slated to serve overseas, but by the time Britain came under attack from the Luftwaffe, the RCAF had only a single squadron of fighter pilots in England.

The limited liability policy, the policy that had constrained Canada's war effort from September 1939 to May–June 1940, had now run its course. The phony war was over and done, and Britain and France had lost. "Obviously," the *Guelph Daily Mercury* editorialized on June 3, "we have been leisurely to say the least. The only thing to do now is to skip the excuses and start vigorously from here." The war had become a struggle for British survival and, almost all Canadians believed, a fight for their democracy and their freedom. Canada began to gear up for the fight.

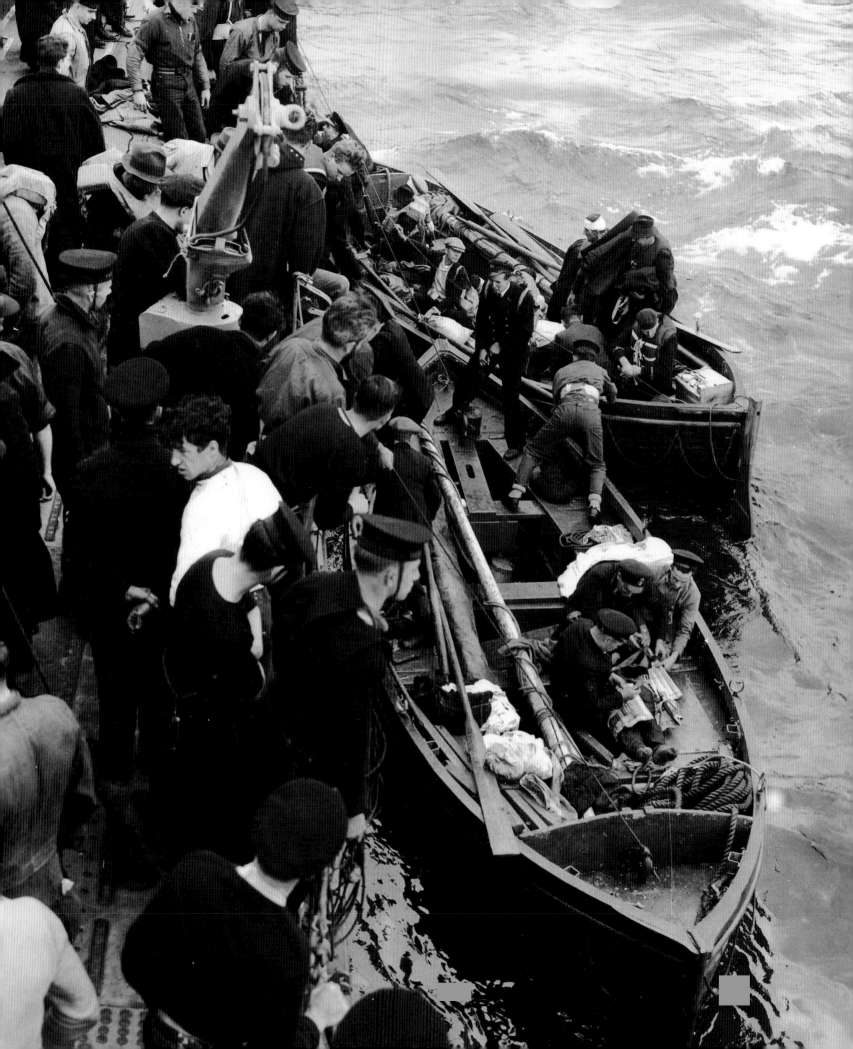

LEFT: The war at sea was brutal, the North Atlantic cold and unforgiving.

These merchant ship survivors, being taken aboard a Canadian navy

ship, were lucky and knew it. (National Archives of Canada PA -111512)

2 | GETTING READY

"I WAS ON WATCH ONE NIGHT," recalled merchant seaman Bruce Duncan, "and first thing: BOOM! BOOM!... Two [merchant ships] gone. People don't realize, to be in a convoy, you have to visualize, it's twenty-four hours a day waitin' for a guy to take a shot at you. If you let it get on your mind ... you thought, 'If a god-damn torpedo comes through here, I'm all by myself.' Then you go up in your room and that was all blacked out, there was nothing open, no radio, it's like a prison. You lay there in the heat, boy, I tell you, it's pressure after awhile."

The war became a serious matter for Canada after the fall of France, but for months and months there was very little Canada could do to effectively help Britain in its fight to survive against Hitler. Armies could not be created overnight, air squadrons and pilots could not be conjured out of nothing, nor could warships be built, crewed and sent to sea at once. Canada did have a small merchant navy, and the nation's food and raw materials fed the British and their industries. But all too often the Halifax- and Sydney-based convoys ran into German U-boat wolf packs, striking quietly and with deadly effect. The war in the North Atlantic for the year and a half after Dunkirk was the main area of operations for Canada.

MACKENZIE KING UNDERSTOOD that the Canadian people were stunned by the events of May and June 1940. "Each day," he wrote in his diary at the end of May, "brings us nearer the attack upon Britain which is liable to produce any kind of reaction in this country. It is going to be a terrific job of holding Canada together." The issue, almost at once, was how to expand the war effort. The prime minister announced the immediate dispatch of the

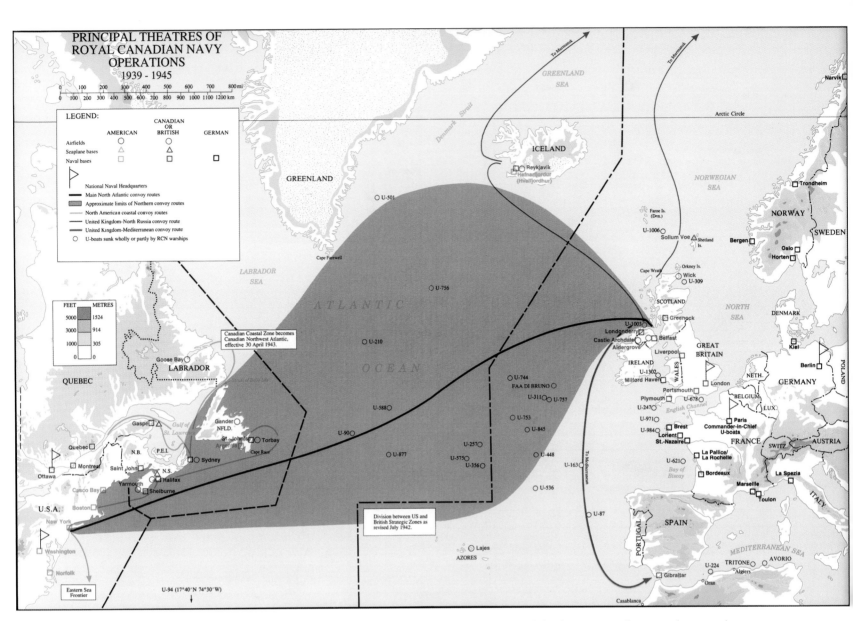

PRINCIPAL THEATRES OF ROYAL CANADIAN NAVY OPERATIONS 1939 - 1945

LEGEND:

	AMERICAN	CANADIAN OR BRITISH	GERMAN
Airfields	○	○	
Seaplane bases	△	△	
Naval bases	□	□	□

▷ National Naval Headquarters
━━ Main North Atlantic convoy routes
▧ Approximate limits of Northern convoy routes
┈┈ North American coastal convoy routes
━━ United Kingdom-North Russia convoy route
━━ United Kingdom-Mediterranean convoy route
○ U-boats sunk wholly or partly by RCN warships

FEET	METRES
5000	1524
3000	914
1000	305
0	0

Canadian Coastal Zone becomes Canadian Northwest Atlantic, effective 30 April 1943.

Division between US and British Strategic Zones as revised July 1942.

(Courtesy Directorate of History and Heritage, National Defence Headquarters, Ottawa)

2nd Canadian Infantry Division to Britain and the formation of a corps there. Orders went out to Canadian shipyards to step up the construction of corvettes—in effect, glorified whalers that could escort convoys and, ideally, fight off the U-boats—and minesweepers. Every ship the navy had available was sent to Britain. Orders went out to the RCAF to speed up the British Commonwealth Air Training Plan (BCATP): the construction of training bases, which had been scheduled to take two years, now had to be completed in one. This, said the officer in charge, was "sheer madness," but somehow it had to be done. At the same time, the British government, hitherto reluctant to place orders in Canada, now needed everything and needed it immediately, and factories began to ready themselves to produce military equipment. It was a beginning.

Most Canadians, however, thought of soldiers and large armies, and inevitably of conscription. The Conservative Party led that charge, but King was quick to scotch the idea of

conscription for overseas service. He and his Cabinet did, however, understand that people needed reassurance that Canada was ready to make the maximum effort. On June 18, 1940, the prime minister introduced the National Resources Mobilization Bill into Parliament. This sweeping piece of legislation gave enormous powers to government "to mobilize human and material resources for the defence of Canada," but its most important clauses concerned manpower. The bill proposed a national registration of men between the ages of twenty-one and forty-five and pointed to conscription for home defence. The government pledged that this was not a prelude to overseas conscription, but Montreal mayor Camillien Houde nevertheless denounced the registration. He was promptly arrested and placed in an internment camp at Petawawa, Ontario, where he remained for four years. Surprisingly, few sympathized with Houde, and most Québécois seemed to be prepared to accept the necessity for home defence. The registration proceeded without much difficulty.

The first thirty thousand home defence conscripts reported for thirty days' training on October 9, 1940. Only unmarried men were called up, a training program that the army's chief of the general staff, Major-General Harry Crerar, called "very superficial." But there were few modern weapons available, so the goal was to make the men "military-minded," a task that presumably was assisted by urgings to trainees "to bring along any basketball or badminton equipment they have available." Men described their training as "downright fun," so perhaps Canada was not yet taking the war with complete seriousness. Nonetheless the training period was extended in February 1941 to 120 days and in April 1941 to the duration of the war. Home defence conscripts were to be encouraged to volunteer for overseas duty; if they didn't, they were to continue to serve in Canada.

But could Canada defend itself without the United States' help? This concern came to the fore in May 1940, as Britain and France teetered on the edge of defeat. President Roosevelt told a Canadian diplomat, sent to Washington to determine if the United States could supply aircraft for the BCATP, that what worried him was the fate of the Royal Navy if Britain capitulated. Would it be handed to the Nazis or dispatched to Canada? Could Mackenzie King pass that message to the new British prime minister, Winston Churchill? Roosevelt was insistent that Churchill save the navy, whatever else might happen.

French-Canadian opinion, remembering the events of the Great War, was sharply opposed to conscription for overseas service.

BELOW: Montreal's mayor, Camillien Houde, soon to be locked away for his intemperate actions, spoke against compulsory service, as did many others. (National Archives of Canada PA-107909)

RIGHT: At this demonstration against conscription, the sign on the truck declares: "La Jeunesse Veut La Paix"—"Youth Want Peace." (*The Gazette*/National Archives of Canada PA-107910)

King was horrified. In his diary, he wrote: "It seemed to me that the United States was seeking to save itself at the expense of Britain . . . My reaction was that I would rather die than do aught to save ourselves or any part of this continent at the expense of Britain." But King dispatched Roosevelt's question to Churchill and, he believed, drew forth Churchill's great speech on June 4: "We shall never surrender and even if, which I do not for a moment believe, this island . . . were subjugated and starving, then our Empire beyond the seas, armed and guarded by the British Fleet, would carry on the struggle until, in God's good time, the New World, with all its power and might, steps forth to the rescue and liberation of the old." There was much anxiety in Ottawa, but Churchill's willingness to fight on was

not in doubt. All Canada was reassured, but many nonetheless worried about the Dominion's security if Britain fell.

In the midst of his campaign for an unprecedented third term as president, Roosevelt was also thinking of continental defence. On August 16, he invited King to meet him at Ogdensburg, New York, to talk over the situation. What FDR proposed was the creation of a Permanent Joint Board on Defence (PJBD), a board that would study the defence needs of North America and make recommendations to the two governments. King agreed at once, seeing that since the United States now had guaranteed Canada's safety, he could send men overseas in a steady and ever-growing stream to Britain. But the PJBD was a clear recognition that Britain could no longer protect Canada and that only the United States could. The Nazis' success in Europe had altered Canada's place in the world, and Mackenzie King appeared to understand this. He told the House of Commons that the PJBD was "part of the enduring foundation of a new world order, based on friendship and good will. In the furtherance of this new world order, Canada . . . is fulfilling a manifest destiny."

In the spring of 1941, while the PJBD did its work, Canada faced a financial crisis caused by a shortage of U.S. dollars. The war had greatly increased Canadian exports to Britain, but the British were

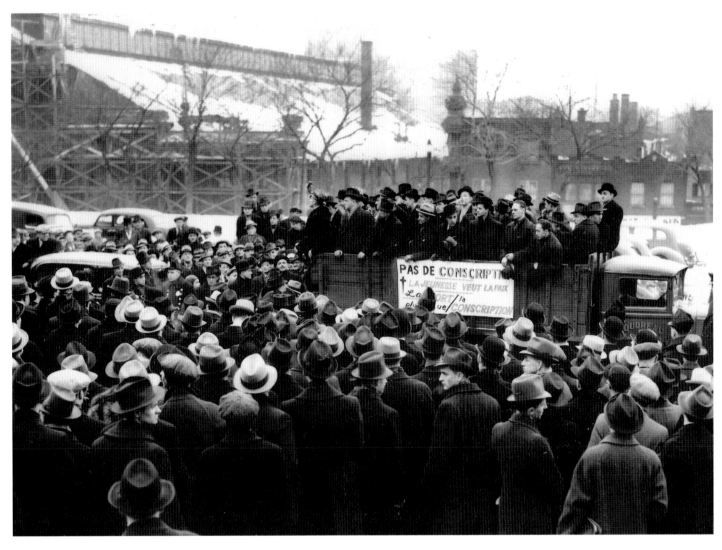

effectively broke and unable to pay Canada for what they needed. At the same time, Canadian imports from the United States had also increased and Canada was running out of U.S. dollars to pay for them. Before the war, pounds sterling could be exchanged for American dollars, letting Canada balance its books; now, exchange controls made this impossible. In April 1941, Mackenzie King visited Roosevelt at his home at Hyde Park, New York, and asked for help. He did not want charity, a loan or even Lend-Lease, which was then under discussion in Congress as a way for the still-neutral Unites States to help Britain get the goods it needed to fight the war. What Canada wanted was for the United States to buy more in Canada: more raw materials and more military equipment. The dollars earned would cover Canada's purchases in the United States. FDR agreed at once, thereby taking a giant step towards the economic integration of Canada into the American empire. Did King know what he had done? Probably, but in a world war there was no choice. Victory was the goal; everything else could be worried about later.

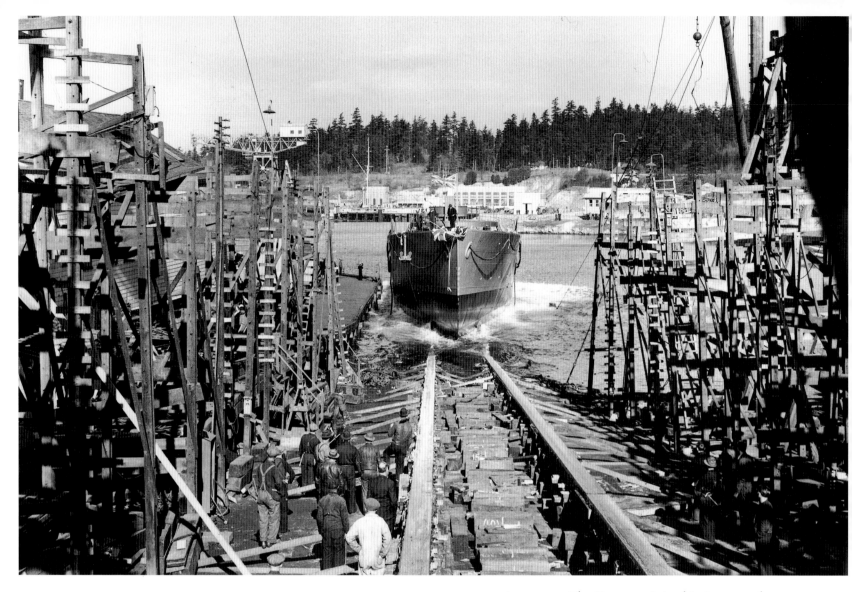

VICTORY SEEMED HIGHLY UNLIKELY in 1940–41. The Germans, joined in June 1940 by Italy, controlled western Europe. They had smashed Yugoslavia, crushed Greece and in June 1941 attacked the Soviet Union. The massive onslaught onto the steppes rolled forward at a pace that astonished observers; huge numbers of Soviet prisoners were taken as whole army groups dissolved. At the same time, small numbers of German troops, working with the Italians in North Africa, drove British armies back towards Cairo. The enemy seemed unstoppable, and Britain and its Commonwealth had little prospect of turning the tide. So serious was the situation that Canada, with just eleven million people, was Britain's ranking ally from the fall of France until the German attack brought the Soviet Union into the war.

The war at sea was Canada's major theatre, and the great convoys of merchantmen were its major national contribution in the first years of the war. Ordinarily forming up in the great protected harbour of Halifax (but joined by ships from Sydney, Saint John and American ports), convoys were made up of vessels from many nations—Britain and

Canada, of course, but also occupied countries such as Denmark, Norway and the Netherlands. A small convoy might be twenty or thirty ships, a large one as many as a hundred, loaded with grain, meat, shells, trucks and every variety of military equipment. The ships formed into a giant grid, six hundred metres separating ships to the left and right, and the same distance forward and astern. "It was a very complex thing," one sailor recalled. "They all moved into their positions: line nine, vessel six; line ten, vessel four. That took almost a day" to get the convoy formed. "The last in the [outside] right-hand column and the last in the left-hand corner [were] always referred to as coffin corner. They were generally the first guy to get it. The Germans would come up from the stern, you see. Tankers went pretty well in the middle; they'd be hard to get at." Still, a convoy was a big target, ships packed together in a slow-moving box covering fifty to one hundred square kilometres of ocean.

The U-boats fought their war with skill and savagery. Admiral Karl Dönitz, the commander-in-chief of U-boats, had for years been planning how to maximize the effectiveness of the undersea weapon. His ideas focused on "wolf pack" tactics, sending a swarm of submarines to fall on a convoy. But how to locate the convoy? Dönitz decided to station a line of U-boats at right angles to the ordinary convoy course across the North Atlantic; the first sub to spot the convoy radioed its headquarters and shadowed the merchantmen. U-boat headquarters then signalled every submarine in the area and guided them onto the convoy, each U-boat captain making independent attacks and using up to twenty-one torpedoes. The wolf packs, which began to operate in September 1940, did terrible damage to the lightly protected convoys. They were aided substantially by the fact that the Germans had cracked the convoy codes and could calculate their positions for maximum effect.

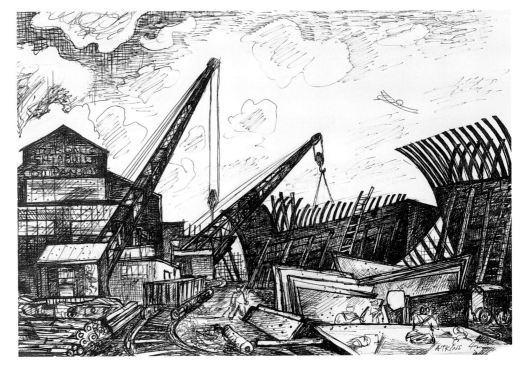

BELOW: Ships were desperately needed. Even these old four-stack destroyers at Sydney, Nova Scotia, painted by T.C. Wood, were pressed into service to protect convoys. (CWM Wood 10598)

RIGHT: Convoys could be huge, a hundred ships spread out over vast expanses of ocean. The merchant navy crews who manned the vessels were in great peril and knew it. These paintings by Harold Beament (*above*) and Alfred Leete (*below*) portray the way in which tranquillity could turn into terror in an instant. (CWM Beament 10051, CWM Leete 87058)

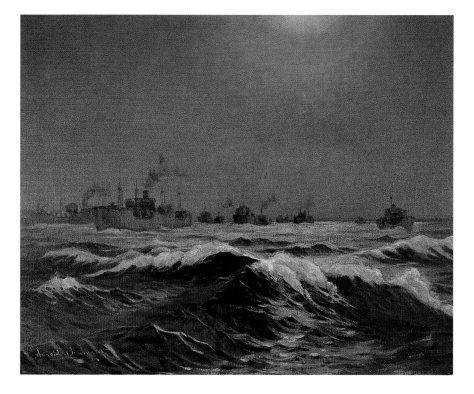

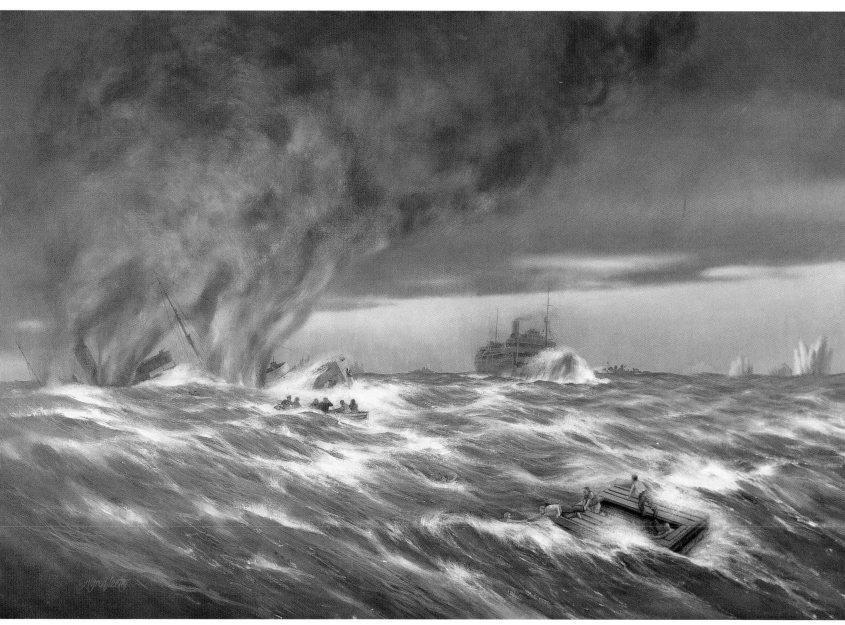

BELOW AND RIGHT: Neither escorts nor merchantmen were supposed to stop for survivors, but many did. Ordinarily an escort would be detailed to return to see if any men survived. The painting by T.C. Wood (*below*) and the photograph of HMCS *Trail* taking survivors aboard (*right*) suggest the sense of salvation experienced by those who cheated death. (*below:* CWM Wood 106071, *right:* National Archives of Canada PA-200322)

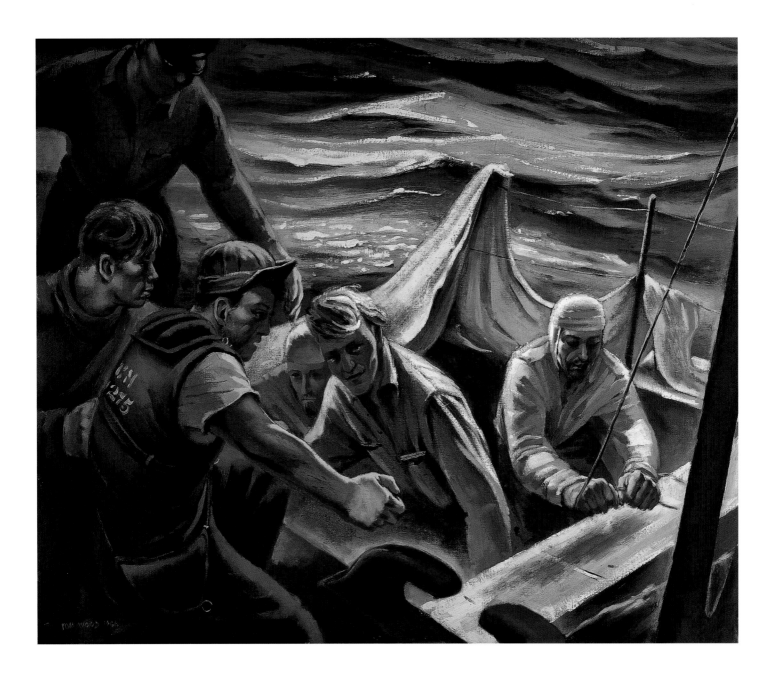

THE LAST GOOD WAR

For both the British Royal Navy and Royal Canadian Navy (RCN), the only weapons available to counter the U-boats in the early years of the war were limited and ineffective. Escort vessels carried depth charges, essentially a barrel of explosives timed to explode at a set depth—but these were blunt weapons. ASDIC, the U-boat detection system, could help locate submarines underwater, but it too was a crude device that could be fooled by schools of fish or different temperature layers in the sea. Radar could locate U-boats on the surface, but it was in its infancy in the early years of the war. Huff-Duff, or High Frequency Direction Finding, could locate U-boats by taking cross-bearings of their wireless transmissions. Aircraft could attack submarines if they were found on the surface; fortunately, U-boats had to surface to recharge batteries and frequently surfaced to make speed or to attack. Even if caught, however, a U-boat could crash dive in thirty seconds, so the window of opportunity was fleeting. Complicating matters further was the limited availability and range of anti-submarine aircraft, which created a "black hole" in the mid–North Atlantic, where U-boats could move about with little threat from the air. The Allies, moreover, had no luck in cracking Dönitz's unbreakable ciphers—until May 1941, when a Royal Navy boarding party captured a U-boat's Enigma machine, complete with its code settings. This was a crucial gain, for enemy codes had baffled the "boffins" trying to unscramble them at Bletchley Park in England. Now they could be read—until the enemy changed them.

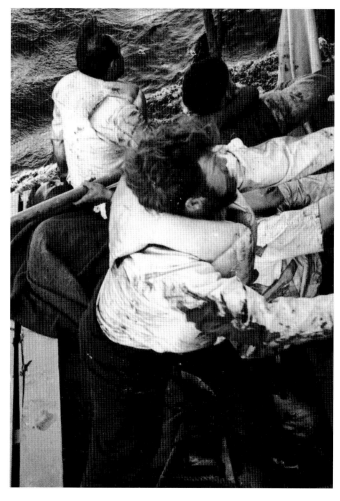

The Battle of the Atlantic, therefore, was a war of technology and stealth, machine against machine. That it was also a war of man against man went without saying.

That war was fought by the U-boat crews, brave men serving an evil cause, who went to sea in their flimsy craft for incredibly long and often tedious cruises that could last up to three dangerous months. The war was fought by merchant seamen hauling explosives, oil, raw and finished materials and foodstuffs across the tossing seas in good weather and

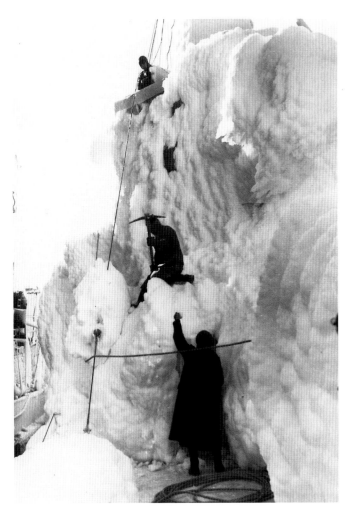

bad. For too many, death came in a sudden explosion at night, a few moments of panic and drowning in a frigid sea. And the North Atlantic war was fought by the RCN, a fleet created out of nothing and manned by amateurs.

Canada's navy began the war with six destroyers, a fleet insufficient for any task. As soon as war broke out, the government, by requisitioning or persuading owners, acquired some sixty auxiliary vessels. Yachts and passenger liners followed, the former converted into escorts, the liners turned into "armed merchant cruisers" by putting a few guns aboard. One armed merchant cruiser, HMCS *Prince Robert*, which had been a Canadian National steamer of 6,300 tonnes, was purchased by the government in December 1939 for $700,000. In the winter of 1940, four 6-inch guns, two 3-inch guns and six machine guns were installed on the ship. With a crew of 241, *Prince Robert* was now a fighting ship. But conversions could only go so far and could not meet all the needs of the RCN. In the summer of 1940, after Britain and the United States had arranged the "destroyers for bases" deal (which saw the Americans acquire bases in Newfoundland, not yet a part of Canada), the RCN received six Great War–vintage destroyers from the U.S. Navy. Old and not all that seaworthy, these ships went into service convoying merchant ships as quickly as possible.

Much of the rest of the RCN's fleet was to be built in Canadian shipyards. The first task was to build sixty-four corvettes, an order that was placed in February 1940 and parcelled out among fifteen yards, including several on the Great Lakes, and twenty-four minesweepers. These were not large vessels, but they were a challenge for builders who had never worked to naval standards before. There were design problems, shortages of skilled workers and difficulties in finding the rubber, steel plate and copper needed to build a fighting ship.

The corvettes, the first of which came off the ways before the end of 1940, were unlovely vessels. About 1,100 tonnes fully laden, some 63 metres long, the corvette initially carried a crew of 47 and could steam for 6,400 kilometres at a speed of 12 knots. Her

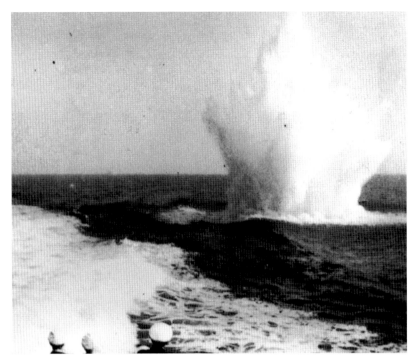

FAR LEFT: The North Atlantic was a vile sea in winter, and the corvettes iced up in extraordinary ways. This photograph shows HMCS *Swansea*. Its crew had little choice: chop their ship free of ice, or capsize. (George Albert Lawrence/ National Archives of Canada PA-106811)

BELOW AND NEAR LEFT: In time, the escorts became better armed and the crews better trained. These photographs show the quarterdeck (*below*) and the satisfying explosion of a depth charge (*left*) launched from the destroyer HMCS *Restigouche*. (CWM, *below:* 19800567-001 P.8A, *left:* 19800567-001 P.7B)

MEN of VALOR
They fight for you

MERCHANT NAVY——Fourth Arm of the Service.

Outfighting submarines and dive bombers in a three day battle, Capt. Fred S. Slocombe, M.B.E., and his heroic crew succeeded in delivering the icebreaker **MONTCALM** to Murmansk as a gift from Canada to the U.S.S.R.

FAR LEFT: The Merchant Navy ordinarily drew little attention, no matter how important its task. This widely issued poster praised one ship's crew on the deadly Murmansk run that helped support the Soviet Union's war effort. (CWM 19880069-838)

BELOW LEFT: As this recruiting poster demonstrates, the RCAF knew the kind of men it wanted. (CWM 19750317-061)

BELOW RIGHT: The army struggled to enlist French Canadians. "Our Army Needs Good Canadians," this recruiting poster proclaimed. (CWM)

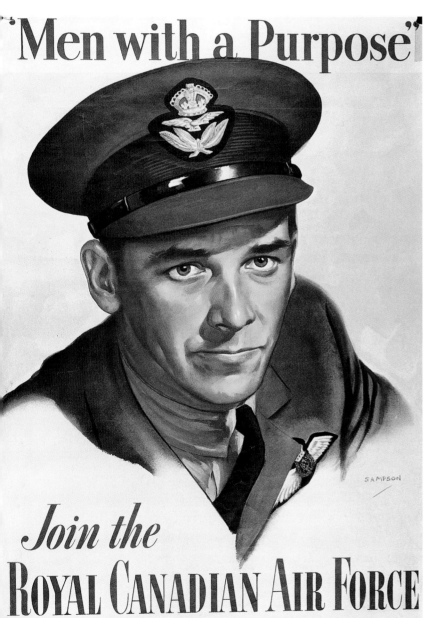

"Men with a Purpose"

Join the
ROYAL CANADIAN AIR FORCE

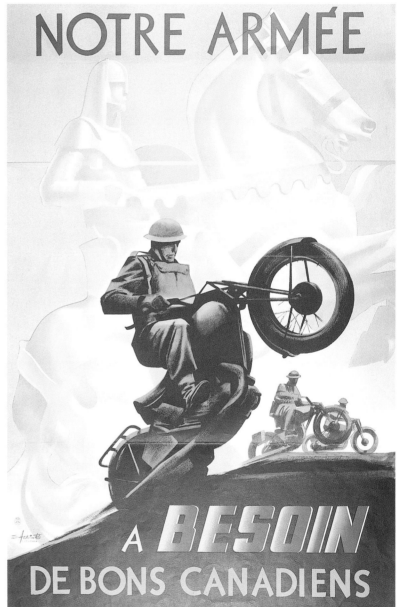

NOTRE ARMÉE

A BESOIN
DE BONS CANADIENS

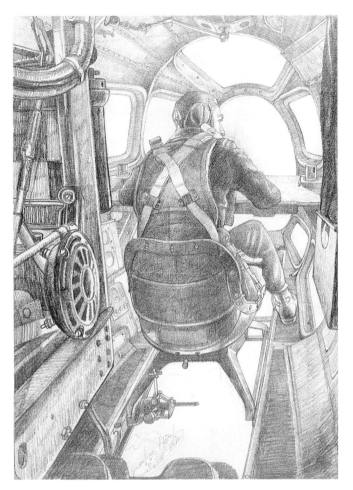

armament was a 4-inch gun, a 2-pounder "pom-pom" and one or sometimes two Oerlikon 20mm guns. Above all, there were depth charges, the main weapon in fighting U-boats. The first Canadian-built corvette, HMCS *Collingwood,* was commissioned aptly enough at Collingwood, Ontario, on November 9, 1940, and reached Halifax the next month. Thereafter, 121 additional corvettes came into service over the course of the war. Over time, modifications resulted in more crew and more weapons being crammed into the hulls, but only a very little more space. (The last surviving corvette, HMCS *Sackville,* tied up in Halifax harbour as a living memorial, provides a vivid example of the conditions in which Canadian sailors faced the enemy.)

Those conditions were simply wretched. The corvettes tossed and pitched in high seas, and the crewmen, living cheek by jowl, sleeping in hammocks pitched above their mess tables, puked their guts up with great regularity in the foul weather of the North Atlantic. In winter, the crews froze, below decks as much as above, and ice could build up with great speed, often thick and heavy enough to threaten to capsize the vessel. The bridge was open to the weather, and in the best Canadian egalitarian traditions, corvette captains, usually "Wavy Navy" lieutenants in their twenties (so-called because as RCN Volunteer Reservists the rank on their sleeve was wavy, as opposed to the straight gold braid of regulars), suffered along with the ordinary seamen.

Anthony Griffin, fresh from his training course as a new naval officer, received a posting to the corvette HMCS *Pictou,* which had been commissioned in Quebec City in April 1941. The captain was a former merchant sailor aged forty-two who drank too much and left the service at the first opportunity. His replacement, another merchant sailor with better seafaring skills, suffered from a reluctance to go to sea and took a shore job as soon as he could get one. That left Griffin, who became captain, the first RCN Volunteer Reservist officer to command a warship. *Pictou,* her crew as green as its new and frequently seasick commander, had to learn all about convoy protection on the job. This, Griffin recalled feeling, was "the blind leading the blind."

As more aircraft became available, the convoys could get the air support they needed.

LEFT: This pencil drawing by Paul Goranson shows an observer in the nose of a Hudson bomber on coastal patrol out of Dartmouth, Nova Scotia. (CWM 11429)

BELOW: The war made St. John's, Newfoundland, a major bastion of the battle of the North Atlantic. Harold Beament painted this view of its extraordinary harbour. (CWM Beament 10061)

Somehow, Captain Griffin and *Pictou* managed. In October, his ship was part of a convoy escort out of St. John's, Newfoundland, a convoy that was hard hit by Dönitz's wolves. After midnight on October 17, the officer of the watch, "a new sub-lieutenant of eighteen from Moose Jaw," reported seeing star shell in the distance. *Pictou* hurried to investigate and embarked on a fruitless search for survivors while at least six ships sank around her. Two hours later, *Pictou* found a U-boat on the surface, fired at it with its four-inch gun, "sadly not equipped for night sighting," and dropped depth charges on the crash-diving enemy. Griffin thought he had scored a kill, but there was no confirmation.

Everyone was learning; the only question was whether the supply of merchant ships would last long enough for the RCN to master its deadly trade. With the U-boats sinking tens of thousands of tonnes of shipping a month—in March 1941 alone, more than 200,000 tonnes went down—that was a real question. Starkly clear to all, Germans and Allies alike, was that the North Atlantic was Britain's lifeline: cut the flow of supplies, and Britain might not be able to continue the war. London reallocated resources among industries, imposed severe rationing on the British people, intensified farming operations and began to cut trees at a great rate—using Canadian foresters to do so. But the imports that in 1940 had been 38.1 million tonnes fell in 1941 to 27.7 million tonnes and in 1942 to 20.8 million. That could not go on.

BRITAIN COULD NOT CONTINUE the war if the Royal Air Force (RAF) could not stop the Luftwaffe from wiping out its air defences. The Battle of France had been lost

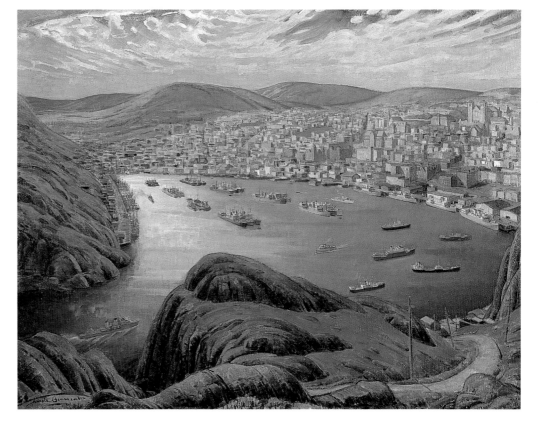

in May and June 1940. The Battle of Britain began within weeks, and although 2,400 Canadian air and ground crew were serving in the RAF, including No. 242 Squadron (which was wholly Canadian in flying personnel), No. 1 Fighter Squadron of the Royal Canadian Air Force (RCAF) was the only Canadian air unit in the fray. And a fray it was. In one mass dogfight on September 15, Squadron Leader Ernie McNab said that "there must have been nearly a thousand aeroplanes milling in a small area just south of London. It was a quick shot and away," he continued, "for someone was sure to be on your own tail." McNab downed a Luftwaffe Heinkel-111 that Sunday, a turning point in the Battle of Britain.

Hartland Molson, a thirty-two-year-old member of the Montreal brewing family, was another Hurricane pilot in No. 1 Squadron, and he survived sixty-two sorties from August until he was shot down on October 5 by a Messerschmitt 109 in a dogfight that pitted the Canadian squadron against seventy-five German aircraft. His instrument panel shattered, his leg wounded, Molson's fighter spun out of control at twenty thousand feet and he bailed out. "I landed with a plunk," he wrote home, "hobbled about thirty yards to a wide path and sat down." Then along came "half a dozen Cockney soldiers" who treated his wounds and got him to a medical officer. Molson had been "fucked by the five fickle fingers of fate, dashed by the deadly digits of destiny, screwed, blued and tattooed, all in one go," as the RCAF slang put it, but he survived. He was luckier than many. Of the 21 pilots in No. 1 Squadron, 3 were killed and 10 wounded, while 16 of 20 Hurricanes, inferior to the Messerschmitts in speed and rate of climb, fell to enemy action. The squadron claimed 30 enemy aircraft, 8 "probable" kills and 35 damaged.

The air war over England that summer was very different from the dogfights over France in Flanders in 1917. The fighters of 1940 were now usually metal-skinned monoplanes, not biplanes constructed of wood and fabric. Their speed was far faster, over 650 kilometres per hour, their rate of climb incomparable, their machine gun and cannon fire infinitely more devastating. The German bombers, most often Junkers 88s, carried heavier loads, mixing high explosives with incendiaries that, once the terror-bombing of British cities began, set roaring fires on the streets of London, Birmingham and Coventry. The air war had accelerated, but the courage and skills of the pilots remained the key. In the result, the RAF's "few" and their Canadian comrades won the first great air battle of the war.

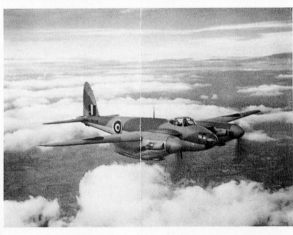

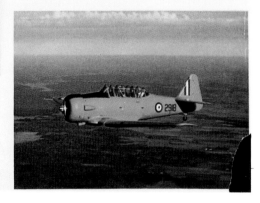

Wings for Victory
As Made in Canada

CANADIAN AVIATION pictures together for the first time — and in full, natural color — all the types of planes now being produced in Canada. Top to bottom they are: Left panel — Norseman, Catalina and Anson; centre panel — Lancasters and Mosquito; right panel — Cornell, Curtiss Helldiver and Harvard. Producers are shown on The Map of Canadian Aviation on the reverse side of the page.

(Photos of Norseman, Anson and Harvard by RCAF.)

THE LAST GOOD WAR

The RCAF looked for the best-educated and fittest Canadians, and then put them through rigorous training.

BELOW: Potential pilots first "flew" Link trainers, here seen at the Virden, Manitoba, Flying Training School. (National Archives of Canada PA-140658)

FAR LEFT: Soon they were in the air, and all too many came to grief in training accidents. (City of Toronto Archives G&M 72446)

NEAR LEFT: How these two Ansons ended up in a stack was a mystery to all who saw this scene. (National Archives of Canada C-60343)

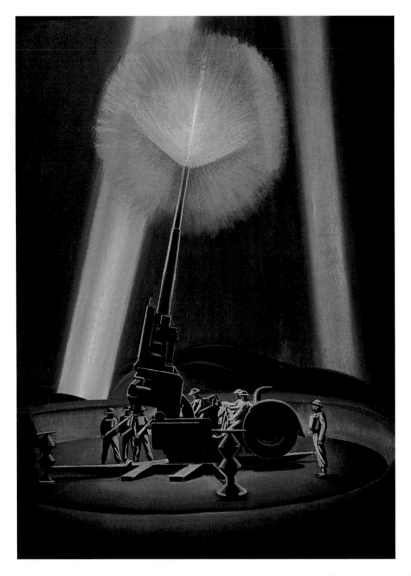

The Battle of Britain buoyed opinion in Canada and lent added urgency to the BCATP, which at its establishment had been estimated to require some 3,500 aircraft and just under forty thousand officers and men to run. The speed-up and expansion demanded by the critical state of the war caused those estimates to be trashed. Aircraft now could not be provided by Britain, so Canada set out to build them, and in larger quantities. The Anson, an outdated twin-engined bomber, was not fit for operational service, but it was a suitable trainer. Canadian firms were making Anson parts, and the government ordered that the aircraft be built in Canada, so Ottawa established Federal Aircraft Ltd. in Montreal, one of the new Crown corporations, to assemble the planes. Engines, however, were deemed impossible to build in the Dominion, so they were purchased in the United States. Eventually 1,832 Ansons went into service in the BCATP, which, even if it had been intended to be a British plan based in Canada, after June 1940 became Canada's air training plan.

The BCATP eventually developed a massive structure extending all across Canada. Potential aircrew joined the RCAF as "Acey-Deuceys," or Aircraftmen 2nd Class, and underwent recruit training. When Bill McRae reported to Manning Depot No. 2 in Brandon, Manitoba, in August 1940, he found that he was to live in a roughly converted horse-show pavilion "about the size of a hockey rink which was now covered by at least 500 double-bunk beds." The washing area "consisted of a long trough of galvanized metal" and beyond "was a line of toilet cubicles without doors." This was followed by Initial Training School (ITS), in effect a ground school whose term eventually was lengthened to ten weeks. McRae went to Regina ITS, housed in a former normal school. Here he lived in converted classrooms and, he remembers, was well fed.

Those who passed the course, heavy on theory and navigation, went on to one of the thirty-two Elementary Flying Training Schools (EFTS), sited in small towns like Cap-de-la-Madeleine, Quebec; Goderich, Ontario; Virden, Manitoba; and Lethbridge, Alberta,

where they were taught to fly in de Havilland Tiger Moth biplanes and, later in the war, in Canadian-made Fairchild Cornells by civilian flight instructors until enough RCAF instructors could be produced. McRae did his training at No. 14 EFTS Portage la Prairie, learned to fly and even received a thirty-six-hour pass at Christmas. "I spent twelve hours on the train getting home, twelve hours at home on Christmas Day, and another twelve hours getting back to the station." The graduates of the EFTS—about 40 per cent did not qualify as pilots, and one trainee died in crashes for every twenty thousand hours of flying time—proceeded to one of twenty-nine Service Flying Training Schools (SFTS) at towns across the land, in places like Moncton, New Brunswick; Summerside, Prince Edward Island; and Souris, Manitoba. There they flew yellow-painted Harvards, Yales or multi-engined

Cessna Cranes or Anson IIs. McRae went to Camp Borden, Ontario, lived in a Great War–vintage barracks and ate "in an equally ancient mess hall in which cockroaches outnumbered diners ten to one."

Those who passed received their wings, and the top third in each class received commissions as pilot officers. McRae received his commission. The remainder were sergeant pilots, who were paid less and had much less status. All proceeded to advanced flying units or to operational training units. Eventually, the BCATP pilot graduates received their postings to squadrons in Canada or overseas. McRae proceeded overseas on May 10, 1941, to an RAF operational training unit to fly Spitfires. Two months later, McRae joined the newly formed RAF Squadron No. 132. This Canadian, like so many others, was to serve with the British air force.

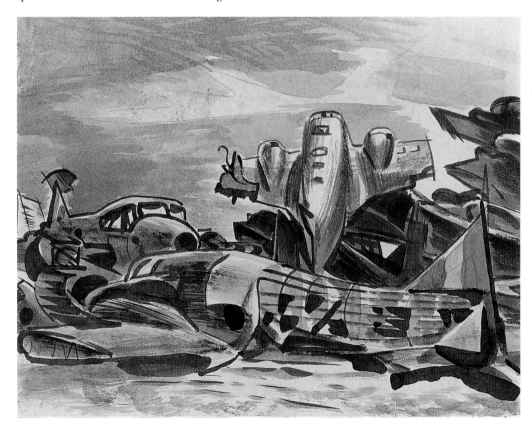

BELOW: The army trained and trained some more in England.
This painting by Charles Comfort shows a Bofors gun at the ready.
(CWM Comfort 12241)
RIGHT: Too often, the army in Canada had to make do with whatever
was available. One soldier photographed his battery's make-believe
ack-ack gun. (CWM 19790301-001 P.37C)

The "washed-out" pilots went to Bombing & Gunnery School, Wireless School, Air Observer or Air Navigation School. They too eventually went to operational squadrons. French-speaking Canadians had a particularly difficult time, the instruction being offered in English only. "There was only one language in the air force," Roger Coulombe recollected, "and it was English. Nothing was ever done in French. No instruction, no demonstration, nothing. You had to understand English, or else." Some francophones wanted to fly enough to learn English; many others washed out.

Some of the BCATP towns were tiny, mere dots on the map in which there was little to do, especially for young men with high energy and much stress to work out of their systems. At Airdrie, Alberta, for example, one trainee wrote in the base magazine, the *Foothills Flier,* that the town was "a runway, a garbage dump, half a hangar, a building in which . . . personnel sleep, eat, lounge, and are administered unto . . . " Fortunately, he added, the "beer parlours of Calgary lay only 30 minutes down the road."

Many men wanted to be pilots, and some were crushed if they didn't make the grade. "I'm waiting for my wash-out tests," Torontonian James Keshen wrote from the EFTS at Virden, Manitoba. "I haven't got what the RCAF calls 'depth perception.' That means that I can't judge how far I am from the ground when I'm landing. And that's one thing they can't teach you." That, he said, was why he had "that crack-up. I was bringing her in for a landing, and I started to level her out when I thought she was 5 feet off the ground." Instead, the trainer was fifty feet in the air, the aircraft bounced, "the wind caught my tail and we flipped right over on our back. I was left dangling upside-down in my harness, but I didn't have a scratch." So Keshen washed out as a pilot and could then announce: "I'm going through for an air-bomber . . . "

Young Keshen and tens of thousands of other Canadians trained with aspiring pilots from Britain, Australia, New Zealand, Rhodesia and other Commonwealth nations. There were also more than 6,100 Americans who, anxious to get into the air, crossed the border

to enlist. By the time it closed down, the BCATP produced 131,533 graduates, almost 50,000 of whom were pilots.

Canadians made up 55 per cent of the BCATP's production, but there also were 42,000 Britons, 9,600 Australians and 7,000 Kiwis. The impact that aircrew trainees from all over the globe had on small-town Canada was profound—marriages, pregnancies, fistfights, housing shortages and a boom in jobs for civilians doing every type of work, from slopping hash in a mess hall to clerical work to driving a truck, changed Canada. At the SFTS at Weyburn, Saskatchewan, townsfolk took RAF trainees into their homes for Christmas dinners. At the nearby SFTS in Yorkton, the first graduating class in the summer of 1941 filled the front page of the newspaper, and the decorations won and casualties suffered by those who trained there were followed throughout the war. In Quebec City, trainees occasionally reported that anti-war sentiments were taken out on them. At Swift Current, local toughs stirred trouble with Brits by calling them "Limey bastards," and there were fights. By and large, however, relations between BCATP trainees and the civilian population were better than good all across Canada.

THIS WAS ALSO TRUE in Britain, where the growing Canadian army had settled in during 1940 and 1941. The 2nd Canadian Infantry Division had arrived in Britain in the beginning of the frightening summer of 1940, and Ottawa announced its decision to begin recruiting a 3rd Division and an army tank brigade. The government created a 4th Division in May 1941 and a 5th Division soon after. There was no real shortage of volunteers; the home defence conscription scheme encouraged many to enlist—and to get their choice of corps rather than be assigned to infantry. Even so, many volunteers chose to be riflemen.

One such was Bill Tucker of Kitchener, Ontario, who enlisted in May 1941. When he went off for his basic training, this twenty-one-year-old was 1.65 metres tall, weighed sixty

kilograms and had a grade 8 education. He was in almost every respect a typical soldier, happy to serve but understandably a little apprehensive. Tucker drew his private's pay of $1.30 a day and sent $20 a month home to his widowed mother. He did his basic training at Chatham, Ontario, and learned how to fire his rifle, strip a Sten gun and work a Bren gun, the infantryman's basic weapons. Tucker shined his boots and "blancoed" his web belt, carried his mess tins and water bottle on it, and wore a small pack and two basic pouches, designed to hold his shaving kit, socks and underwear, and ammunition magazines. Now a "trained soldier," he was posted to the Saint John Fusiliers and served with them in Debert, Nova Scotia; Prince George, British Columbia; Jasper, Alberta; and Melville, Saskatchewan. Like many, he did not get sent overseas until 1944, but Bill Tucker was nonetheless the prototypical Canadian soldier.

The Canadian divisions headed overseas in their turn to form the First Canadian Army, created in April 1942 to consist of two corps with three infantry divisions, two armoured divisions and two armoured brigades. This was a very large force, far larger than the Canadian Corps of the Great War and, since there was a large air force and navy as well in the Second World War—as there had not been in 1914–18—this was perhaps more than Canada could sustain. But in 1941, with no Canadian ground forces yet committed to battle, this was supposition, not certainty.

Meanwhile the Canadians in Britain prepared to meet a German invasion and trained, and trained some more. General Andrew McNaughton became the commander of the Canadian Corps in July 1940, with Major-General George Pearkes, V.C., taking his post at 1st Canadian Division and Major-General Victor Odlum commanding the 2nd Division. Pearkes had won the

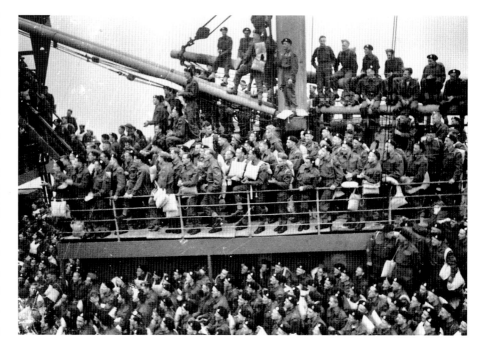

Victoria Cross in the Great War and been a regular since then; Odlum was a much-decorated officer in the Great War and a militiaman for most of the post-war years. Both were brave; neither was totally attuned to the era of the blitzkrieg, and neither were the soldiers they led. The Canadians were good material, everyone said, but their commanders . . .

What began to turn matters around for the Canadians in Britain was a British officer with firm views on training and fighting. Lieutenant-General Bernard Montgomery was one of the few British senior officers to emerge from the debacle of May 1940 with credit, and he was in charge of South Eastern Command, in which the Canadian Corps served. Montgomery made his officers and men fit, he conducted long, hard exercises and he visited units regularly, pointing out shortcomings and demanding that they be corrected. McNaughton, Pearkes and Odlum had not done this, but under Monty's lash the too-old, the unfit and the incompetent began to be weeded out. The younger and more capable gained experience and took over the battalions and brigades. The Canadians were becoming an army at last.

But even an army could not train all the time. As invasion fears receded, the Canadian soldiers formed attachments in the towns around their camps. Men married local women and began families, hung out in the pubs and drank too much or visited relatives in

Scotland. "Is your boyfriend a soldier?" the joke among English women went. "Oh no, he's a Canadian," was the response. Grace Craig from Toronto wrote to her husband in England that she'd heard that "half the married men with the Canadian Army were no longer corresponding with their wives. Surely the English women aren't as fascinating as all that?" Jim Craig tried to reassure her, but he did not tell her that venereal disease rates among Canadian soldiers were high despite the free distribution of condoms (most soldiers contracted the disease in London). Eventually, the Canadian and American armies protested loudly enough that the British authorities began tracking down infected women. A soldier with VD was a casualty, unavailable for action, and that could not be tolerated.

Fortunately, some soldiers took educational courses run by the army or played baseball and football on unit teams; others lolled around at every opportunity. All craved action, or so they claimed, but neither General McNaughton, who wanted his Canadians to be a dagger pointed at the heart of Nazi Germany, nor the government at home, which feared that action meant casualties and could mean a conscription crisis, was eager.

And so the soldiers trained. Early in 1942, battle drill training came into vogue and a young officer, Robert Thexton from the West Nova Scotia Regiment, attended the British Army Battle School at Barnard Castle. There he heard a talk on "hate," went to a slaughterhouse "where an unfortunate dead steer was hanging with its belly cut open" and watched an instructor stick his hands into the intestines, "saying 'Gentlemen, these are the guts. They tumble out quite easily, but are a lot harder to put back!'"

Such demonstrations were supposed to harden men to the horrors of battle, but Thexton was not impressed. "Personally, I could never really learn to hate the Germans," he wrote much later, "in fact I rather respected them for the fine soldiers they were..." What did impress him was that he and his mates doubled everywhere, trained hard and learned much through performing exercises under live fire. "I do not think I have ever felt so physically fit either before or since," he said. Thexton later instructed his own regiment on battle drill and did other such courses; virtually every fighting unit went through the process, the Canadians setting up their own Battle School at Highden House, south of Worthing. Perhaps it was just as well, for the Canadians soon enough would get their fill of action at Hong Kong and Dieppe.

LEFT: Keeping the Canadians occupied was a problem that taxed the commanders' ingenuity. Hockey was popular, naturally enough, and General Bernard Montgomery was even pressed into handing out prizes at the army championships. (CWM 19830440-016 P.50B)

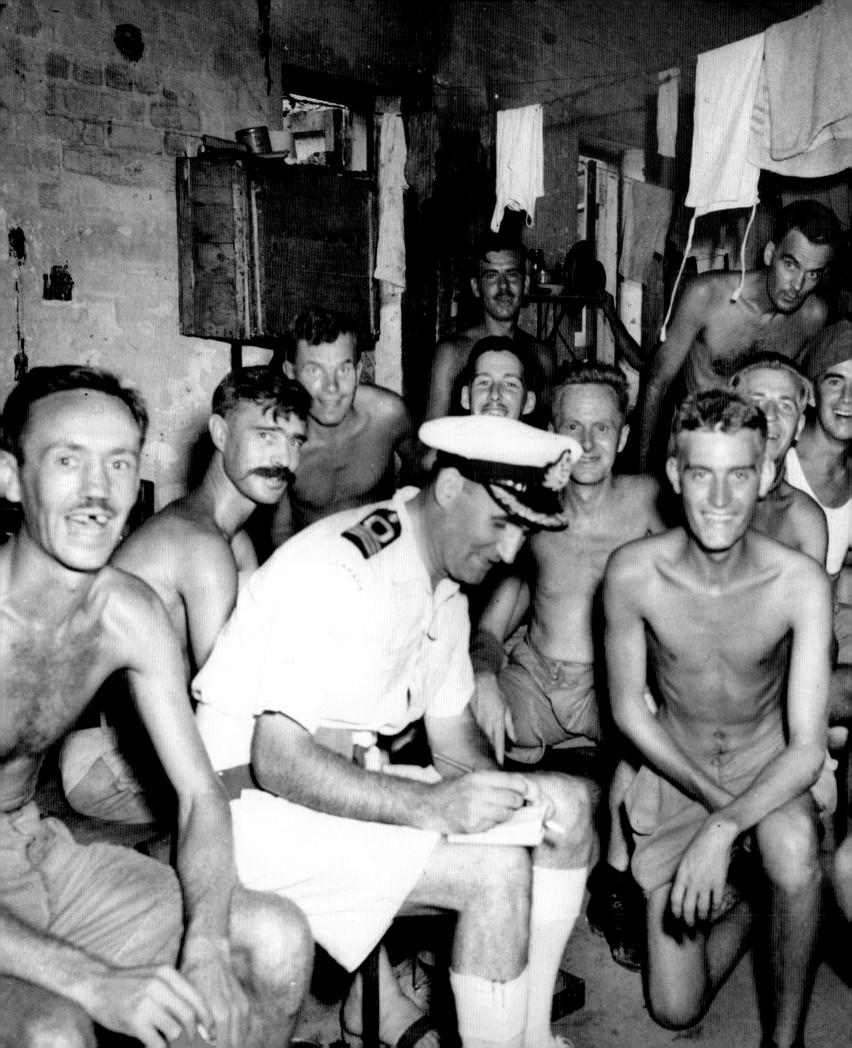

3 | DISASTER IN HONG KONG AND AT DIEPPE

SERGEANT GEORGE MacDONELL heard his orders with incredulity. His company of the Royal Rifles of Canada was to attack Stanley Village at 1 PM and recapture it from the Japanese. "The sheer stupidity of the order to send us without artillery, mortar or machine gun support into a village full of Japanese, in broad daylight, was not lost on me," he wrote. His platoon listened to his orders in "complete silence. Not one of them could believe such a preposterous order. They simply stared at me." But the men did what they were told, and MacDonell gave them the order "to fix bayonets and charge. Within seconds, emitting fearful war whoops, we were upon the enemy..."

After hand-to-hand fighting, using grenades and their tommy guns, the platoon cleared the village of its completely surprised defenders, even decimating a platoon of Japanese riflemen coming forward as reinforcements. Quickly, the tactically proficient enemy regrouped and began to shell the village, readying a counterattack that aimed to outflank the Canadians. Then the word came for the Royal Rifles to pull back, and MacDonell's company left twenty-six killed and many of its seventy-five wounded behind. That night, the governor of Hong Kong, Sir Mark Young, capitulated. It was Christmas Day, 1941. MacDonell and the surviving Canadians would spend almost four years as prisoners of war.

AFTER TWO YEARS OF WAR, Canadians worried that Canada had not yet begun to play its part. The Royal Canadian Navy was growing, learning its trade and playing an increasing role in defending the convoys carrying North America's treasure to Britain. But this struggle was offstage, blanketed with secrecy. The Royal Canadian Air Force also grew in strength, the British Commonwealth Air Training Plan hitting full stride and squadrons

heading overseas. Bombers took off to attack targets in occupied Europe almost daily, and fighters engaged Messerschmitts and Heinkels with increasing success. But Canadians thought in terms of the army, their memories full of the exploits of the Canadian Corps. Where was the army?

In England, the army was protecting the island-nation from invasion and training. In Canada, it was training. Unfortunately, however essential these activities were, there was little that was glamorous about them, and Canadians fretted that the war might end before their soldiers got into action. Not that there was much chance of that. In late 1941, the Germans were at the gates of Moscow, their armies never bested. In Asia, Japan continued to make aggressive noises. And the United States, Britain's one hope for future victory, remained neutral: helpful, but not yet engaged in the war.

This was the situation in August 1941, when Major-General A.E. Grasett, retiring commander of British troops in Hong Kong, passed through Ottawa on his way back to England. Grasett was a Canadian, a graduate of Kingston's Royal Military College, and a classmate of Harry Crerar, the chief of the general staff. Grasett was not impressed with the Japanese, spouting the then-conventional view that they could not stand against white troops. If Canada could send even a small number of troops to Hong Kong, the moral effect of Imperial solidarity on the Japanese could be disproportionate. Crerar was properly non-committal, but he had been "exceedingly worried" about "the insidious campaign of criticism" that the army was not doing its part in the war—or so he confidentially said to reporter Grant Dexter of the *Winnipeg Free Press*. When a formal request from London arrived the next month, Crerar was eager to see the government agree to it.

How could Mackenzie King say no? The rumblings about the nation's lacklustre role in the war were starting to increase, the Opposition claiming that Canada was short of men because the government refused to put conscription into effect. If word leaked out, as it would, that a British request for troops for Hong Kong had been denied, the critics would shout that Canada was refusing to support the Empire because it was so short of men. On the other hand, Canada had no intelligence sources of its own in the Far East, and there was the nagging fear that the tiny territory of Hong Kong was indefensible. Mousetrapped, the Cabinet felt it had no choice. It agreed to send two battalions of infantry and a brigade headquarters to the Crown colony.

General Crerar selected the regiments, picking the Winnipeg Grenadiers and the Royal Rifles of Canada. Both battalions had served stints of garrison duty in Jamaica and Newfoundland respectively, and Crerar hoped that service in Hong Kong might be comparable. The Royal Rifles were from Quebec City; many of the soldiers were francophone, and that was a plus. More worryingly, neither regiment was well trained, but there was time to remedy this, army headquarters believed, both on the

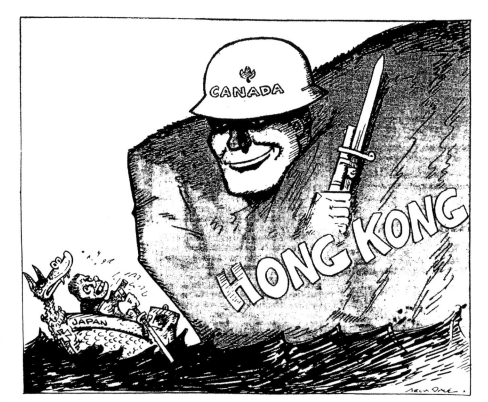

voyage to the Far East and after the battalions' arrival. Through the incompetence of staff officers in Ottawa, the force's vehicles and heavy equipment failed to reach Vancouver in time to be loaded on the ships, but the 1,973 officers and men and two nursing sisters set off on October 27. The transport, which was in Manila at the time the war in the Pacific began, ended up being used by American troops.

Commanded by Brigadier J.K. Lawson, an able regular soldier, the Canadians of C Force, as it was called, landed in Hong Kong on November 16. The men settled into their barracks, heard a few briefings and looked at the positions they were to occupy in the event of war, an eventuality that no one seemed to expect. There were now fourteen thousand British, Indian and Canadian troops in the Crown colony, and the military's intelligence suggested that the Japanese had only five thousand second-rate troops in the area around nearby Canton. In fact, Tokyo had issued orders to seize the territory on November 6, and the experienced and well-equipped 38th Division, hardened by service in the brutal war that Japan had been waging in China, was given the task.

The attack came on December 8, a few hours after pilots of the Imperial Japanese Navy had struck at the U.S. Navy's anchorage at Pearl Harbor, Hawaii, and Japan's naval, air and army forces had successfully invaded Britain's Malayan colony. Nonetheless the attack against the "Gin Drinkers' Line," north of Kowloon on the Hong Kong mainland, came as a surprise to the British troops manning the bunkers. The enemy also quickly eliminated

the five obsolete aircraft allocated for Hong Kong's defence and, on the first day of that war, shattered the defenders' morale. The fight for the Crown colony now was to be made on Hong Kong island.

The Japanese got ashore on December 18, driving back the British and Canadian troops, their efforts helped by local Japanese residents, Chinese fifth columnists and their air force's total control of the skies. The British commander, General C.M. Maltby, curiously decided to defend the gaps and the valleys, leaving most of the high ground to the enemy, who made good use of it. Maltby also split up the Canadian battalions, the Royal Rifles fighting under an Indian Army brigadier, the Grenadiers under Lawson. Lawson's command soon was destroyed, as the enemy surrounded his headquarters at the Wong Nei Chong gap in the centre of the island on December 19. His last message was that he and his staff were "going outside to fight it out." Then Lawson and many of his Grenadiers

THE LAST GOOD WAR

were killed in the terrible carnage that followed, which also was the scene of great courage. The Japanese appreciated Lawson's bravery; a colonel later noted: "We wrapped up his body in the blanket of Lt. Okada, O.C. No. 9 Company, which had captured the position. I ordered the temporary burial of the officer on the battleground on which he had died so heroically."

This instance of apparent chivalry did not preclude the utmost ferocity. In a successful counterattack on the Japanese troops who had taken Mount Butler, Company Sergeant Major John Osborn, a Great War veteran, repeatedly picked up enemy grenades and flung them back at the Japanese. Osborn then pushed one of his men aside and fell on a grenade, saving all but himself. He was awarded a posthumous Victoria Cross, the first to a Canadian in the Second World War.

The struggle for Hong Kong finally slipped out of British hands once the Japanese split the defences in two. The enemy controlled the air and the sea, and the Japanese artillery had all but eliminated the British guns. Short of water, food and ammunition, and with central control destroyed, the Grenadiers and the Royal Rifles tried to hold on, knowing that there was no possibility of relief. But clever Japanese tactics outflanked them time after time. The Japanese soldier proved to be well-led, tough and skilled, and the stereotypes died along with the hopes of the defenders. On Christmas Day, British prime minister Churchill sent "Christmas greetings to you all" at Hong Kong. "The order of the day is hold fast." By then, the Royal Rifles were in the "fortress" from which they launched their "last glorious charge" on Stanley Village under the direct order of their British brigadier and over the vehement protests of their commanding officer, who thought the battalion had shot its bolt and the last attack was suicidal.

The surrender came that night, word of it being received just before the Winnipeg Grenadiers, having gathered every last soldier, including clerks and drivers, prepared themselves to mount another counterattack. That futile effort at least was negated by

the capitulation. "We've been beaten by these miniature men," Signaller Georges Verrault wrote on Boxing Day. "How embarrassing! What shame! We ran out of ammunition … It's atrocious my comrades died for nothing." It was, however, not yet over.

The victorious Japanese behaved with utter brutality. Prisoners were tortured or killed out of hand. At St. Stephen's Hospital at Stanley, two doctors and three Volunteer Aid Detachment nurses' aides were killed, the women raped repeatedly first, as were two nursing sisters who survived. "Japanese troops went wild," wrote Canadian nursing sister Anna May Waters, "bayonetted patients in their beds." A Canadian regimental padre at the hospital recorded that he was put in a room with ninety soldiers. "A Japanese soldier came in and made us put up our hands. He then stole our watches and rings from us … One Japanese soldier came in and took out a prisoner. We heard screams which I believe came from him … The men in the room," the padre said, "asked me to tell the Christmas story and to say some prayers. We all thought it was the end." It was horror, and for the Canadians who survived to become prisoners of war, it was only an introduction to years of starvation, maltreatment and forced labour.

One of the Japanese guards who became most hated by the prisoners of war was Sergeant Kanao Inouye, born in British Columbia. Inouye had returned to Japan in 1938, bitter at his treatment in Canada, and he punished the POWs with great zeal. "Anybody here from Kamloops?" he asked with a smile when he arrived at Sham Shui Po prison camp shortly after the surrender. One soldier, indicating that he was from Kamloops, was punched and beaten. "You called me a yellow bastard in Canada and now you people are going to suffer," Inouye later told another Canadian prisoner. And suffer they did, with little to eat and prey to every disease malnutrition could bring. "We all seem to think, dream and speak of food," Major Kenneth Baird of the Grenadiers wrote in a diary he secretly kept. "It is a long time to go from 5:00 PM until 9:00 AM on a dish of rice, especially when one has to look forward to just another dish of rice."

In all, the Japanese experienced 2,096 casualties in their victory at Hong Kong. On the other side, 290 Canadian soldiers died in the fighting, and 493 more suffered wounds. This was 40 per cent of the Canadian force and testimony to the stout defence these half-trained troops put up. Another 128 were to die during their vile imprisonment in Hong Kong, and a further 136 died in Japan, where they had been taken to work as slave labour

in mines and shipyards. Of the 1,975 Canadians who had arrived in Hong Kong in November 1941, only 1,418 would make it back to Canada. Most suffered from illness and disease for the rest of their lives.

Hong Kong was a tragedy, a great mistake. There was no villain of the piece, however; not the government and not the army's high command. The cause of the debacle was that Canada had no intelligence sources of its own, and as a psychological colony, it could not tell the British that they were foolish to reinforce an indefensible island off the coast of China. The Royal Rifles and Winnipeg Grenadiers paid the price in full.

What also needs to be said is that the soldiers that Canada sent abroad were less well trained than they should have been after two years of war. Captain H.L. White of the Grenadiers wrote after his repatriation that, when his position on Mount Cameron on the western part of the island was under attack at night, he had fired his Verey pistol. "This was the very first time I had ever fired one," he said. "I got the angle slightly too high and lit up my own positions...and caused a hell of a commotion. At that time I had spent five years in the Militia, and had been on active service two years. This," White remarked with the bitterness of a man who had passed four years as a prisoner of the Japanese, "is the kind of training Canada gives her soldiers."

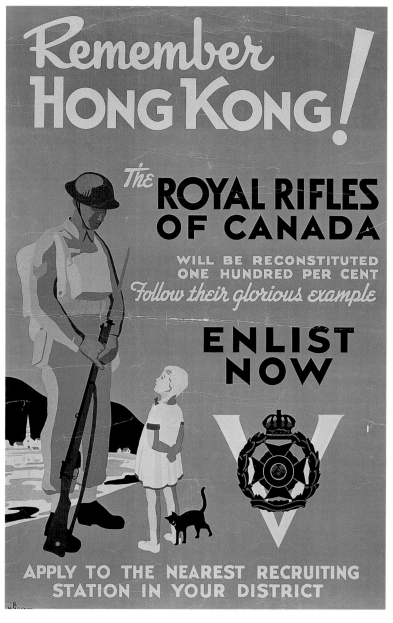

THE BEGINNING OF THE WAR in the Pacific changed the course of events dramatically. It brought the United States together with Britain and the Soviet Union as allies, all but guaranteeing the defeat of the dictators. But the immediate consequences were defeat after defeat. The successful surprise attack on Pearl Harbor devastated the Americans' Pacific Fleet, sending their battleships to the bottom; fortunately, the U.S. Navy's aircraft carriers

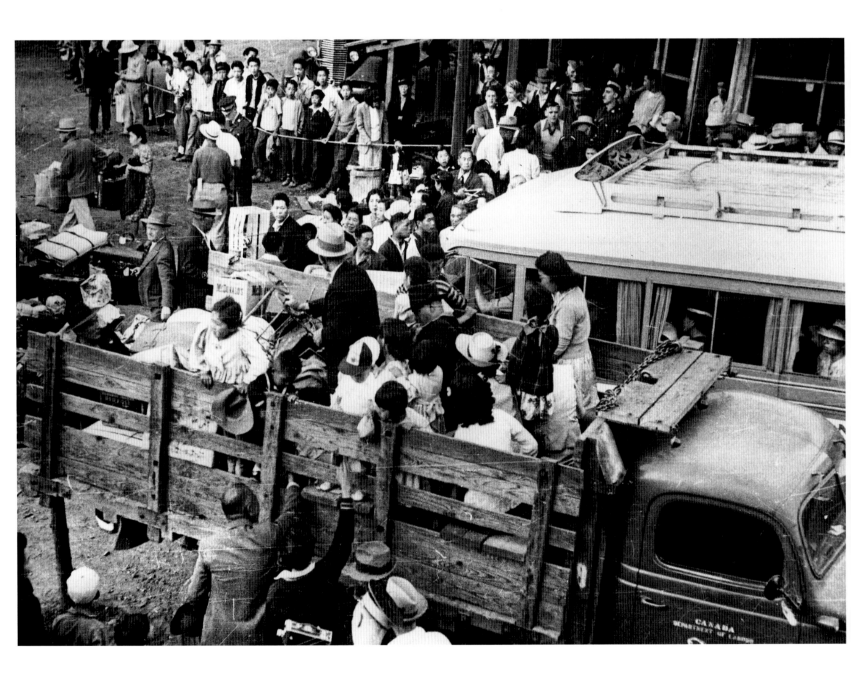

THE LAST GOOD WAR

were at sea and escaped the carnage. Hong Kong fell to Japan, and Malaya and Singapore soon after. The Dutch East Indies and the Philippines followed. The Japanese seemed virtually unstoppable as their soldiers, sailors and airmen acted with daring and skill.

Hitler declared war on the United States a few days after Pearl Harbor, and the British and American chiefs of staff agreed that Germany had to be defeated first. The two allies, with their junior partners, including Canada, began to forge a series of combined military and economic organizations, creating close bonds that augured well for the future.

In the immediate aftermath of the Japanese attack on December 7, 1941, there was near panic in North America. The disaster that had befallen the U.S. Navy left the West Coast open to attack, and both the United States and Canada began to rush forces to the area. Stories of fifth column activity in the territories taken by the Japanese fed the fears, as did reports of the abuse of prisoners of war. The immediate victims of the wave of panic in Canada were the 22,000 Japanese Canadians who lived in British Columbia.

Mostly fishermen, truck gardeners or small business owners, and mostly Canadian-born, Japanese Canadians had endured racism for the half-century they had been in British Columbia. Many of them compounded their difficulties in the 1930s by actively supporting Japan's invasion of China (just as Chinese Canadians took the other side), and their English-language newspaper published Japanese propaganda that was paid for by the consulate in Vancouver. Once the war came, people looking for reasons to get the Japanese Canadians out of British Columbia would point to such actions, which looked very different after December 7 than they had before. What only a few officials in Ottawa, Washington and London knew—through intercepted and decoded telegrams—was that the Japanese consulates in North America, including Vancouver, had been ordered to recruit spies to secure military information.

After Pearl Harbor, municipal, provincial and federal politicians in British Columbia demanded action against Japanese Canadians, their calls reflecting a frightened public opinion. The lieutenant-governor, W.C. Woodward, stated privately that he had "rarely felt so keenly about the impending danger as I do about the Japanese on this coast being allowed to live in our midst." Military officers in the province, fearing attack, virtually bereft of intelligence about the Japanese Canadians and worried about Japanese-Canadian fishermen providing information to an invader, also supported the demands. In Ottawa,

LEFT: The first Canadian victims of the war in the Pacific were the Japanese Canadians of British Columbia. These 22,000 people, mostly Canadian citizens, were evacuated inland carrying only hand luggage. A few hundred Japanese-Canadian men, deemed threats to national security, were interned at camps in northern Ontario. (National Archives of Canada C-46350)

RIGHT: One consequence of the war with Japan was the construction of the Alaska Highway, the first land link between the United States and its northern territory. Thousands of Americans poured into Canada to build the highway—and posted this signpost at Watson Lake, Yukon Territory. (National Archives of Canada PA-121715)

however, key advisers to the prime minister, both civil and military, downplayed the threat and urged caution lest Japan act even more brutally to the Canadians in its hands. But the calls for action could not be checked. There can be no doubt that racism played a major part in the antipathy to the Japanese Canadians.

At once after December 7, the Royal Canadian Mounted Police (RCMP) began rounding up Japanese-Canadian fishing vessels. The RCMP urged, and the community complied with, the closing of Japanese-language schools and newspapers. Then, on January 14, all male citizens of Japan were ordered off the B.C. coast. Six weeks later, after the fall of Singapore, all people of Japanese origin living in designated "security areas" of British Columbia, male or female, British subject or not, were ordered to move inland to evacuation centres. These centres were rough townsites in the B.C. interior. The Japanese Canadians were soon free to leave the evacuation centres, providing they moved eastwards. Many did move, to sugar beet farms in Alberta or to cities in Manitoba, Ontario and Quebec. "This is just to warn you," Muriel Kitagawa wrote to her brother Wes Fujiwara in Toronto in March 1942. "Don't you *dare* come back to B.C., no matter what happens, what reports you read in the papers ... You stay out of this province. B.C. is hell." Not until 1949, well after the war ended, were the evacuees permitted to return to their West Coast towns. Many in fact were "repatriated" to a Japan they had never seen. This was not Canada's finest hour.

Compounding the personal tragedies of the 22,000 individual Japanese Canadians, the federal government confiscated the property of the evacuees and sold it off at fire-sale prices. The military justification for the evacuation at least had a rationale behind it; the judicial theft of property had none. Very few in British Columbia or anywhere in Canada protested, however. People were frightened. The disasters that had destroyed the British, American and Dutch positions in the Far East, and the ruthlessness of the Japanese military, made Canadians fear that they were next. In early 1942, with the Imperial Japanese navy and army roaming freely over the Pacific, that did not seem an unreasonable fear.

Indeed, in mid-1942, Japanese troops occupied islands in the Aleutian chain off Alaska, and the United States and Canada believed this might be a prelude to attacks on the mainland. Thus, a full-scale invasion of Kiska was carried out in 1943, by American and Canadian troops—the first time the two armies had directly co-operated. They found the island

deserted, and the Japanese incursion proved in the end to be a diversionary attack. But in 1942, no one could be certain of that.

After Pearl Harbor, Canada had also agreed that a land route to Alaska, something U.S. president Roosevelt (and the province of British Columbia) had long desired, could proceed. The bulldozers and graders streamed north, and although many Canadians worried about the U.S. Army using "too many" black construction units to build the highway, the process was generally smooth. A network of American weather stations and airfields, designed for defence as well as for sending planes to the Soviet Union, simultaneously took shape, and the development of oil fields at Norman Wells, Northwest Territories, the construction of pipelines and the posting of large numbers of U.S. troops in Canada followed. Edmonton became the main U.S. base in Canada, and thousands of American soldiers were stationed there.

The Canadian Northwest was transformed by the American "occupation," as the locals called it, only half-jokingly. The full force of change perhaps fell most heavily on aboriginal peoples, who found jobs but also suffered from the easy availability of alcohol and the dirty money that could be earned through prostitution. The landscape similarly was ravaged by the hasty construction methods demanded by the strategic situation. And by 1943, the Canadian government had begun to fear that its sovereignty over large areas of Canada had been placed in doubt by the "fit of absence of mind" it had demonstrated in not keeping closer watch on U.S. activities. Ottawa's answer was to buy every American installation in Canada at the war's end.

THE WAR IN THE PACIFIC forced the government to increase its forces in British Columbia, and it allowed Mackenzie King to argue against the growing demands for overseas conscription—demands now led by Arthur Meighen, the November 1941 choice of the Conservative Party as its leader. Meighen was the architect of conscription in the Great War and a brilliant debater, and he had not changed his views. Conscription was essential to mobilize Canadian manpower, he believed, and French Canadians, in particular, had to be made to fight.

Some in Mackenzie King's Cabinet agreed, and early in January 1942, the prime minister decided to hold a plebiscite—non-binding, unlike a referendum—on conscription. Should the government be released from its pledges against the use of men overseas? This question roused French Canadians, who argued that although the promises against conscription had been made to them, King now proposed to ask all Canadians for a release from those promises. An effective propaganda campaign, led by La Ligue pour la Défense du Canada, galvanized francophone public opinion. In English Canada, the issue was not contentious, though supporters of conscription suffered a setback when Meighen lost his attempt to get into the House of Commons in a Toronto by-election on February 9. Still, Meighen had to support the plebiscite, and King enjoyed his opponent's discomfiture. The result on April 27, 1942, was that 2.95 million votes were cast for the "yes" and 1.64 million for the "no." The problem for King was that most of the "no" votes were from French Canadians in Quebec, New Brunswick and Manitoba and from heavily German- and Ukrainian-speaking areas on the Prairies.

The next few weeks saw the Cabinet and Liberal caucus torn apart. King and his Quebec ministers took the divided vote as a reason to doing nothing. Some of his ministers, notably Defence Minister J. Layton Ralston and Navy Minister Angus L. Macdonald, wanted overseas conscription enforced at once. Ralston threatened to resign unless King accepted the decision of the electorate. The result was a compromise reached in late spring 1942: Parliament passed Bill 80, amending the National Resources Mobilization Act of 1940, to authorize the use of conscripts overseas, but not yet. That satisfied Ralston but not Quebec minister P.J.A. Cardin, who promptly resigned, claiming the betrayal of his province, and proving again the potency of compulsory military service as a hot-button issue.

But the prime minister claimed, as always, to be firmly in the middle. King's temporizing policy was encapsulated in his most famous phrase: "Not necessarily conscription, but conscription if

necessary." It sounded like Kingian gobbledegook, but in fact it was a very precise political statement of intention, and it helped to cool the question. What the plebiscite and Bill 80 did was put conscription for overseas service on the political back burner for more than two years.

THE WAR, HOWEVER, went on, and the pressures on the army to get its troops into action increased. In Britain, the men of the First Canadian Army were restless; discipline problems increased as the endless routine of training and more training palled. Lieutenant-General Harry Crerar, now commanding a corps in England, heard rumours of planning for a large raid on the French coast, and he lobbied hard to see that Canadians got the job. By April, the British had agreed, arrangements had been made and Crerar and General McNaughton, commanding the army, selected the 2nd Canadian Division for the task. The division, commanded by Major-General Hamilton Roberts, was thought by the British to be the best-trained Canadian formation.

The target was Dieppe, a small town on the English Channel that for decades had been a favourite day trip for British tourists. The raid was intended to test out the possibility of seizing a defended port, which was thought essential in staging a full-scale invasion. It would be a dress rehearsal for invasion, trying out theories of fire support from air and sea, as well as experimenting with landing craft and the use of tanks on the beaches. The raid also had political uses. The Americans were pressing hard for an invasion of France in 1942. The Dieppe raid, scheduled for July, could assess its feasibility. The Russians, hard-pressed by the Wehrmacht, which was closing in on Stalingrad, were desperate for an invasion too, hoping against hope that this would ease Nazi pressure on them. The Dieppe raid might force Hitler to move troops from Russia to France. And it might ease political pressure in Canada for the army to see action. There were many benefits anticipated from Operation Rutter, as it was called.

But Rutter was not to be. The weather in July was bad—so bad that the planners had to call off the raid. The unhappy, disappointed troops of the 2nd Division dispersed to their camps, took leave and chatted to their friends in pubs about the hard training they had undergone for the raid that never was. But the planners still wanted a go at Dieppe. Deciding that no one would expect a once-cancelled raid to be remounted on the same target with the same troops, they rescheduled it for August 19.

The new plan called for eight squadrons of Hurricanes overhead to provide close support and five light bomber squadrons to lay smoke or bomb. Two squadrons of American B-17s were to bomb the nearest Luftwaffe airfield, and forty-eight squadrons from RAF Fighter Command hoped to provoke the enemy into coming up to fight on British terms. At sea, six destroyers and a gunboat were readied to shell the beaches. Then, the Royal Hamilton Light Infantry and the Essex Scottish, accompanied by the tanks of the Calgary Regiment, would land on the beach in front of Dieppe. To the east, at the village of Puys, the Royal Regiment of Canada and most of a company of the Black Watch were to storm ashore on a beach with one exit that was known to be defended. To the west, at Pourville, the South Saskatchewan Regiment and the Queen's Own Cameron Highlanders were to land. The floating reserve was the Fusiliers Mont-Royal. To the extreme east and west, British commandos were to destroy German batteries that could threaten the main beaches. About six thousand men, five thousand of them Canadians, were involved in what was now called Operation Jubilee.

Some Jubilee; nothing went right. Unluckily, the attacking party's vessels bumped into a German coastal convoy in the early morning hours of August 19, and the firing alerted the coastal defences. The aircraft covering the assault effectively strafed beach defences, and coastal batteries at Varengeville-sur-Mer on the flank were hit hard, but the weight of firepower was insufficient to put the enemy out of action anywhere. Heavy bombers might have been more effective; they had been included in the original plan but were dropped, in part because of fears of civilian casualties. The naval gunfire from the destroyers' four-inch guns similarly proved too light to cause significant damage to the enemy's positions. Battleships would have been more effective, but the Royal Navy had come to fear air attack and the narrow waters of the English Channel did not provide an optimal area in which to commit capital ships. The Canadian soldiers were on their own.

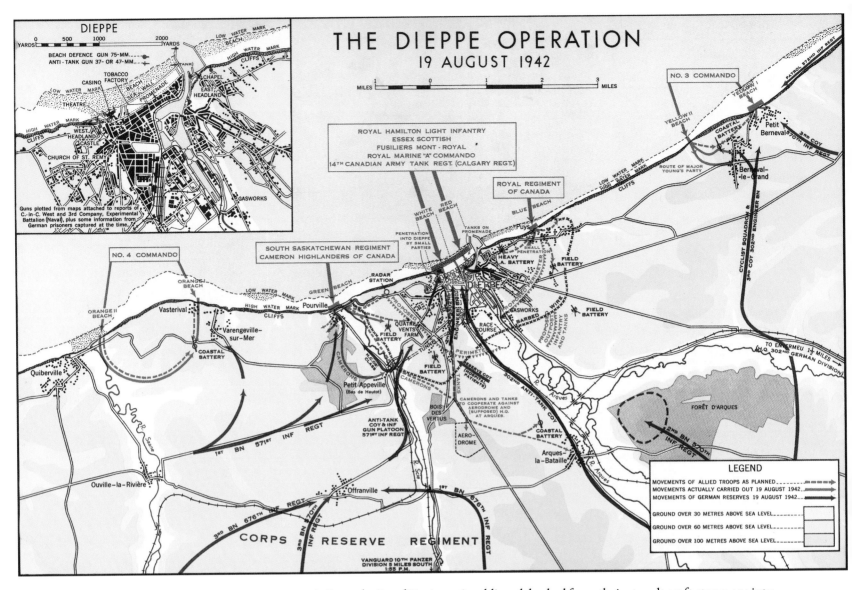

THE DIEPPE OPERATION
19 AUGUST 1942

(Courtesy Directorate of History and Heritage, National Defence Headquarters, Ottawa)

At Puys, the Royal Regiment's soldiers debarked from their assault craft at 5:10 AM into the teeth of a withering fire from Germans atop a cliff to the flank and in a strongly fortified house. The first wave got ashore, despite many casualties, and made it to the protection of the seawall, where most stayed and died. The second and third waves, some dumped into deep water, staggered ashore in full daylight, reinforcing failure, and they too were cut to pieces. The medical officer on the beach, Captain Charles Robertson, was pinned down. "Really," he recalled, "there wasn't anything medically that I or anybody else did. You sure weren't out on the beach." The Royals' commanding officer, Lieutenant-Colonel Douglas Catto, somehow led a small party of men up the cliff, but it was to no avail. Except for a handful of Royals who were rescued from the beach, the survivors surrendered around 8:30 AM. One German lieutenant years later remembered two of his young soldiers in their first action vomiting repeatedly because of the carnage they had helped create.

At Pourville, the South Sasks and the Camerons made their way ashore against only light opposition. The Camerons landed to "The 100 Pipers," played by Corporal Alec

Cameron on the pipes, reputedly the last time Canadians were piped into battle. They would penetrate up to three kilometres inland before pulling back to the beach. Lieutenant-Colonel Cecil Merritt's unit, however, faced heavy fire at the River Scie, and here Merritt, a militiaman who had served in Vancouver's Seaforth Highlanders before the war, won the Victoria Cross. Leading his men across the bridge on repeated trips, Merritt ignored the enemy fire, waving his helmet and urging the infantry on. The South Saskatchewan Regiment had been intended to turn to the left to take Dieppe from the rear, but the advance was stopped short. Merritt and his platoons had to head back towards the beach, where the commanding officer organized the defence that allowed some six hundred of his troops and the Camerons to swim or wade several hundred metres out to sea to the waiting landing craft. A good swimmer, Merritt might have made it himself, but as Lieutenant Buck Buchanan of his regiment remembered, "He started off but then he said, 'Oh God, my job is back there,' and he swam back to the beach" through enemy fire. "So he stayed there" to look after his men the best he could.

On the main beach, the Royal Hamilton Light Infantry and the Essex Scottish touched down thirty minutes after the flank attacks went in. There was no surprise there, and the well-placed Germans, atop the cliffs that dominated the beach and in fortified buildings directly in front of it, slaughtered the attackers. Enemy gunfire blew up assault craft before they touched down; the Calgary Regiment's Churchill tanks were late getting ashore and then had trouble manoeuvring on the "shingle" beach of baseball-sized stones that jammed their tracks. Fifteen of twenty-nine Churchill tanks, however, did cross the seawall, and their machine guns helped the infantry. But because there was little information to urge caution, General Hamilton Roberts dispatched the Fusiliers Mont-Royal at 7 AM, thus adding more men to the debacle. "Show 'em what French-Canadian boys can do," the commanding officer, Lieutenant-Colonel Dollard Ménard, shouted. But Ménard and his men were cut to pieces. Corporal Robert Bérubé remembered that only seven of the twenty men in his boat made it across the beach. "The rest were all killed. We just stayed on the beach. You moved and you'd had it."

Above the battle, the air forces fought one of the great dogfights of 1942, struggling to gain air superiority. As the day wore on and more aircraft of the Luftwaffe appeared, more and more of the RAF and RCAF squadrons found themselves in a colossal struggle.

BELOW AND RIGHT: These beach scenes, shot by German military photographers immediately after the surrender, made good Nazi propaganda. The shingle beach in front of Dieppe that proved very difficult for some of the Canadian Churchill tanks shows clearly. (*below*: National Archives of Canada c-14160, *right above*: National Archives of Canada c-17296, *right below*: CWM 19760072-001#5)

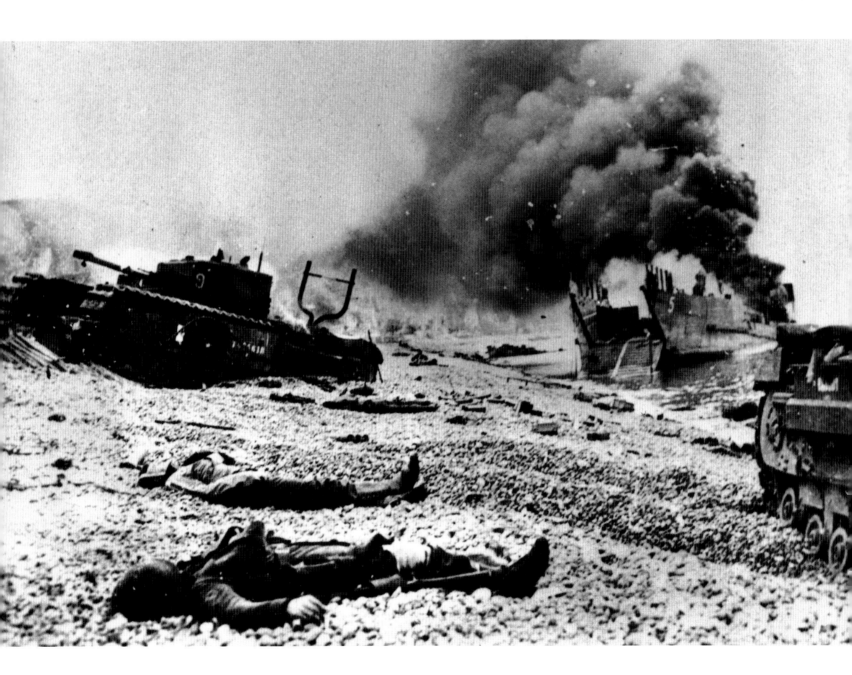

THE LAST GOOD WAR

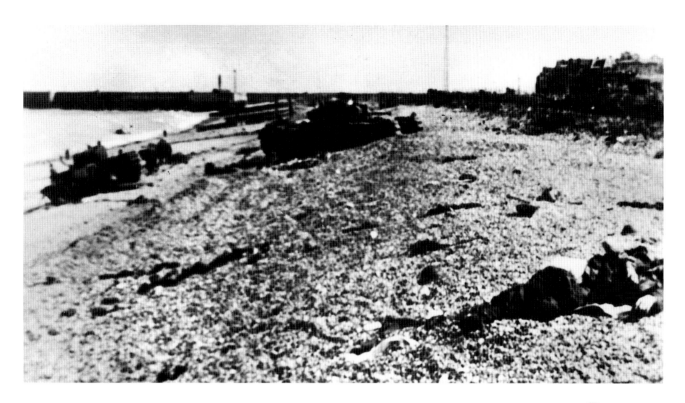

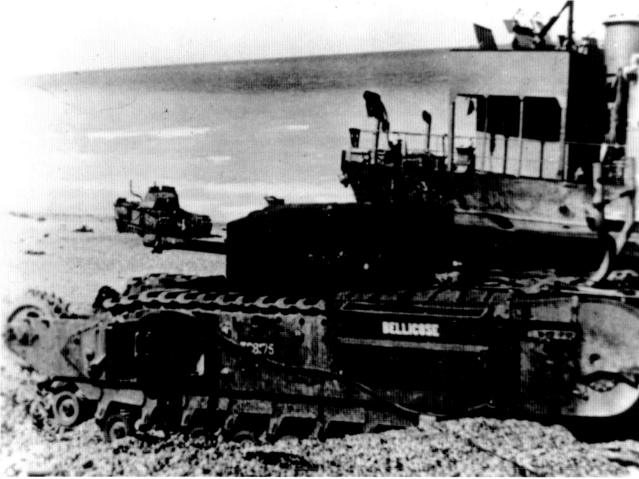

Flight Lieutenant J.M. Godfrey of No. 412 Squadron noted that "the sky was evidently filled with a swirling mass of Spitfires and FW190s milling about... Everybody had a squirt at about 3 Jerrys but it was impossible to see the results, because as soon as a pilot squirted he could be sure a Jerry was on his tail and had immediately to take evasive action." Another Canadian, shot down by an FW190, ditched his Mustang alongside a British destroyer and was picked up—without getting his feet wet. By the end of that dreadful day, the RAF and RCAF had lost 99 aircraft. Pilots claimed 91 enemy kills, a figure that later was reduced to 48, of which 25 were bombers. The air battle was almost as one-sided as the disaster on the ground.

That disaster continued to unfold. A few small groups of Canadians pressed forward into the town, despite the fire, and shot up enemy reinforcements heading to the beaches. Some of the Rileys made it into the Casino, the enemy's main fortified position on the beachfront, and cleared the enemy out room by room. But most of the Canadians lay dead or wounded or huddled behind any protection they could find. A German artillery officer, looking down at the shingle beach, recalled "two whole regiments... clinging tightly against the concrete wall... Everywhere along the whole strand our shells were exploding, their effect multiplied ten times by the exploding of the stone splinters."

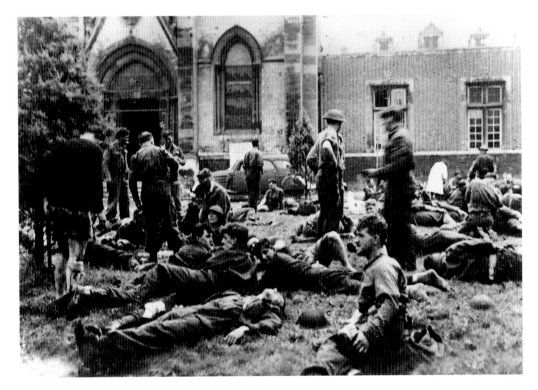

Jubilee had become a disaster, and despite extraordinary efforts by the Royal Navy to get men off the main beaches, fewer than four hundred men made it to the dubious safety of the boats, which were subject to air attack and artillery shelling. Many boats sank from overcrowding, were hit by shells or were forced to return to the

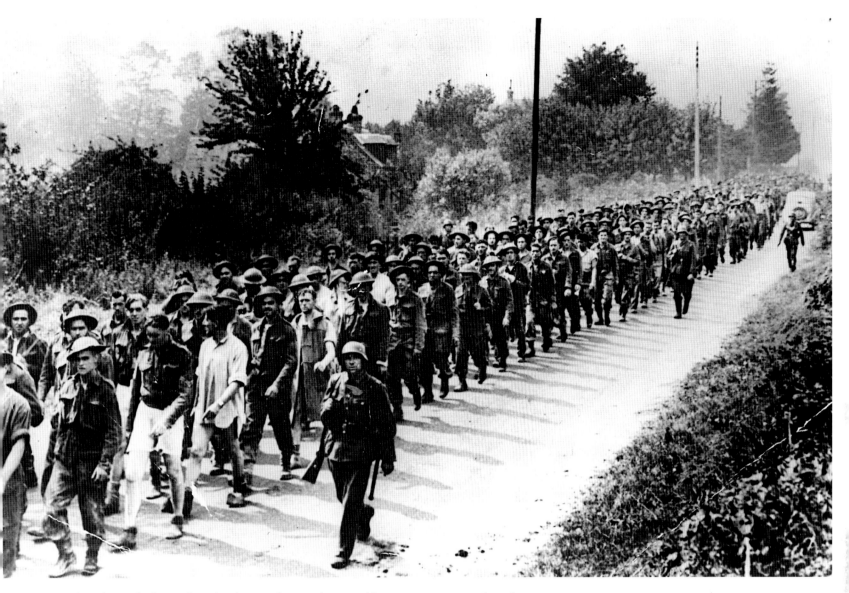

beach. In all, thirty-three landing craft were destroyed by enemy action. Padre John Foote of the Rileys, who had hauled wounded men to safety during the long day, now chose to remain behind with those who could not make it off the beach. "It seemed to me," the padre said, "the men ashore would need me more than those going home." Like Colonel Merritt, he too was to receive the Victoria Cross.

The Germans by almost all accounts generally behaved correctly immediately after the surrender, providing water and medical care to the wounded. Some of the critically wounded at Puys, however, were put "out of their misery" by German officers. "Even though I realized they were doing it as an act of mercy," Jack Poolton of the Royal Regiment said, "I didn't want to see any more because it made me sick." Later, some wounded men were transported in boxcars without care and some underwent operations at a hospital in Rouen without anaesthetic. By the time unwounded POWs arrived at a prison camp by rail eight days after the raid, according to a British medical officer at Obermassfeld, "these people just fell out—absolutely whacked. Covered in excreta and in terrible shape. They'd

MEN of VALOR
They fight for you

"When last seen he was collecting Bren and Tommy Guns and preparing a defensive position which successfully covered the withdrawal from the beach." — *Excerpt from citation awarding Victoria Cross to Lt.-Col. Merritt, South Saskatchewan Regt., Dieppe, Aug. 19, 1942*

been in there for days ... the stench, the horror, the tragedy of it all." Private Jack Griss, one of those taken prisoner, wrote in December 1942 from Stalag VIIIB, his POW camp, that "the only thing I lost in action was a tooth, very lucky eh?"

There had been no luck at Dieppe, which was a bloody disaster. Of the 4,963 men who had sailed from England, only 2,210 returned; more than half of them had never left their boats for the French shore. Those killed and dead of wounds numbered 907, the wounded 586 and the prisoners of war 1,874, more than were captured during the entire campaign from D-Day to V-E Day.

The raid initially had been trumpeted as a great success, and the Canadian media gave it extensive coverage. But as the casualty returns came in, the shock in Canada was profound. The Royal Hamilton Light Infantry, from the Hamilton, Ontario, area had been devastated, and a company from Winona, including many workers at the local E.D. Smith jam factory, was all but wiped out. The Royals from Toronto, the South Sasks from Estevan and Bienfait, the Fusiliers from Montreal, the Essex Scottish from Windsor, the Calgaries from Alberta's second city—the Canadian regimental system concentrated men from localities together, and a disaster could shake a town to its very foundation. The 2nd Division was also shaken, its confidence shattered as units—their barrack rooms now empty—faced years of rebuilding.

The lessons learned, supporters of Dieppe claimed then and since, justified the cost. D-Day, two years later, could not have been a success without the correction of the errors of Dieppe. Moreover, the Germans were forced to reinforce the French coast, and this helped the Soviet Union survive. The Americans were at last persuaded that an invasion of France was impossible without massive preparation. There is some justice in these arguments, but only some.

The lessons of Dieppe were that heavy gunfire and air support were necessary to get men ashore, but this was nothing mysterious in August 1942; American seaborne assault doctrine, for example, already stressed this. The original Rutter plan had in fact called for much more supporting firepower than Jubilee received. Tanks had to be better prepared, waterproofed and equipped with specialized gear, such as flamethrowers or obstacle-crossing devices. This was correct, but what doomed the Churchills in front of the town was the shingle beach, something that intelligence had failed to discover (even though hundreds of thousands of visitors had crossed the English Channel to Dieppe in the decade prior to the war!). Intelligence had also discounted the cliffs at Dieppe—where else would the defenders have placed their guns? Better intelligence was essential, but the egregious errors made by Combined Operations Headquarters in August 1942 were inexcusable. Another lesson, certainly correct, was that an open beach made a better landing site than a defended port. It was also true that landing craft had to be better suited to their task.

Yes, there were lessons, but clear-thinking planners might have decided that most of them were obvious before Jubilee set off. The British way of war in 1942—and hence the Canadian—was still too amateurish to have much chance of dealing with the tough professionalism of the Germans. All one can say with confidence more than six decades later was that Dieppe was a hard lesson in how not to do it right.

Major Mike Dalton, the padre of the Essex Scottish, did not go on the raid, but on August 21, he wrote in his diary that "no Essex officer returned . . . Out of 30 officers who lived together at Aldershot and previously, I am the only original." Two days later he preached a short sermon to the remains of the regiment. "When we enlisted we bargained for hardships of war, but didn't realize we would miss our pals so much after almost 3 years of friendship . . . Although only 44 out of 550 Essex Scottish who invaded returned, personal loss is [the] nation's gain (we hope)."

LEFT: As they had done after Hong Kong, recruiters made the best of the Dieppe raid. This poster, part of a series, featured the bravery of the commanding officer of the South Saskatchewan Regiment, Lieutenant-Colonel Cecil Merritt, V.C. (National Archives of Canada C-87124)

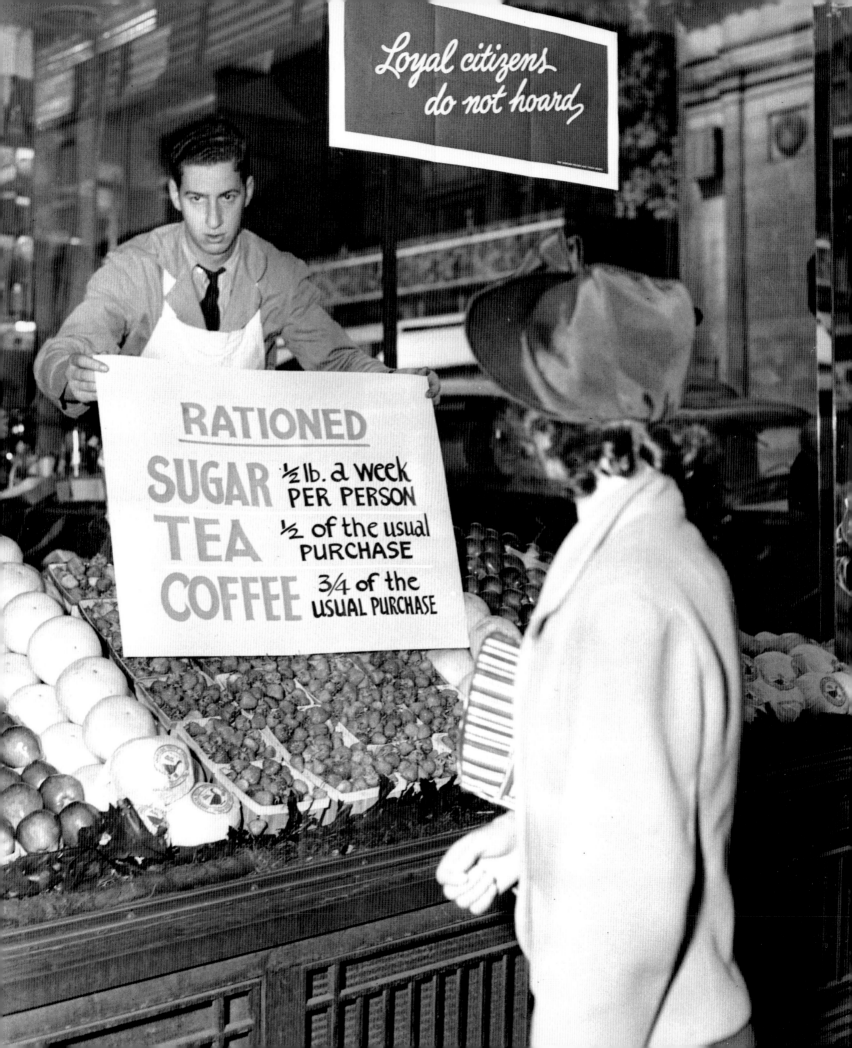

4 | THE WAR AT HOME

"NIGHT SHIFT AT JOHN INGLIS starts at 7:30," Gwen Lambton said of her job in the blueprint office at an ammunition plant, "so I have to be on the Yonge Street car by 6:30 at the latest . . . We work a ten-hour shift, so we don't get out till 6 AM. There is a half hour break for a meal at midnight, and it's just as well that I'm not too hungry then, for I can't afford a meal." Even though she wasn't working on the production line, she wore coveralls. "They're cheap, they cover old and mended clothes. One doesn't even have to wear stockings . . ." Lambton earned twenty-five dollars a week, but with two children to feed and no husband to help, she could barely manage. The cost of rent and food ate up most of her money.

THE WAR CHANGED EVERYTHING for Canadians at home. The war economy gave everyone who wanted a job all the work he or she could handle, and if Gwen Lambton could barely survive on her pay, most of her factory mates suddenly had more money in their purses than ever before. Twenty-five dollars a week was real money in 1942, even if there was little to buy with it—rationing and controls determined what was available.

But money was in good supply, and the government, remembering the way inflation had swept through Canada during the Great War, made sure this would not recur. After permitting some increase in prices—a deliberate effort to counter the deflationary effect of the long economic depression of the 1930s—in October 1941 the federal government announced a freeze. Prices were now to be fixed; wages were to be frozen; and a large bureaucracy in the Wartime Prices and Trade Board, bolstered by an army of housewives who reported on price-gouging, made sure that the rules were followed.

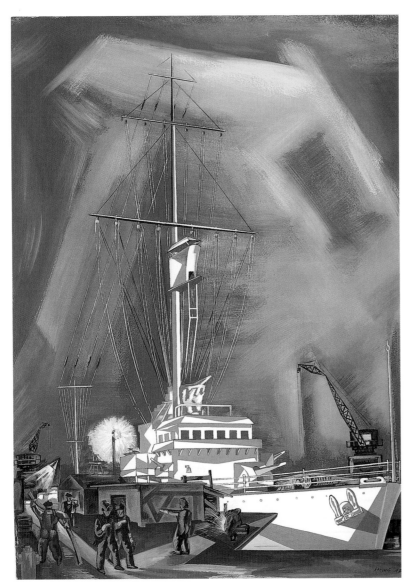

The federal government had one great advantage as it planned Canada's war. The Great War had become a total war, and the government of Prime Minister Sir Robert Borden, fighting a long-drawn-out conflict for the first time, had lurched and staggered as it tried to cope. Income taxes were introduced late in that war, controls on food and materials were put in place slowly and half-heartedly, and the mobilization of Canada's resources had been fitful at best. As a result, the King administration now knew what worked and what didn't.

The government had one additional advantage over Borden's. The civil service in 1939 was far different than it had been a quarter-century before, primarily because men of ability were in the key departments. The Department of Finance was led by Clifford Clark, a former university professor and businessman, who could call on the country's economists for help. The Bank of Canada, created in the 1930s, was led by Graham Towers, formerly a chartered banker, and he had at his side able economists like Donald Gordon and Louis Rasminsky. The Department of External Affairs was full of men of talent—O.D. Skelton, Norman Robertson, Hume Wrong, Lester Pearson and many others—men who represented their department in Ottawa's proliferating committees and their nation abroad. Even the Prime Minister's Office and the Privy Council Office now had able people, ensuring that the Cabinet War Committee, its membership made up of the key ministers, functioned properly and that decisions made were followed up. This sounds much like the way any government should function; it was not, however, the way in which Canada had been run during the Great War and most of the years after it. Without the bureaucracy, greatly expanded during the war and bolstered by "dollar-a-year" men from industry, Canada's domestic war effort simply could not have functioned.

The war economy could not function without money, either. The war cost billions to fight. The peacetime government's expenditures had been $680 million in 1939. During the war, the government ratcheted up spending each year until in 1945 it expended $5.136 billion. The gross domestic product, the total value of everything produced in the country, rose from $5.6 billion in 1939 to $11.8 billion in 1945. Those increases were unprecedented, an indicator of the way in which Canada's factories and farms had been mobilized.

But where did the government get the money it used to pay its bills? Income taxes were one way, and the squeeze was very hard on wage earners. At the beginning of the war, a married man with two children paid no income tax at all unless he was in the upper brackets. If he made $3,000 a year (about double the average income), his income tax was only $10. Four years later, after a series of increases, this taxpayer had to send Ottawa $334 plus an equivalent amount in compulsory savings that would not become available until after the war. The savings feature was deliberately anti-inflationary, designed to keep dollars from chasing scarce goods and, hence, from driving up prices. A subsidiary aim was to reduce imports because U.S. dollars, in particular, remained scarce. A well-off Canadian, say one of the few earning $10,000 a year, paid $3,446 in income tax and an additional $1,200 in compulsory savings in 1943. Corporations too faced corporate taxes that rose from 18 to 40 per cent along with excess profits taxes of 100 per cent, but their profits, hammered during the Great Depression, also rose. Canadians grumbled at the tax burden they carried, but they paid their taxes anyway. Winning the war was worth it.

Even so, there was still money out there, and the government wanted it. Beginning in January 1940, a succession of Victory Bond campaigns asked Canadians to invest in victory. And they did. Eleven War Loan and Victory Loan campaigns raised an incredible $12.5 billion for the war effort (usually at 3 per cent interest), and the country's advertising agencies pulled out all the stops to play on patriotism and guilt to encourage contributions. "Oh please do! Daddy," announced one Victory Bond ad that featured a four-year-old girl pleading with her father.

The nation's youth were mobilized along with their parents. Kids, in fact, were actively solicited to buy War Savings Stamps at twenty-five cents apiece, each featuring a tank or ship or aircraft, and then to stick them onto a card. Once sixteen stamps had been affixed, the card could be taken to any bank, where a War Savings Certificate would be

LEFT: Work for the war effort went on late into the night. This painting by Caven Atkins illustrates the outfitting of a minesweeper at night, likely in 1942. (CWM Atkins 14055)

The war saw Canadians exhorted at every turn.

FAR LEFT: Posters and billboards demanded that Canadians give their money to the war effort and produce more. (CWM 19750539-007)

BELOW LEFT: "What Kind of People Do They Think We Are?" Winston Churchill had asked. Canadians wanted to show the enemy that the democracies had the will to fight. (CWM 19750317-182)

BELOW RIGHT: The pressure to work harder, to produce more, was incessant. (CWM 19750317-171)

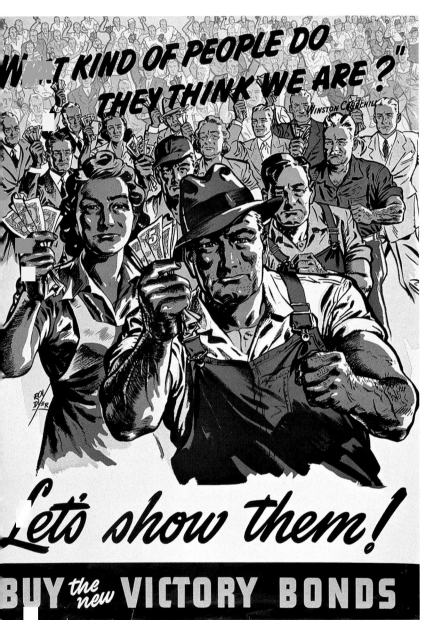

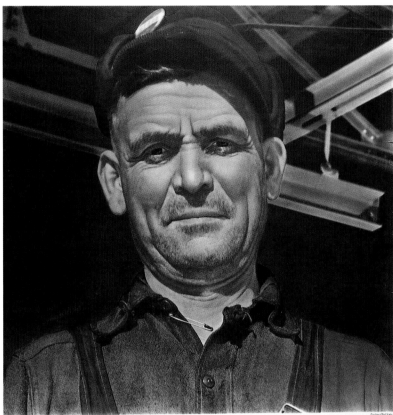

given in exchange. "We are grateful for the sacrifices you are making for us," one advertisement quoted a source it called "We Commandos." The children's "war savings have supplied us with all kinds of fighting equipment. You have done a wonderful job . . . Never forget that you are commandos too . . ." The children's quarters reduced inflationary pressures and helped pay the government's bills.

The industrial mobilization was just as impressive as the mobilization of children. In the first four months of war in 1939, Canadian war orders had amounted only to $60 million. But month after month from 1940 onwards, orders and production mounted. In 1941, war production surpassed $1.2 billion, or more than Canada had produced in the entire Great War; in 1942, industry now going flat out, war production was an incredible $2.5 billion, and before the war ended, Canada delivered $11 billion in goods and food for the war. (The equivalent in 2005 dollars would be at least $100 billion.) Canada had become an arsenal of democracy, and production in every sector of the economy doubled and then doubled again.

The shipbuilding industry, for example, had been tiny before the war, but between 1939 and 1945 the country's shipyards in the Maritimes, along the St. Lawrence River and the Great Lakes, and in British Columbia produced 391 cargo ships, 487 corvettes and minesweepers, and 3,600 specialized vessels, including landing craft. Tankers of up to 10,000 tons came off the ways in Canadian yards, a feat many thought impossible before the war. The auto industry, largely based in Oshawa and Windsor, Ontario, produced more than three-quarters of a million trucks and Jeeps, and almost 50,000 armoured vehicles, including tanks and Bren gun carriers. At one point in 1944, car factories churned out 4,000 trucks and 450 armoured vehicles a week! There were some things Canadian industry could not do, however. Canada had tried to develop its own tank, the Ram, in 1941, and although some innovative features were experimented with at a locomotive works in Montreal, the Ram was quickly superseded by the American-designed Sherman.

But there was much to boast of. The Canadian aircraft industry had scarcely existed before the war. But the British Commonwealth Air Training Plan needed thousands of training aircraft, so Ottawa either created them through Crown corporations or financed them through the conversion of private firms into an aircraft industry. At its peak, the aviation industry produced 4,200 military aircraft a year. Skilled workers in Fort William,

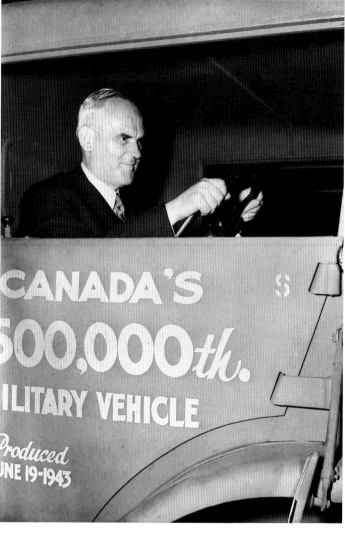

Ontario, built Hurricane fighters, and other factories produced a wide range of trainers. The pinnacle of achievement, perhaps, was that by 1944, nine thousand workers at Victory Aircraft Ltd., one of the twenty-eight wartime Crown corporations created by the federal government, were turning out huge four-engined Lancaster bombers from a plant on the northern edge of Toronto. (Modified Lancs also went into transatlantic service for Trans-Canada Airlines, giving the government-owned airline its first cross-ocean operations.) Did you need wood veneers for fast, all-wood fighter bombers? Ottawa created Veneer Log Supply Ltd., a Crown corporation, to produce them. Want synthetic rubber after Japan closed off Far Eastern supplies? Another Crown corporation, Polymer Corp., sprang into existence to ensure the military had what it needed. Need radar sets? Canada began slowly—and with great difficulty—to build radar equipment for the ships of the Royal Canadian Navy; over time, the quality and range increased. Need artillery and ammunition? Canada's factories built twenty-five-pounder guns and the shells that won the First Canadian Army's battles in Italy and Northwest Europe and the four-inch guns that the Royal Canadian Navy's ships carried.

Directing this extraordinary production juggernaut was Clarence Decatur Howe, the minister of munitions and supply. "C.D." was American-born, an engineer trained at the Massachusetts Institute of Technology who had come north to teach at Halifax's Dalhousie University. Then he set out to build grain elevators in the West, made himself rich and ran for Parliament in 1935. Mackenzie King put Howe in the Cabinet at once and in 1940 made him Canada's wartime industrial czar. Howe was tough and smart, a man who picked the best people from industry, persuaded their companies to pay them while they worked for him and gave them free rein—so long as they produced the goods. And they did. There were challenges every day—shortages of supplies, raw materials, people—but Howe bullied the government and the country to give him what he needed. The achievement was simply remarkable.

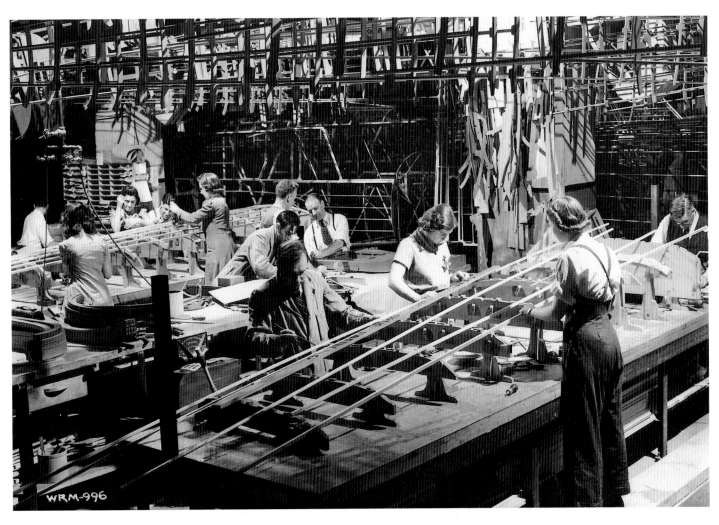

WRM-996

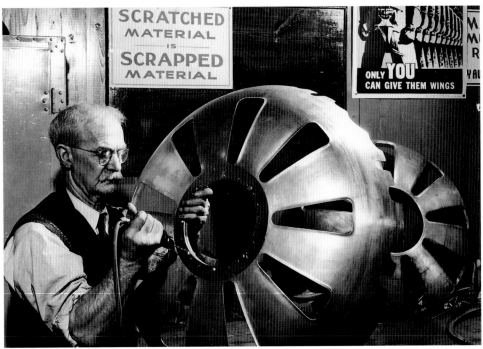

Aircraft plants sprang up where none had existed before.

LEFT: In Winnipeg, men and women workers built wings for Anson aircraft (*above*) and worked on the engines (*below*). (Manitoba Provincial Archives, *above*: #6012, *below*: #5942)

BELOW: The finished product rolls out of the factory on its way to trainees in the British Commonwealth Air Training Plan. (Manitoba Provincial Archives #6021)

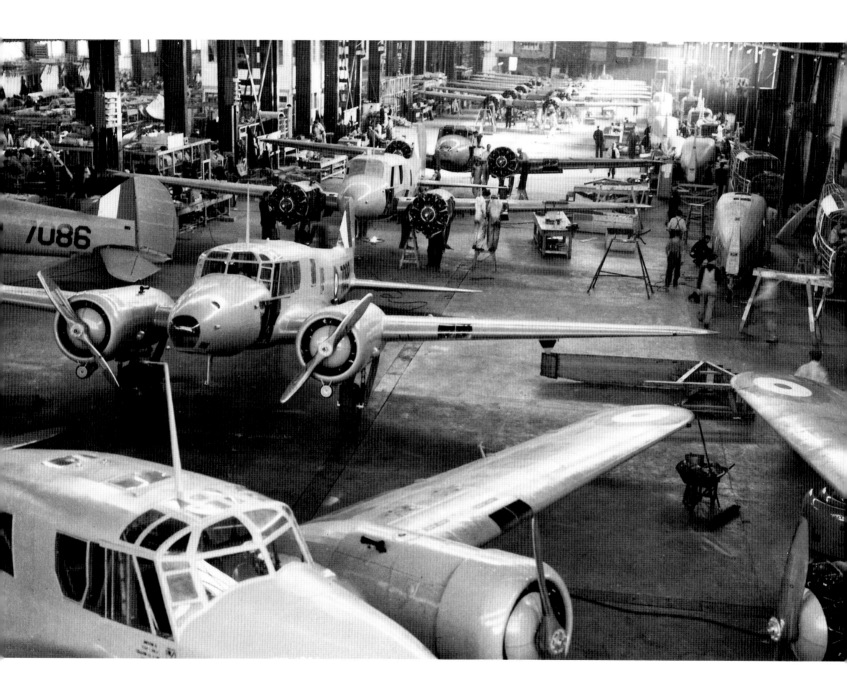

EVERY CANADIAN MUST FIGHT

One of the greatest needs was for workers like Gwen Lambton. To get the factories up and running, hundreds of thousands of workers had to be found and trained. Complicating matters was the fact that the armed forces swallowed men in the hundreds of thousands. This meant that the young and the old had to go into the factories while the fittest and strongest men went into the army, navy and air force. A family that in the 1930s counted itself lucky to have one breadwinner now could see every member over sixteen and under sixty-five years of age bringing home a paycheque. Wartime expansion also meant that hundreds of thousands of rural workers had to move into urban areas to work in factories. In Alberta, for example, while Edmonton increased its population by twenty thousand by 1942, the province's rural population fell by forty thousand between 1941 and 1946, even while farms grew in size and production increased. Farmers worked harder while labour grew scarcer. By 1942, the labour "surplus" that had existed since the Depression had disappeared, and employers sought people to do the work.

Women everywhere took over jobs that had hitherto been male preserves. They drove buses and streetcars in Vancouver and Halifax, poured into Ottawa to find jobs in the growing civil service and assumed jobs in the service industries. At the period of wartime peak employment in 1943–44, there were 439,000 women employed in the service sector and 373,000 in munitions factories, making everything from Bren guns to aircraft to corvettes. The number of women employed outside the home doubled during the war, and many more married women went onto the labour market. This was a virtual revolution, one deliberately created by government in September 1942 as it registered women born between 1918 and 1922 in a desperate effort to discover how many might be able to enter the work force and how many were suitable for special training programs.

The governmental propaganda machine also worked overtime, portraying attractive young women, their hair covered in bandannas and their figures draped in coveralls,

producing the munitions that Canada's war required. Women responded, too. The lure was patriotism, a change from their prewar existence, and the pull of the big cities. The paycheque also didn't hurt—a generation that had grown up with privation was attracted by the opportunity to have some cash to spend. Factory or office work might be boring, but to a farm woman used to milking cows or to a teenager used to skimping on meals during the 1930s, a change, any change, was an improvement. Female wages were not equal to men's, but the gap narrowed during the war. By V-E Day, layoffs of men and women munitions workers began in earnest; and by V-J Day, eighty thousand women had been let go—a deliberate policy to give returning vets jobs, but also a reflection of the end of munitions production.

Wartime industry had to compete for women with the armed services. In mid-1941, the RCAF began recruiting women; the army and navy soon followed suit. The aim was to free men for the front lines by giving women some of the cooking and clerical jobs the services needed, but there were mixed feelings in Canada about the program. "Women were not expected to work out of the home except on rare occasions," Neva Bayliss remembered. "My own father . . . was quite furious at the thought of my going" into the air force. Others feared their daughters would be exposed to the licentiousness of the military, and there were malicious and untrue stories of troopships returning to Canada, laden with pregnant women in uniform. There was no front-line service for WDs (Women's Division, RCAF), CWACs (Canadian Women's Army Corps) or Wrens (Women's Royal Canadian Navy Service), however, though fifty thousand women enlisted. Their contribution was substantial, and it expanded into signals and code work, parachute packing, driving and dozens of other military trades. "The only ones that really appreciated our efforts," Bayliss said, "were those who had lowly jobs like peeling vegetables and washing dishes. They were only too glad to see us come. Finally we were accepted and we held some very responsible positions . . ."

Who... **ME?**

yes... **YOU!**

YOU'RE NEEDED NOW TO FREE A MAN TO FIGHT

You may drive your car once more When you've helped to win the war,

Join the **C.W.A.C.**

Apply to C.W.A.C. Recruiting Officer H.Q. M.D. № 6, Halifax

Nursing sisters had served overseas ever since the South African War, and 4,439 served in the Second World War. Army policy decreed that nurses could not be sent into a battle zone, but during the struggle for Ortona in December 1943, the 1st Canadian Division was suffering such casualties that senior officers feared morale might be severely hurt. Brigadier Bert Hoffmeister asked nursing sisters to volunteer to serve in a casualty clearing station that was regularly being shelled. They did en masse, and wounded soldiers saw a smiling Canadian face offering TLC—tender, loving care—and morale soared.

Those not in the forces or in the labour force had to do their part as well. A constant barrage of exhortations encouraged women to do volunteer work in soldiers' canteens or with the Red Cross. "Make a date with a Wounded Soldier," the Red Cross demanded of women rolling bandages, "and KEEP IT!" "Remember it's up to you!" another advertisement reminded the hesitant. "Will you become a blood donor?" Old ladies and young children knit socks for soldiers: "We knit before work, during work, during our lunch hours, after work and at home," recalled Dorothy Inglis of Toronto. Others packed parcels for prisoners of war in Japanese or German camps, sending cigarettes, canned milk, canned salmon, chocolate and other foodstuffs that frequently helped to keep POWs alive. Families in Britain, suffering under much tougher rationing than Canadians, also received ten-kilogram parcels of canned meat, biscuits, salmon and other foods from generous Canadians.

Families created Victory Gardens, growing vegetables to supplement the foods available under Canada's rationing system. Sugar, coffee, tea, butter and gasoline were rationed, and each family carefully carried its ration books along on every grocery shopping expedition. "My shortage was tea," one woman remembered. "I drank tea by the gallon, which meant that I was always on the lookout for someone who wasn't quite so addicted." Ration coupons could be traded, in other words. The Wartime Prices and Trade Board published ads telling Canadians "What You Should Know and *Do* about Sugar Rationing," adding a cautionary phrase: "You Must Obey the Law." Women's magazines and the newspapers

LEFT AND ABOVE: Competing with farm and factory for Canadian women were the army, navy and air force. The Canadian Women's Army Corps (CWAC) would grow to be the largest of the women's services, freeing many men to fight. (CWM, *left:* 19880069-860, *above:* 18700186-115)

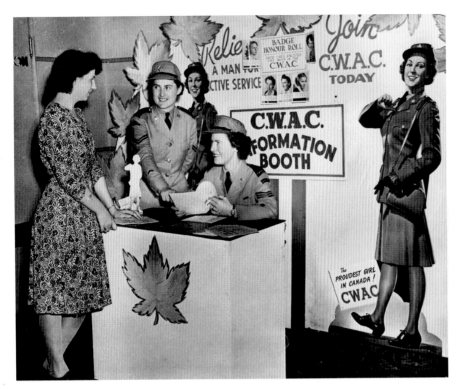

offered "Economy Recipes for Canada's Housoldiers" that avoided sugar, which was scarce, or claimed to produce delicious meals from powdered eggs and unappetizing cuts of meat purchased with the blue cardboard meat-ration discs. Making jam became a patriotic act, as did canning fruits and vegetables. Fats and bones were recycled to "Help Smash the Axis"; Boy Scouts collected fruit baskets along with newspapers, tin foil and metal scrap, while kids gathered milkweed pods for mysterious wartime uses and proudly wore a "Wedge Airforce Style Cap," available for thirty-nine cents. Even used toothpaste tubes, collected at drugstores, had their solder recycled "To make a Bolingbroke Bomber ready to Bomb Berlin."

Rationing made auto tires all but impossible to get (except for doctors), and gasoline was rationed toughly—only 545 litres a year were available to pleasure drivers. No new cars were produced, so Canadians drove their clunkers into the ground. Canadians today talk of conservation in a "green" society. Wartime Canada was far ahead in every way, all urged on by relentless propaganda to waste not. Even comic books, essential for children, were printed in black and white only, which saved scarce dyes for more important military purposes. Today those "Canadian whites" are treasured by collectors, their pages showcasing heroes, both real and imaginary.

Older Canadians entertained themselves by watching films, many with war themes and most produced by Hollywood or in Britain, and hardly any featuring Canadian servicemen. One exception was *Captains of the Clouds*, which starred Jimmy Cagney as a troublesome trainee in the British Commonwealth Air Training Plan. Another movie extraordinarily featured Laurence Olivier as a French-Canadian trapper. If you brought a tin saucepan or a jar of cooking grease, movie theatres frequently gave free admission; at Calgary's Uptown, uniformed servicemen and women paid twenty-five cents admission, a discount of ten cents, every night except Thursday. The new National Film Board, however, reached into the theatres, telling Canadians about their war effort in a hugely successful

series, *Canada Carries On*. The radio too filled a great void: Lorne Greene, "the Voice of Doom," read the CBC news, the Happy Gang entertained with its music and fun, and "L for Lanky" kept listeners in the know about a Lancaster bomber crew. The army, navy and air force sent entertainment troupes into camps around the country and overseas, even into makeshift stages just behind the lines. All were well choreographed and featured performers, like Wayne and Shuster, who were or later would become well known. "A show by soldiers for soldiers," *The Army Show* boasted. "Every member of its cast a soldier in Canada's Active Army." The services had hockey, football and baseball teams as well, some verging on professional calibre or, if they could find enough players from the National Hockey League (NHL), for example, at least as good as the six teams then in the league. The NHL, according to widespread rumour, tried to get exemptions from military service for many of its players or found them "jobs" in munitions plants to spare them from fighting—off the rink. Those players who enlisted, like Montreal defenceman Kenny Reardon, decided to do so on their own and sometimes over the opposition of management.

Canadians were overtired and busy, but there was in some respects little to do. Although Halifax's population expanded greatly during the war, the number of restaurants, for example, did not, nor did their quality improve. Sailors and the crews of merchantmen complained about the city's coldness, the gouging landlords and the lack of amenities. Even the hookers, sailors complained, were more matter-of-fact about their work. In truth, Halifax was not all that different from the rest of the nation's cities, all of which had suffered from a decade of economic crisis before the war and all of which had trouble finding accommodation for wartime residents. In Montreal and Quebec City, moreover, anti-war sentiments sometimes led to verbal denunciations and physical assaults on servicemen.

To pass the time, people listened to records of Vera Lynn singing "We'll Meet Again" and "The White Cliffs of Dover," or Gracie Fields urging listeners to "Wish Me Luck as You Wave Me Goodbye." Grown men and women still weep at those songs sixty years later. High schoolers and war workers mixed at dances in night clubs like Edmonton's Silver Glade,

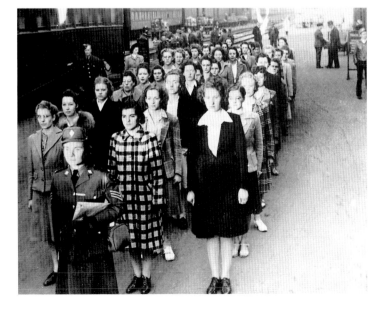

BELOW: *Gas Drill,* painted by war artist Molly Lamb in 1944. This drill, part of CWAC training, involved exposure to tear gas both with and without a gas mask. (CWM Molly Lamb Bobak 12059)

RIGHT: CWACs could not take front-line roles, but their range of military employment was wide. These army telephone switchboard operators let the Quebec Conference of 1944 function. (National Archives of Canada PA-144866)

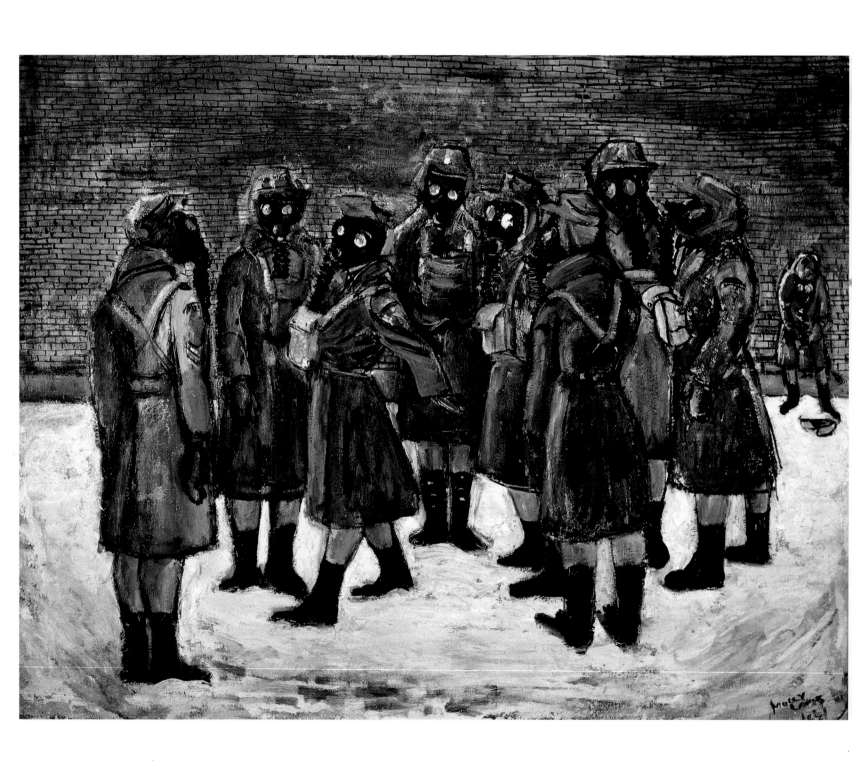

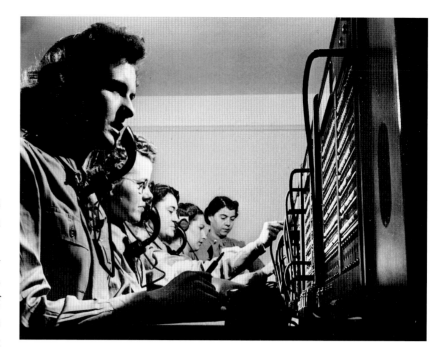

jiving to the big bands or to Benny Goodman records, and both young women and young men tried their best to dress up for the occasion.

This was hard, even if people had more money than they'd had before the war, because the government controls affected clothing. The length of women's dresses was regulated too, as were the number of buttons permitted. Men's trousers lost their cuffs, saving an inch or two of gabardine. The quality of fabric—and of shoe leather— slowly deteriorated over time as well, though the costs, fixed by the price freeze of October 1941, never seemed to decline. Canadians grumbled and cursed, but went along. Seamstresses who could convert pre-war outfits did a booming business—if they could find the thread they needed and keep their sewing machines working. Neither was easy to do.

The government controls also froze wages, infuriating the trade unions that saw the full employment of wartime as a historic opportunity. Their numbers rose dramatically during the war, perhaps helped by the working-man's fear that the end of the war would see a return to economic depression; maybe unions could help protect wages and jobs. For the government, the fear was that increased wages would fuel inflation. But lest any suffer unduly, the wage freeze regulations allowed a 25-cent-a-week increase for each one-point rise in the cost of living, in effect 1 per cent of the average wage of $25 a week. From the implementation of price controls to v-E Day, however, the increase was only 2.8 per cent. Canada proved hugely successful in controlling inflation. Nonetheless, with most workers paid by the hour and with overtime always available, the average earnings of factory workers rose from $975 a year in 1939 to $1,500 in 1946. The Liberal government in February 1944 also gave unions what they most desired: an order-in-council that recognized the rights of workers to organize, engage in collective bargaining and strike provided organized labour with its Canadian Magna Carta.

Inevitably, some Canadians tried to evade the regulations that constrained purchasing freely. Some farmers bypassed the controls by selling directly to black marketers, who passed on cattle meat to illegal slaughterhouses. They in turn had their own clients; often butchers had favoured clients to whom they sold steaks. Similarly, garages could find tires

and gas for a high price, and bootleggers always seemed to have booze for sale. But the Wartime Prices and Trade Board prosecuted harshly those it caught, and the press cooperated by publicizing sentences. There was evasion, but what was most striking was the high level of compliance.

Parents and grandparents worried about the impact of the war on their families. What might happen to children raised without a father? This was a real question, since birth rates rose sharply as "now or never" children were fathered by men soon to go overseas. "I still wonder just why I was so happy," Jean Lucier of Deep River, Ontario, said much later. "I had no memory whatsoever of my father," who had enlisted early, was wounded at Dieppe and spent the rest of the war as a prisoner. "I only knew what he looked like from the pictures my mother showed me." Was juvenile delinquency going to destroy society? The number of children under age sixteen who were convicted of crimes rose during the war. That zoot-suited gangs, sporting heavily draped trousers and wide-lapelled suits (where did the material come from?) fought running fights with servicemen in the big cities seemed to be proof that stability was breaking down.

Psychologists offered free advice in the media, but people fretted nonetheless. How could marriages survive the strain of wartime separations? Not all that well, as it turned out, for the number of divorces almost quadrupled between 1939 and 1946. Soldiers away from their wives found other companions, and often their wives back home did too. And what about those young women working in war factories and exposed to the temptations of city life? For a child to be born out of wedlock was a stigma, the double standard of sexual behaviour an article of faith, and clerics, especially in Quebec, complained that working mothers, by putting their children in day care, were letting down the future. There were real problems—the number of illegitimate babies increased by more than a third in Alberta between 1939 and 1943 while abortions increased nationally—but somehow Canada survived.

In many ways, the war changed the way Canadians lived.
LEFT: Although most of Canada was safe from attack, blackout regulations were enforced—sporadically. (National Archives of Canada PA-112885)
BELOW: Housing shortages were endemic, and families, including the old woman shown here, were crammed into every corner of space. (National Archives of Canada PA-112901)

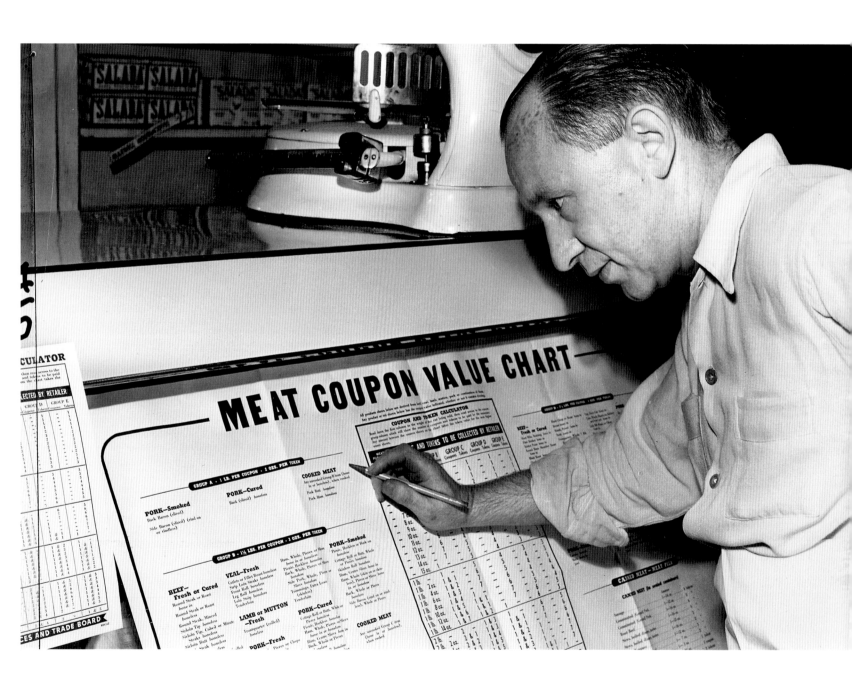

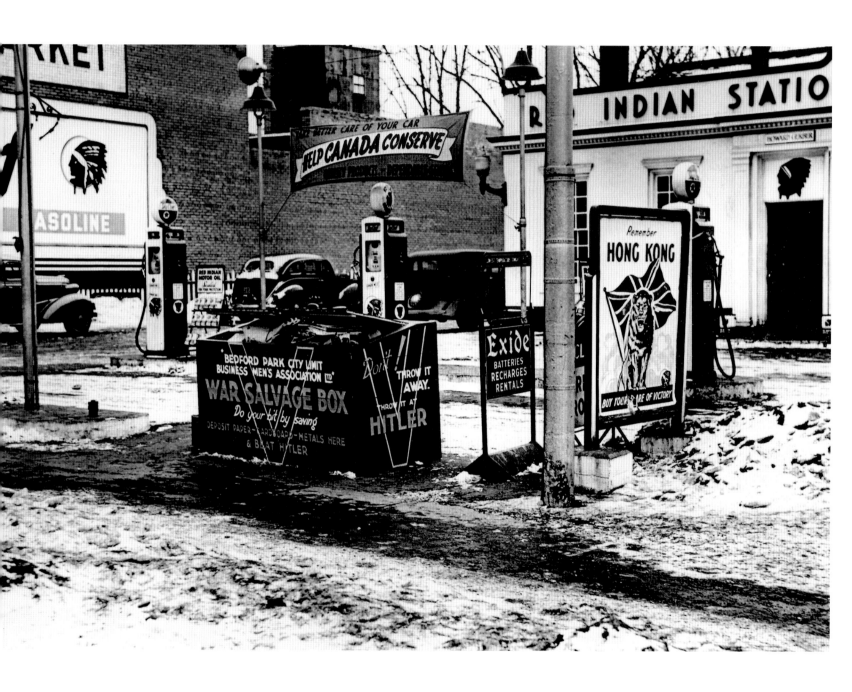

Indeed, the nation prospered. What was striking about the war years was that Canadians ate better, worked more and had more money than ever before. The rationing of food was an inconvenience, not a real hardship, and for most, life was far better than it had been during the Great Depression. The levelling effect of taxation and rationing actually seemed to work, spreading both goods and pain fairly around the population. But life wasn't fair, and those who lost a son or brother or father overseas felt something that most of their friends and neighbours could not. The daily, continuing fear, the worry that Johnnie might get killed, weighed on Canadians.

SO TOO DID FEAR of what the peace might bring. Would the jobs disappear? Would wartime prosperity dissolve into another decade of grinding poverty? The government worried about this too, obviously for political reasons, but primarily because a return to stagnation would be disastrous for Canadians. But how to avoid a post-war bust?

The answer seemed to be provided by Keynesian economics. The British economist John Maynard Keynes had argued in the 1930s that western governments had dealt wrongly with the Depression. They had cut spending, he said, instead of increasing it. Prime the pump, put money into circulation, give people money to spend—and this will create jobs in factories and work for farmers. Keynes had his disciples in Canada, some in government, and as the old economic verities had so obviously failed, Cabinet ministers seemed willing to try new methods.

The first move in Canada was unemployment insurance, passed into law in 1940. "UI," as it became instantly known, was an insurance scheme—workers paid into the scheme when they had jobs, and if they lost employment, they could draw on

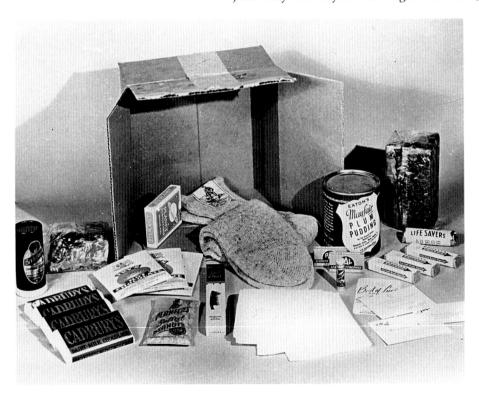

UI to support their families. Mackenzie King understood that such a scheme could not have been implemented during a period of high unemployment; there was no way a pool of money could be built up with millions of people out of work. At the beginning of a war, however, at the onset of full employment, UI could get underway. Workers would pay in and, if the worst happened and there was a major economic collapse when peace returned, the UI scheme would have money in the bank to cushion the fall. This was progress.

Then, as the war consumed the government's energies, nothing more occurred. But there were signs of public concern for the future. Conservative leader Arthur Meighen lost a 1942 by-election to a Co-operative Commonwealth Federation (CCF) candidate who campaigned on social welfare policies. In 1943, the Ontario CCF formed the Opposition in the provincial legislature, and in 1944 Tommy Douglas led the CCF to victory in Saskatchewan, forming Canada's first social democratic government. Mackenzie King and the Liberals took notice.

Their first major step was to implement family allowances. The freeze on wages, the government believed, had to be maintained, but if some way could be found in good Keynesian fashion to put money in the population's hands . . . The war had demonstrated that many potential soldiers were in poor health, their constitutions ruined by poor nutrition in childhood. What if mothers could get a baby bonus, a fixed sum of five dollars for each child (with that sum rising as the child's age increased) each month? Would they use it for milk and Pablum and baby shoes, or—as critics instantly said—would they spend it on drink? Would it encourage the unfit to breed, eugenicists asked? The government heard the complaints but persevered. The family allowances, the Cabinet concluded, were a perfect measure, a way of giving women some financial independence and helping their children thrive.

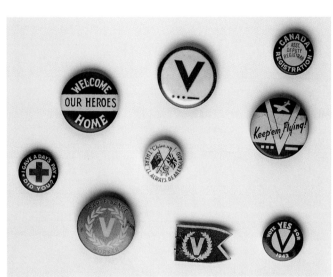

ABOVE: The government allocated metal to make buttons of use to the war effort. Adults wore them and children collected them. (Granatstein Collection)

RIGHT: Kids also saved their nickels and dimes to buy comic books, almost all of which had war themes. (CWM 19920174-003)

They had other uses too. The money, initially almost $250 million a year—nearly half as much as the whole federal budget in 1939!—would be spent at once and would help keep the economy going. French-Canadian families were large, and this would bolster government support in Quebec. And the family allowances would take a major campaign plank away from the CCF, now booming in opinion polls. Many Conservatives supported the measure, but the party was tarred by Ontario premier George Drew, who denounced the plan for giving a bonus to Quebec families that had been unwilling to defend their country. The Tories, as a result, suffered dearly in Quebec in the 1945 election. The baby bonus was tried out in Prince Edward Island and came into effect nationally in the summer of 1945.

Family allowances instantly became the most popular government program. The baby bonus probably helped encourage young couples to start the families they had delayed because of the war. "We were happy," one woman recalled, "because the war was just over and we could settle down together and start our families." Most women left the wartime factories happily enough. "My job [now] was my home and family," one said. "This was our reason for marrying."

At the same time, the federal government was taking more interest in health generally. The Department of National Health and Welfare was created in early 1944, and studies began on the creation of a system of hospital and health insurance. It took years to implement, but the groundwork was laid. Planning speeded up in the Ottawa bureaucracy for the creation of a pool of public-works projects to create jobs if the economy slowed, and steps were taken to get tens of thousands of houses built with low-interest loans from Central Mortgage and Housing, a government agency. Canada was already short of housing, and the return of men from overseas, with the accompanying creation of new families, would require many more homes. Industry was offered, and gratefully received, funds to retool from wartime to peaceful pursuits and to sell goods abroad, and there was a huge pool of funds in Canadians' bank accounts waiting to be spent on stoves and refrigerators, sofas and bedroom sets. Ten years of economic depression and six years of war

Wartime comics were printed in black and white to conserve dyes. This
story from the May 1944 issue of *Canadian Heroes* suggests the contents.
(CWM 19920174-003 P.38, P.39, P.40, P.43)

THE LAST GOOD WAR

JOIN YOUR UNION *AND* KEEP 'EM ROLLING!

UNION ORGANIZATION
AIDS VICTORY IN WAR
— SECURITY IN PEACE

MORE THAN HALF A MILLION MEMBERS S.W.O.C. YOUR UNION STEEL WORKERS ORGANIZING COMMITTEE

Listen to **THE VOICE OF LABOUR** - CHML 4⁴⁵ P.M. Sundays

CULHANE LIMITED.

ABOVE: The war gave the labour movement its opportunity to grow. Unions argued that union organization equalled patriotism. (City of Toronto Archives SC 488)

RIGHT: The government was not so sure, suggesting in this poster that workers' agitation could slow victory. (CWM 19770650-022)

had left many needs waiting to be filled, and the government aimed to help manufacturers to meet them. The extent and depth of the planning for post-war Canada was impressive.

Above all, the government determined that it would spend money to ensure that the men and women who had fought the war would be well treated. The folks at home did not and could not understand the horror of battle, any more than the men overseas could make sense of the fact that politics went on as usual in Canada, that people griped about shortages or that workers in aluminum plants, for example, could go on strike at Arvida, Quebec, when aluminum was necessary to win the war. After the Great War, there had been resentment, indeed anger, at the way returned men had been treated, at the way the civilians' utter incomprehension had seemingly been put into policy.

But never again. The Veterans Charter, as it was called, was a comprehensive package ensuring that vets were rewarded for the victory they had won and the risks they had run. The money to reintegrate them into society was made available, and the creation of the Department of Veterans Affairs in 1944 guaranteed that vets would have continuing political clout. There were grants of $7.50 for each month's military service and $15 for each month of overseas service; a $100 clothing allowance; cash for education or to open a business or buy a farm; medical care; a year of free unemployment insurance; and good-sized pensions for those who had been wounded in service. Women veterans received the same benefits as men, a giant step towards equal rights, and 2,300 female vets went to university under the Veterans Charter. The charter was both deserved and generous, a nation's thanks to its fighting men and women. That the money spent on veterans went back into the economy and helped to keep the Canadian wartime boom alive was no coincidence.

THE SIZE AND SCOPE of the war effort gave Canada power. The Dominion was one of the great food-producing nations, for example, a nation ideally situated for post-war air transportation and blessed with civil servants who had ideas. How could Ottawa get the

THIS, MEANS
D·E·L·A·Y

THIS IS VICTORY

THE LAST GOOD WAR

great powers to listen to Canadians' ideas and demands? One way was to be modest and practical. Diplomat Hume Wrong urged the government to adopt the functional principle as its approach. This entailed recognition that Canada could not claim a role in grand strategy—realistically, a country of eleven million simply didn't qualify to sit as an equal with the United States and the United Kingdom. But in food production? In natural resources? The functional principle argued that in areas where small states had great-power capacities, they should be so treated.

Britain and the United States were not impressed, and in 1942 they created a series of "combined boards" to coordinate the war—and left Canada in the cold. But Ottawa argued toughly, threatening to hold back its resources and suggesting that the billions of dollars' worth of supplies and equipment being given freely to Britain, for example, might dry up. London was horrified at such crude threats, but it worried that Canada just might be serious. Very soon, Canada won a seat on the Combined Food Board and the Combined Production and Resources Board, huge symbolic gains. The Dominion took a seat on the Supplies Committee of the United Nations Relief and Rehabilitation Administration, the agency created to give food and relief to devastated Europe and Asia. And Canadians played front-rank roles in wartime conferences, not least in the Bretton Woods meeting that laid out the structure of post-war international finance. Men like Louis Rasminsky of the Bank of Canada and W.A. Mackintosh of the Finance Department, civil servants of great capacity, worked as equals with John Maynard Keynes. In 1939, this would have been inconceivable; in 1945, it made perfect sense.

Canada had grown up. The psychological colony that had entered the war in 1939 had come of age. Backed by a huge military and booming industries, Canadian diplomats had clout in the world. They had ideas too, and they weren't afraid to press them forward.

The Canada that emerged from the war thus was very different from the troubled country that had entered it. There was more confidence, more equality, more money. The people had done great things together and believed that they could do great things in the future. That this was the definition of nationhood was not coincidental, for during the Second World War the efforts of Canadians at home—almost as much as those fighting overseas—guaranteed that a far stronger and much more mature country would go into the post-war years.

LEFT: The end of the war with Japan in August 1945 brought an end to gasoline rationing. Gas coupons were no longer required. (City of Toronto Archives G&M 98410)

5 | THE HINGE OF WAR

THE 1ST CANADIAN DIVISION spent Christmas 1943 fighting house-to-house against skilled, determined German paratroopers in the streets of Ortona. The small Italian town was a killing ground, and casualties on both sides were terrible. Civilians too suffered, as Corporal Ted Griffiths, a tank commander with the Three Rivers Regiment, recalled in his memoirs. He was thinking especially of "the old woman who ventured out of her house only to be shot by a German sniper. Her body slumped down against the front wall of her house and there was no way" in the town's narrow streets "to avoid her as we went by. Gradually her legs were ground into the cobbled street and by the second day only her torso was left. There she remained like a silent sentinel as we wound our way past her day after day for the next week."

AFTER THREE YEARS OF DEFEAT after defeat, by late 1942 the war at last had begun to swing in the direction of the Allies. In the North African desert, General Bernard Montgomery's Eighth Army defeated Field Marshal Erwin Rommel's Afrika Corps at El Alamein. This was the first real victory the British had scored over the Nazis, and it was followed by "Torch," the invasion of French North Africa by American and British troops. The destruction of the German and Italian forces in Africa now was only a matter of time. At sea, the Battle of the Atlantic still hung in the balance, but the addition of U.S. Navy resources to those of Britain and Canada, as well as new technologies and perfected techniques, were beginning to tell against the U-boats. The bombing of Germany by the British Royal Air Force and Royal Canadian Air Force by night and the U.S. Army Air Force by day had forced Germany to devote ever-increasing resources to the defence of its

cities. This had its effect in Russia, where the Germans were surrounded at Stalingrad, cut off and battered in a colossal struggle that would end in the utter destruction of Field Marshal Friedrich von Paulus's army.

The war against Japan also had begun to go well. At Midway, a group of islands in the central Pacific, in mid-1942, aircraft carriers of the U.S. Navy sank four Japanese carriers—the first great sea battle in history to be fought wholly by carrier-borne aircraft—crippling Japan's power to continue its expansion. Meanwhile, the Americans under General Douglas MacArthur and Admiral Chester Nimitz had begun to island-hop their way north and east from their secure base in Australia.

What next? everyone wondered. Winston Churchill and Franklin Roosevelt met in the spring of 1943 to consider this question. The two leaders agreed that they could not invade France until 1944, but they could strike at Sicily and Italy. Their aim was to force Benito Mussolini out of the war. Canada's army, still smarting from its defeat at Dieppe, would get a chance to participate in the attack on Sicily in July 1943.

THE GENERAL OFFICER COMMANDING-in-chief of the First Canadian Army did not want any of his formations to fight in Sicily. Andy McNaughton wanted to keep his two corps together in Britain, readying for the invasion of France, whenever it might come. But McNaughton's clout was dissipating. In a major exercise, Spartan, in March 1943, he had handled his troops clumsily, confirming the view of British senior officers that he was not up to the job. In Ottawa, meanwhile, the minister of national defence and the chief of the general staff believed strongly that for the sake of public and military morale, Canada simply had to be part of the invasion. J. Layton Ralston and General Ken Stuart were correct, but the bitterness created by the acrimonious debate poisoned the well between the First Canadian Army and Ottawa. Much to the satisfaction of the War Office in London, McNaughton would be gone before the end of the year.

But the Canadians would go to Sicily. The 1st Canadian Division and the 1st Canadian Army Tank Brigade were the troops named for the task, with the young, intelligent Major-General Guy Simonds as their commander. The Canadians sailed from Britain on July 1, 1943, in two convoys. The fast convoy arrived off Sicily untouched; the slow convoy, attacked by submarines, lost three ships and fifty-eight Canadians died. Simonds's headquarters also lost its vehicles, signals equipment and artillery, some forty guns.

Curiously, what stuck in the mind of one trooper aboard a ship in this convoy was buying food from British Royal Navy stewards on his transport. "The stores, with the exception of beer and liquor, were all American foodstuffs and these had made a definite impression on us during the outbound voyage ... After a couple of years or so of the bland, restricted diet of wartime Britain," Ted Griffiths said, "we found a reunion with North American food an absolute dream ... seven-pound tins of Spam ... tins of dried egg powder, gallon cans of peaches, pears and other tinned fruits ... we loaded the goodies into our tank."

The invasion went in on July 10, the Canadians at last joining their allies in action. The landing went well, and the casualties were much lighter than feared. One soldier wrote that he had celebrated his birthday "in an assault craft loping over long swells in to the beaches," and he recalled being struck by the amount of equipment his platoon commander carried: "web belt, water-bottle, compass, entrenching tool, rolled gas-cape, Verey pistol, map-case, binoculars, tommy gun, ammunition clips, small pack on the back,

LEFT: The war in the Atlantic against German U-boats continued. This photo shows HMCS *Swansea* in rough seas off Bermuda. (Gilbert Alexander Milne/ National Archives of Canada PA-107942)

radio set strapped on the front of his shoulder . . . A German wouldn't need to shoot him; he'd just have to walk up to him, snick him on the nose, and he'd fall over and not be able to get up." Soldiers carried much the same gear, as well as a rifle or Bren gun and more ammunition clips.

Sicily, defended by weak Italian formations and first-rate German units, was perfect defensive terrain. The steep hills and winding roads meant that a few men with a machine gun or two could hold up a brigade, force it to deploy and cause delay. Time after time, this was the formula the Wehrmacht employed. On July 15 the Canadians, advancing up the centre of the island, first encountered the enemy at Grammichele. The next day at Piazza Armerina, it was the same, the Loyal Edmonton Regiment taking the town at a cost of twenty-seven casualties. On July 17, Simonds mounted a two-brigade attack against a battalion of the enemy at Valguarnera, the first major action by the division. In a stiff fight, the Canadians took the town, although they had been much hampered by their inexperience, the terrain and the skilful enemy defence. The cost was 145 casualties.

Learning how to fight well took time. Simonds had never commanded men in action before, and his icy personality did not draw his senior officers or his troops to him. Some of the battalions had weak spots in command, and three and a half years in

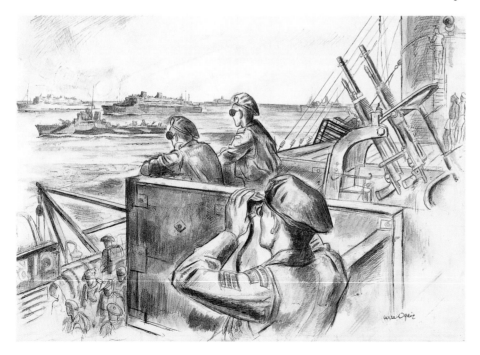

Britain had been too long for some of the men. But all the Canadians learned on the job. They took Assoro by climbing an impassable ridge that overlooked the enemy's positions, they seized Leonforte, and after some clumsy tactics by Simonds they seized Agira at a cost of 438 killed and wounded. On August 3, Sherman tanks of the Three Rivers Regiment moved forward and crossed the Salso River, intending to support the Loyal Edmonton Regiment. But they encountered Bert Hoffmeister, the commanding officer of the Seaforth Highlanders, the storied Vancouver regiment,

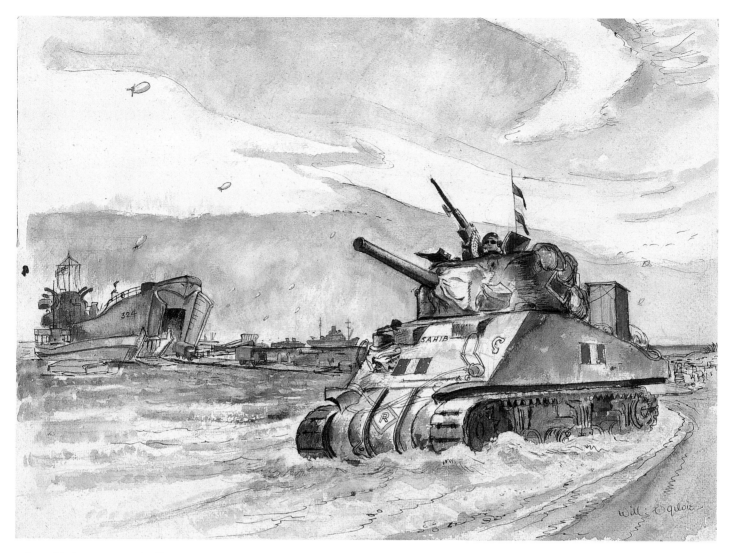

who told the armoured officers that his battalion was held up by German resistance. "We fired about 30 shells at the target," Lieutenant Jack Wallace wrote, "and then climbed the hill to support an attack by Hoffmeister's troops." Another squadron arrived to offer support, and the tanks soon had the enemy trapped with fire. "About 11 AM Lieut. Col. Hoffmeister came over and thanked us for our work."

That was typical of Hoffmeister, a very able officer. The finest attack by the Canadian Division and its attached armoured brigade came in the valley of the River Simeto on August 5. Simonds created an ad hoc striking force out of Hoffmeister's Seaforths, the tanks of the Three Rivers Regiment, a bilingual Quebec unit, a battery of self-propelled artillery and anti-tank guns, and he let the unit commanding officers draw up the plan.

This they did, deciding that the Sherman tanks would carry the infantry as close to the objective as they could and at speed. Hoffmeister rode in the Three Rivers' command tank with an extra wireless set so that he could be sure to keep in touch with his companies,

BELOW: The 1st Canadian Division that landed in Sicily came under command of Britain's Eighth Army and General Bernard Montgomery. Here Monty talks to the troops soon after the landing. (National Archives of Canada PA-130249)
RIGHT: General Andy McNaughton, the First Canadian Army commander in England, had to struggle even to be allowed to visit the troops in Sicily. (National Archives of Canada PA-136200)

ensuring coordination. "The troops stayed on the tanks for a surprisingly long time," Hoffmeister remembered. "We were all delighted to do so because we were pretty tired." Surprise was the key to success, and the Canadians caught the defending 3rd Parachute Regiment without anti-tank weapons. The tanks gave the dismounted infantry maximum support with their cannon and machine guns, sometimes setting the grass afire with tracer bullets. Although the Germans resisted strongly, the assault was a complete success, a model infantry–armour attack that demonstrated just how much the Canadians had learned since July 10. This was the last major action by the Canadians in Sicily, for the Germans soon evacuated their troops to the mainland.

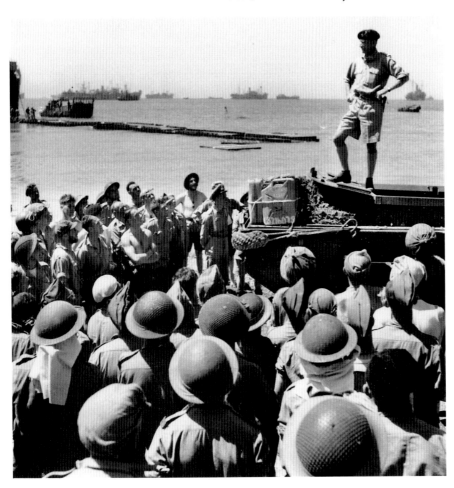

Sicily was no cakewalk—no fight against the Germans ever was. Captain Harry Jolley, a dental officer with 1st Canadian Division, observed that in light of the "soldierly fighting qualities of the bloody Germans," the liberation of Sicily in "38 days ranks as a military miracle." He was right, but the Canadians paid in blood: their casualties in the brief campaign totalled 562 killed, 1,664 wounded and 84 taken as POWs. The toll on officers was especially severe. The Seaforths, for example, lost 7 killed, 13 wounded (including 3 being treated for battle fatigue, a problem that affected many) and 2 missing. But the island was liberated, and Italy was next.

THE FIGHTING IN SICILY was not the only war front for Canada's fighting men. The battle for the convoys in the North Atlantic was, if anything, even more critical to victory. That

it was fought by a few handfuls of ships and relatively small numbers of men did not make it any less crucial. Without a steady flow of food, munitions and men, victory over Hitler could not be achieved.

The Royal Canadian Navy (RCN) unquestionably had a major role in fighting the Battle of the Atlantic. In May 1941, the navy took over responsibility for convoy escort in the area of Newfoundland, the command going to Commodore Leonard Murray, who made his headquarters in "Newfyjohn," or St. John's, a small city much loved by the RCN for its hospitality. The Newfoundland Force consisted of RCN corvettes and destroyers and two Royal Navy (RN) destroyers, and these ships picked up convoys from Halifax or Sydney when they entered Newfoundland waters. Murray's sole responsibility extended to Iceland, where additional ships joined in, the two forces providing escort until British-based escorts took over the final leg. The "black hole"—the area of the North Atlantic without air cover—was now only about five hundred kilometres wide, but unfortunately it lay wholly in the RCN's sector. Given the importance of the convoys to survival, it is simply inexplicable that so few modern long-range aircraft were devoted to air cover.

The RCN's responsibilities soon altered. After the meeting of President Roosevelt and Prime Minister Churchill off Argentia, Newfoundland, in August 1941, the still-neutral United States assumed responsibility for the western Atlantic in September 1941. This too was extraordinary, for Murray now reported to a United States Navy (USN) officer. This chain of command prevailed until April 1943, when (after the Americans entered the war) the RCN and RN took control of convoys on the northern route. Murray, now a rear admiral, became commander-in-chief of the Canadian Northwest Atlantic, with authority over all Allied air and naval forces committed to convoy operations in the area. This was the sole time in the Second World War—and before or after—that a Canadian had command of an entire theatre of operations.

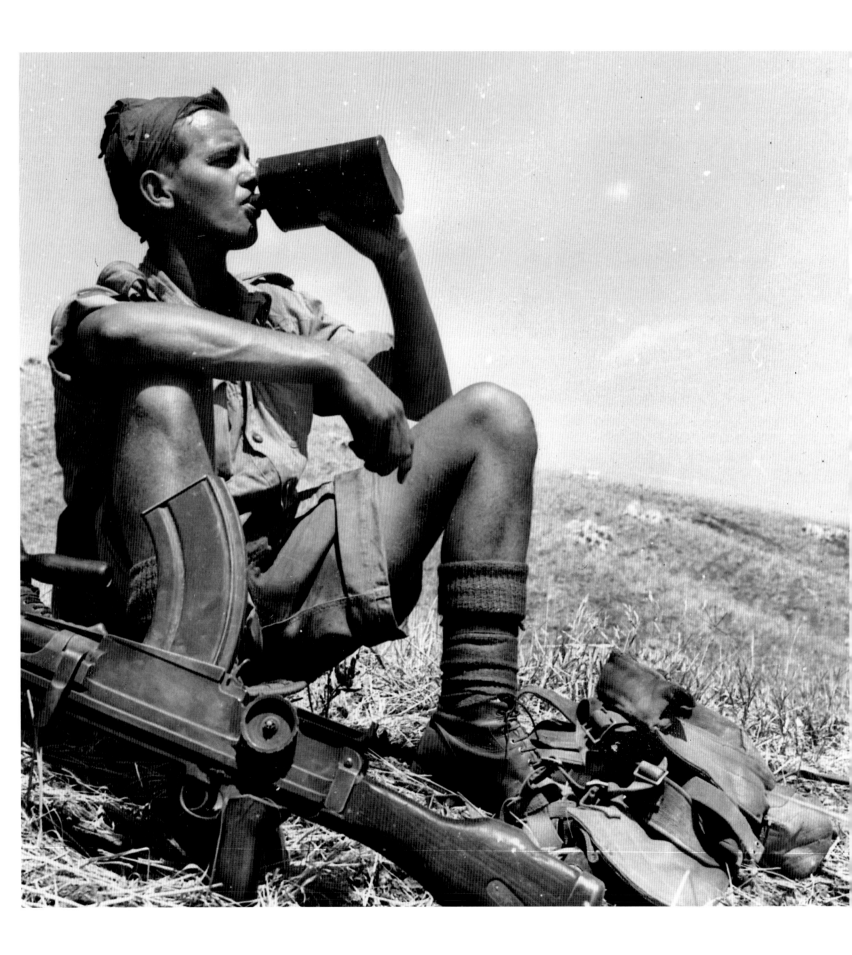

In fact, the RCN was struggling desperately to do the job. The U-boats, their numbers steadily increasing as German production outran the ability of the Allied navies to sink them, continued to refine their tactics and to take advantage of the gaps in air cover. The ordinarily terrible weather in the North Atlantic also limited air patrols and gave the submarines their chance, not least because corvettes iced up in winter, slowed speed and exhausted their crews, which had to hack away at the ice with axes lest their ships capsize. The Allies tried to remedy the problem of long-range Luftwaffe attacks by Condor aircraft by

putting a Hurricane fighter, hurled into the air by a catapult, on some merchant ships. The fighter pilot had to ditch or jump and hope for rescue. A better option was putting a gun or two, manned by RCN sailors, on the merchantmen. The creation later in the war of small escort carriers by slapping a carrier deck on a merchant hull meant convoys could take their own air cover with them on their perilous voyage.

But the skill and daring of the U-boat skippers remained the major problem. After the Americans entered the war, they had a field day on the East Coast. For some inexplicable reason, the United States left the lights in the cities glowing, creating silhouettes that left the freighters as vulnerable as fish in a barrel. The USN, moreover, was slow to institute convoys, and three million tonnes of shipping went down. It was the "happy time" for the U-boats.

Then there were Canadian waters. In the spring of 1942, U-boats entered the Gulf of St. Lawrence, where Canada, quick to jeer at the Americans, had similarly failed to use convoys. The RCN reacted quickly after two merchantmen were torpedoed on May 11–12 off the north shore of the Gaspé, creating a shoestring escort force out of motor launches and converted yachts; the Royal Canadian Air Force (RCAF), however, stepped into the battle in

a major way with frequent bomber and fighter patrols that caused U-boats to crash dive. Two escort ships and fourteen freighters fell victim to the enemy submariners, and Ottawa, in a fit of panic, closed the gulf to shipping as bodies began to wash up on the shores of the Gaspé. This forced the railways to pick up the slack by moving goods to New Brunswick and Nova Scotia ports, a move that greatly increased the strain on Halifax's port facilities.

U-boats also staged two attacks in September and November 1942 on shipping at Bell Island, Newfoundland, destroying three merchant ships. "One of the torpedoes fired during the second raid," wrote Steve Neary, then a seventeen-year-old student, "hit the Scotia loading pier." This was the only direct (if unintended) U-boat attack on North America during the war. "In a sense," Neary said, "we had been 'invaded.'"

The RCN continued to have its own particular problems. Its huge expansion—to more than 75,000 officers, ratings and Wrens by the end of 1943—meant that professionalism and experience were ordinarily in short supply. In other words, its "Wavy Navy" captains and crews too often remained amateurs, and the RCN had to face the reality that all too often they knew little about the basics of anti-submarine warfare. R.P. Welland, an RCN regular officer, noted: "A corvette would come up the river from some building yard like Sorel, the crew having been shipped a week before . . . In some cases they didn't know how to light the boiler fires." He added, "We had those ships three or four days and they were sent out into the Atlantic Ocean." Better training was obviously required, but the pressure was so great for escorts that there was scarcely time to offer this. The best the crews could get was on-the-job training while they continued on operations.

Then there were delays in fitting up-to-date radar on corvettes. The British shipyards gave preference to RN ships, and the Canadian-developed radars were markedly inferior in

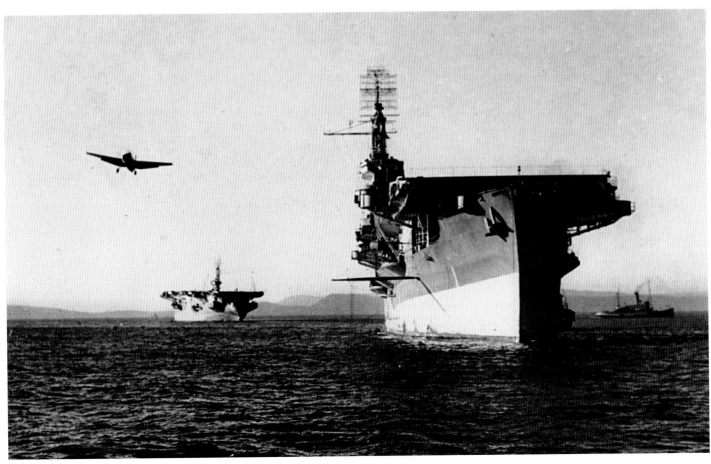

performance on the rough North Atlantic. (On HMCS *Battleford,* the radar was installed in what had hitherto been the officers' washrooms. Not all the officers were pleased, one saying, "It's a fine f—ing thing when a man can't have a f—ing shit in his own f—ing ship in peace.") Up-to-date ASDIC, the U-boat detection system, similarly was hard to come by. And in terms of weaponry, depth charges were being replaced by the forward-throwing Hedgehog, which launched 140-kilogram bombs 210 metres ahead of the corvette. But the RCN's ships seemed to be at the end of the queue for refitting, in part because Naval Service Headquarters in Ottawa pressed too slowly for the best weapons for its ships. "It is a blunt statement of fact," one RCN officer said flatly, "that RCN ships are outdated in the matter of [anti-submarine] Equipment by 12 to 18 months, compared to RN ships doing the same job ... " Some captains and crews did master their trade, despite the problems, but most, struggling manfully, could not.

The RCN's high command understood the importance of the convoys and realized that the escorts mattered greatly to their safety. But this wasn't a real navy of destroyers, cruisers and aircraft carriers. And the professional sailors and admirals ached to have a real navy. Thus in 1943, when the British agreed to let the RCN take over a range of vessels, there was exultation. Ottawa had already agreed to build in its Halifax shipyards Tribal Class

destroyers, which were bigger and far more complex than any ships ever built in Canada. Cruisers or carriers could not be built in Canadian yards, but the RCN believed it could man them. And it did, even if this accomplishment owed more to naval penis envy than anything else. The "big ship navy," consisting of two aircraft carriers (*Nabob* and *Puncher*), two cruisers (*Ontario* and *Uganda*), and six Tribals, operated with some success in the last year or more of the war. That its operation and the diversion of resources entailed in creating and manning it hurt the RCN's anti-submarine warfare efforts is beyond debate.

This was an important point, because the U-boats' toll on Allied shipping continued to mount well into 1943. In November 1942, they sank 119 ships; in February 1943, 63; and in March, 108. An RN analysis demonstrated that most losses took place in the RCN's areas of responsibility. For a time the Canadian escorts pulled out of the vital western Atlantic and were reassigned to the Gibraltar–Great Britain run, a less stressful operational area, so that they could hone their skills. That respite for training helped, and when they returned to the North Atlantic run, the RCN ships performed far better.

In part, the improved rate of U-boat kills by the RCN and its allies was the result of better weapons. The air gap was closed at last, the presence of escort carriers a great bonus. The Hedgehogs and radar gave the corvettes—and the increasing number of bigger, more powerful frigates, seventy of which were launched in Canadian yards—the upper hand. But above all, experience, that greatest of teachers, meant that by late 1943 many of the Canadian skippers had become very expert in combatting the U-boats.

Hal Lawrence, a twenty-two-year-old sub-lieutenant on the corvette HMCS *Oakville*, recalled one convoy of oil tankers proceeding out of Trinidad in August 1942. His ship's depth charges forced a U-boat to the surface, and the corvette tried to ram the submarine. The first try missed, but the second struck a glancing bow. At one point, the corvette and submarine were so close that the Canadian vessel's guns could not depress enough to fire. Then six stokers started flinging empty Coke bottles at the Germans. "Ducking heads on U-94 testified to their accuracy," Lawrence wrote, and then the U-boat skipper's courage deserted him. Soon depth charges began to break up the U-boat, and Lawrence led a boarding party that by mischance consisted only of himself and a petty officer. With substantial daring, Lawrence (who had lost his pants in the action) made it to the conning tower, forced the crew to come up and went below in an unsuccessful effort to find code

LEFT: The regulars in the Royal Canadian Navy wanted their service to become a big-ship navy. By 1944, when they had the opportunity to man the new aircraft carrier HMS *Nabob* for the British Royal Navy, they were on their way. (CWM 19840285-001 P.27C)

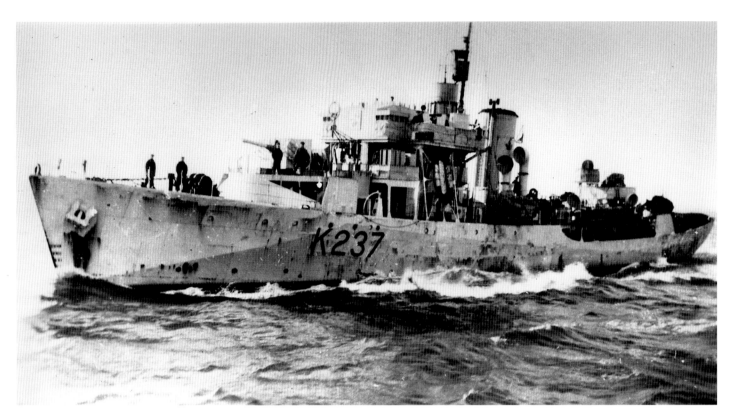

books. But the sub sank, and Lawrence and some of his prisoners had to swim for it. An American ship picked them up, and once Lawrence had persuaded the crew that he was in fact not a German, he was feted and soon awarded the Distinguished Service Cross. And deservedly so.

Oakville's success was a sure sign that some ships' crews in the RCN were getting more skilled. Just as well, because Admiral Dönitz's fleet also improved. He had acoustic torpedoes now, and the snorkel, the device that let submarines stay submerged for as long as ten days at a stretch and to recharge their batteries without surfacing, was a perfect way of countering the Allies' air superiority and increased submarine-killing capacity. The cat-and-mouse game, the struggle for the technological and human upper hand, continued through to V-E Day. The RCN—and its British and American allies—eventually won the battle, but it was a near thing.

Winning the battle of the North Atlantic meant that the RCN escorted more than 160 million tonnes of cargo to Britain. The navy's role is known, but that of the merchant marine that hauled the goods overseas in the great convoys is all but forgotten. Canada's flag flew on 210 merchant ships during the war, and the men who crewed these vessels were in as much danger as the naval crews. Sixty-seven ships went down, and Canada's twelve thousand merchant sailors lost 13 per cent of their number killed by enemy action, a terrible toll; almost 90 per cent of those killed were lost before 1943 and the beginning of success in the war against the U-boats. Because they worked for higher wages than the

Anti-submarine weaponry had improved by 1943.

BELOW: Depth charges still had to be manhandled into place but could be fired in salvos. (National Archives of Canada PA-206445)

RIGHT: A few merchant ships had a launcher to hurl a fighter aircraft into the sky if long-range German bombers appeared overhead. (National Archives of Canada PA-105943)

Canadian military did, the survivors had to struggle for years to win recognition for their services, frequently over the opposition of veterans groups. Their success came only in 1992. They deserved better from their country.

THE ROYAL CANADIAN AIR FORCE (RCAF), like the navy, was in the thick of the fight. By mid-1941, the RCAF had five fighter squadrons in England, and much of the pilots' time was spent on raids against enemy targets in German-occupied France. Pilots serving in Royal Air Force (RAF) squadrons went everywhere the British forces were—North Africa's

Western Desert, India and Burma, Ceylon (now Sri Lanka) and Malta. In April 1942, Squadron Leader Len Birchall, flying a Catalina flying boat out of Ceylon, spotted an invading Japanese fleet and sent a message just before the aircraft was shot down. Taken prisoner, Birchall survived vicious beatings and interrogation aboard ship and lived through three years in a POW camp. In Malta, another Canadian, George "Buzz" Beurling, became the Second World War counterpart of Billy Bishop. A superb shot and natural flier, Beurling scored twenty-seven kills in his Spitfire fighter on the Mediterranean island, giving him a total of twenty-nine for the war.

Other airmen had their own adventures. Flying a Wellington bomber from North Africa on November 6, 1943, RCAF Flight Lieutenant Robert Adams and his British and Australian crew bombed and sank a German ship at the island of Naxos, south of Athens, but their aircraft was hit

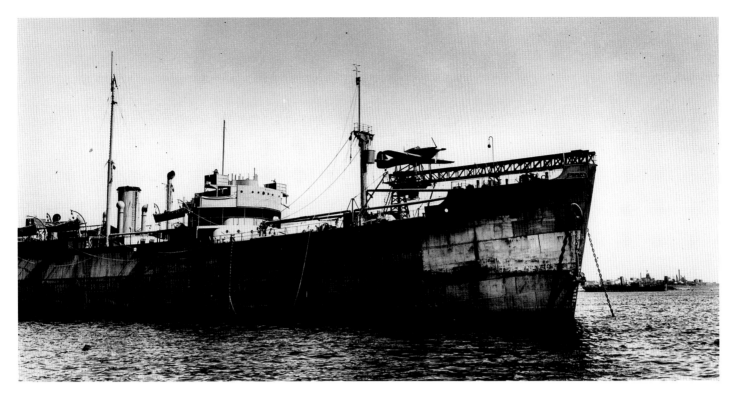

by flak. The baby-faced twenty-two-year-old Adams ditched into the Aegean Sea, and the entire crew paddled to the island of Sifnos. For a month, anti-Nazi Greeks sheltered the men, until an RAF gunboat picked them up. "They were starving," Adams said of his rescuers, "and yet they gave us everything. They were superb." After the war, Adams, eternally grateful to those who had risked their lives for him, worked in the Royal Air Forces Escaping Society to honour those who helped Allied airmen evade capture.

The main RCAF effort, however, turned out to be in the RAF's Bomber Command, flying from England against enemy targets on the continent. The first RCAF bomber squadron, formed in June 1941, consisted wholly of Canadians serving in the RAF. The next year, seven more squadrons became operational, and on January 1, 1943, the RCAF's No. 6 Bomber Group, now including eight squadrons, took to the air. At its peak, No. 6 had fourteen squadrons.

The RCAF struggled to master the task. Its problem was not the morality or otherwise of the bombing campaign. The use of heavy aircraft to target urban populations had begun with the Nazi attacks on Warsaw and Rotterdam and continued with the "blitz" against British cities. The Germans had set the template of terror bombing, and the Allies improved upon it. In fact, the bomber campaign through 1941, 1942 and 1943 was the sole way the Allies could strike at Germany, the only method of bringing home to Hitler's people that retribution was coming. Given the unsophisticated aids to precision bombing, the bomber crews knew that they were hitting civilian targets most of the time. But this was total war, and almost all of the crews believed that the only way to win it was to kill Germans. RCAF

(Courtesy Directorate of History and Heritage,

National Defence Headquarters, Ottawa)

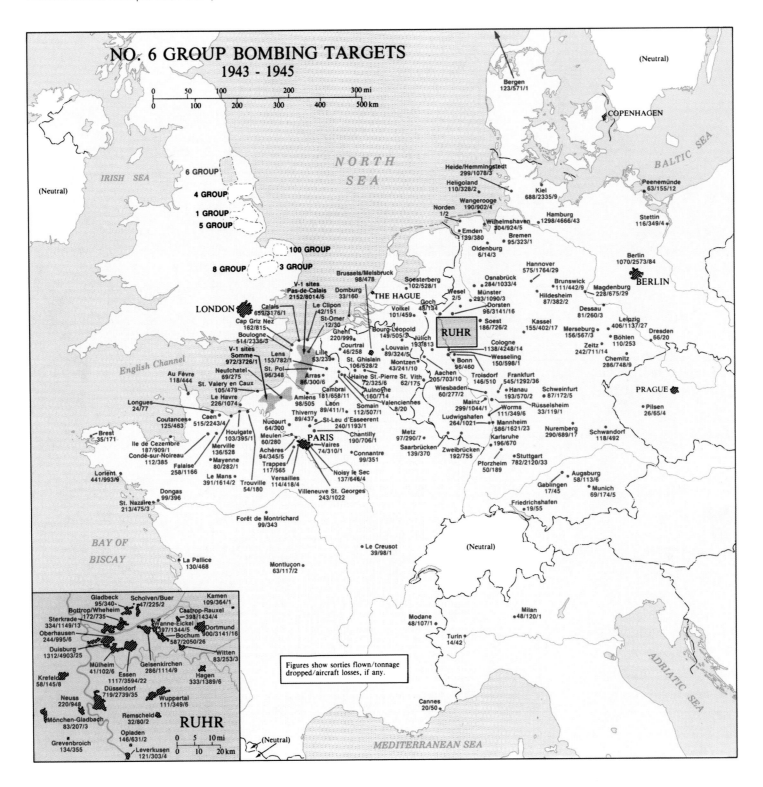

veteran Ted Radford noted that "Bomber Command dished out the dirt when no one else on our side could." On the other hand, Dennis Quinlan wrote his mother in August 1942 that "the thought of what we are doing sometimes appals me." He added, however, that "one derives a terrific sense of satisfaction from playing such a part in striking these devastating blows at our enemy . . . pounding the Hun with ever-increasing ferocity . . ."

Thus what slowed the RCAF's efforts in the bomber war was not the question of the morality of the bombing; instead it was leadership, geography and technology. No. 6 Bomber Group got off to a shaky start: almost all its pilots and commanders were more than brave enough to do the job, but perhaps less disciplined than they might have been. Canadians were better paid than the men in the RAF and their uniforms of better quality. This caused problems with the Brits, which were worsened by the sloppy, hands-in-the-pockets style of many aircrew. Too many Canadians wore their ill-discipline as a badge of honour, scorning the tight-arsed, stiff-upper-lip approach of the British. The British, for their part, looked on the Canadians as bloody, bumptious colonials who had to be put in their place. The tensions were likely greatest between RCAF squadrons and those RAF squadrons in which serving Canadians formed close bonds with their British and Australian mates. One RAF wireless operator, Les Dring, who served with an otherwise Canadian crew, recalled that he became ill and missed two operations. When the rest completed their tour, they volunteered as one to do two extra operations so that Dring could complete his tour with his own crew. "What can I say," Dring said emotionally; they "made me feel as if I was a Canadian."

Certainly, the effectiveness of No. 6 Bomber Group increased dramatically when the Canadians began to impose discipline on their own men, notably when Air Vice-Marshal C.M. McEwen—known as "Black Mike" to his crews—took command in January 1944. A tough man, McEwen enforced dress and saluting regulations, reduced the numbers of pilots aborting missions, flew on operations with his squadrons, and made No. 6 a highly successful organization. Moreover, McEwen secured Halifax and Lancaster bombers for all his squadrons, some of which had still been flying Wellingtons. The Hallies and Lancs were massive aircraft with huge engines and an enormous bomb load. Their longer range mattered, too. The Canadians' airfields were in Yorkshire, a long way from targets in Germany, and the extra range and capabilities of the bombers made a tremendous difference. The

Lancasters (some were built in Canada) flew at 435 kilometres per hour, carried a crew of seven and up to ten tonnes of bombs, and had nine .303 machine guns for defence against Luftwaffe fighters. The Halifax, with many of the same characteristics, created a near-mystical faith in its crews that it could absorb punishment and still get them home.

For aircrew, getting home was the goal. Briefings before an operation explained where the target was and the timings. Enemy defences were detailed, and diversionary tactics laid out. But the crews instantly could tell the difference between "milk runs"—attacks on lightly defended targets—and assaults on well-defended places like the Ruhr valley, where the Nazis had huge concentrations of anti-aircraft guns, fighter interceptors, searchlights and ground radar. Everyone understood that, although a milk run counted as one operation, just as an attack on, say, Dortmund did, there was no comparison. The only edge the bomber crews had was that as the sophistication of their equipment improved, so too did their chances of survival.

On every operation, milk run or not, aircrews had to battle their own fears. They were flying a machine stuffed with high-octane fuel and explosives, and the enemy was firing at them. If they weren't afraid, they simply weren't normal. Under operational stress, men could begin to twitch uncontrollably; some suffered from depression, many had nightmares and a few literally became paralyzed with terror. The RCAF did not help by declaring many such men as "LMF," or Lacking Moral Fibre, a stigma that would not go away and a harsh way of not recognizing that each man had a breaking point. That almost all the aircrew dealt with their terror and continued to function under tremendous stress says volumes about their courage, commitment and training.

The flight technology was perhaps the most difficult part of the equation. It was no simple task to pilot a large aircraft hundreds of kilometres, line up on a target and, while under fire from anti-aircraft or enemy fighters, drop bombs on a machine-tool factory from three thousand metres. In fact, in the first several years of the war, bombers missed their targets by five to ten kilometres far more often than they hit them. British scientists—or "boffins," as they were called—eventually developed ways to put crews on target. There were improved bombsights, for a start. There were direction-finding devices like "Oboe," which employed two pulsing radar beams to direct the bomber to its target and to indicate the point to get the bombs away. Another device, called "Gee," let a bomber

navigator calculate his position by figuring out the difference in time travelled between signals sent by three radio stations on the ground and the aircraft. Gee was accurate to two kilometres at six kilometres high. "H2S," a radar aboard some but not all the bombers, bounced an echo off the ground and produced a picture of the topography below on a screen. Poor visibility no longer mattered with H2S. All these devices made bombing more accurate, though precise targeting was almost never achieved. The use of Pathfinder aircraft, usually fast Mosquito fighter-bombers, that flew ahead of the Halifax and Lancaster bombers, marked targets and directed the Hallies and Lancs onto them, also helped. Late in the war, the Allies had long-range fighters that could cover the bomber streams all the way to their targets and back; this, along with rear-looking radar on the bombers that alerted crews to enemy fighters, also improved the bomber crews' chances.

What made bombing so effective, however, were the huge numbers of aircraft and the heavy bomb loads now at the disposal of Bomber Command and the United States Army Air Force (USAAF). Air Marshal Sir Arthur Harris, the determined leader of Bomber

THE LAST GOOD WAR

The RCN's sailors lived, ate and slept in cramped conditions.

FAR LEFT: The ratings on HMCS *Kamsack* ate their grub under the hammocks of their mates. (Pugsley/DND/National Archives of Canada PA-170292)

NEAR LEFT: The grog ration, a British tradition cherished by Canadians and here being honoured on the destroyer HMCS *Ottawa*, helped make the conditions tolerable. (National Archives of Canada PA-206685)

BELOW: When they could, sailors slung their hammocks up top, as did the sailors of HMCS *St. Catharines*. (National Archives of Canada PA-139291)

Command, wanted to saturate the Nazis' defences around their industrial cities to inflict maximum damage. The enemy's radar and ack-ack guns seemed able to deal with raids of three hundred bombers and inflict heavy losses. But could they handle a thousand-bomber raid—especially if their radar defences were jammed with "window," strips of aluminum foil dropped from aircraft that could put such clutter on enemy radar that the defences would collapse?

The first real test of Harris's system was at Hamburg, Germany's greatest North Sea port, on July 24, 1943. A shower of window paralyzed the enemy's radar, and both radar-controlled anti-aircraft guns and fighters became completely blind and ineffective. Eight hundred bombers streamed over the city, dropping incendiary and high-explosive bombs and causing huge destruction with a minimal loss of aircraft. Three days later, the ruins still smouldering, Bomber Command returned to hit the port again. This time the incendiaries created a swirling firestorm of incredible temperatures that sucked all oxygen out of the air and tossed people around like scraps of paper. Al Avant, a Canadian serving with RAF No. 115 Squadron, said: "You had to see the place to believe it. The whole city seemed to be burning." Another Canadian remembered, "Halfway home we could still see the smoke rising..." At least fifty thousand soldiers, munitions workers and civilians—men, women and children—died, and three quarters of the city lay in ruins. A million survivors fled Hamburg, and its industrial production and morale collapsed for a substantial period. The Nazis now were reaping the whirlwind they had unleashed.

The German government had to deal with this horrific threat to the survival of its regime and people, and it did. The population bounced back from the Allied bombing with relative speed, and industrial production scarcely flagged. German scientists developed ways to counter window, and the Nazis moved more and more 88mm anti-aircraft guns (also the Wehrmacht's most effective anti-tank gun) back to Germany. By September 1944, more than ten thousand guns and almost 900,000 men were devoted to German anti-aircraft defences. This helped the Allied armies by weakening the enemy's offensive capability. Hitler stripped the German front lines of at least 20 per cent of their fighter aircraft and posted squadrons to locations in Germany for home defence. This too enabled the Allied air forces to hold air superiority over the battlefields. Very simply, Germany devoted ever-increasing resources to the battle against the bombers because it had no choice.

MEN of VALOR
They fight for you

Two-man boarding party from the Canadian corvette 'Oakville' subdues crew of German sub in Caribbean

BELOW: The "black hole" of the North Atlantic, the section of sea without air cover, gradually closed. Eric Aldwinckle's *Sunderland Buoying up in the Rain at Slipway* shows one of the RCAF's big flying boats. (CWM Aldwinckle 10732)

RIGHT ABOVE: Albert Cloutier's *Return from Patrol, Torbay, Newfoundland* offers another view of a flying boat's crew. (CWM Cloutier 11025)

RIGHT BELOW: Eric Aldwinckle's painting captures the endless tedium of anti-submarine patrols. (CWM Aldwinckle 10719)

And the German defences had successes, sometimes inflicting 5 per cent (or higher) losses on the bombers. In one low-altitude raid on Peenemunde, where Allied intelligence knew that German V-1 and V-2 rockets were being developed, No. 6 Bomber Group lost 19.3 per cent, or twelve of the sixty-two aircraft participating. Such losses obviously could not be sustained for long, and by the spring of 1944 the loss rate in No. 6 fell as low as 1.8 per cent per month. The RCAF, RAF and USAAF bomber squadrons ran the gauntlet of searchlights and flak, they faced the enemy's radar-directed day and night fighters—some of which used upward-firing cannons while flying underneath the Lancasters—and the aircrews knew that their chances of getting safely out of a wounded bomber were sometimes slim. Flying Officer Jo Forman, a navigator, recalled the night he was shot down:

> I heard a series of bangs—like thunder claps, and Robbie told our rear gunner to keep firing ... he gave the order to "bale out" ... I was very fortunate that the cannon fire went up the port side. It jammed the tail gunner's turret, killing the mid-upper [gunner] and also the wireless op, as well as creasing the pilot's head, but my desk was on the starboard side. Suddenly the plane went into a spin, and when I was conscious again, I was in my chute which was open but had 3 panels on fire ...

Fortunately, French civilians found Forman and hid him until American troops reached his location.

The bomber crews' casualties were high, and the odds of a Halifax or Lancaster crew surviving a twenty-five-operations tour were not good. In its two and a half years of operations, No. 6 Bomber Group lost 814 aircraft and 4,272 men killed, of a total Canadian toll of 9,919 men in Bomber Command operations. The RCAF suffered fatal battle casualties of 13,498 in all, so bomber crews made up almost 75 per cent of the total. In March 1944, RCAF aircrew overseas numbered just 22,728, many in fighters or transports and many serving in other theatres. The extent of the casualties was therefore severe, and many more aircrew

were wounded or died in training. Such numbers would have been almost inconceivable in Ottawa in the first months of the war, when the British Commonwealth Air Training Plan and a concentration on air combat seemed the ideal way of avoiding casualties.

At home, next-of-kin of those killed, wounded or listed as missing received a telegram from the RCAF casualties officer: "Regret to advise that your son . . . is reported missing after air operations overseas . . . " Then, ordinarily, a letter from the squadron commander would offer sincere but stilted words of praise for the aircrew member and assurances that everything that could be done was being done to get information. An official letter from Air Force Headquarters in Ottawa followed, and then, all too often, another cable: "Regret to advise International Red Cross quoting German information states your son . . . lost his

BELOW: The crews of Bomber Command faced heavy losses in their nighttime raids over Nazi-controlled Europe. (National Archives of Canada)

RIGHT: Those who survived often numbered their "ops" on the nose of the bomber; the swastikas indicate the enemy fighters they had downed. (CWM 19800125-001 P.33B)

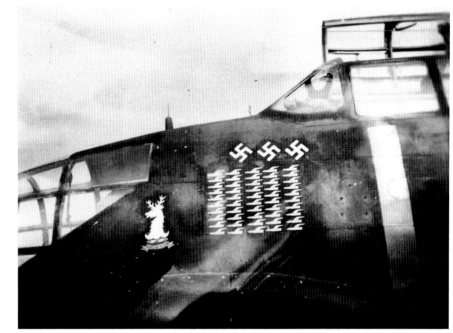

life . . ." After that, there was only grief, not at all assuaged by letters of condolence from the squadron chaplain, government ministers and politicians, the chief of the air staff, the Canadian high commissioner in London and the king. The government sent a Memorial Cross, and when more information on the death became available, this too was forwarded, along with personal effects. Finally, well after the war was over, the RCAF would send a photograph of the grave. Canada cared, but this was small compensation for the tens of thousands of Canadians who lost a son, brother or husband.

THE ARMY'S CAMPAIGN IN ITALY also produced heavy casualties. In the eighteen months that Canadians fought in Sicily and Italy, they suffered 25,889 casualties, including 5,399 killed. The grinding battle up the Italian boot was bloody and long.

It did not seem that way at the outset. The 1st Canadian Division crossed the Strait of Messina on September 3, 1943, and took the port of Reggio Calabria without resistance. Within a week, the division advanced 120 kilometres over very difficult terrain. Robert Thexton, an officer with the West Nova Scotia Regiment, remembered a nighttime march on September 6 as "one of the toughest," and it culminated at dawn in an attack by Italian paratroops. Thexton was one of the casualties, but the advance continued. The highlight of that first week was less the Allied advance than the announcement from Rome that Italy had surrendered unconditionally. It was the first of the Axis powers to quit; now the only resistance would come from German delaying actions. This changed nothing for the soldiers, however. The Germans simply stuck the Italian army in POW camps and continued to fight. The paratroops' attack on the West Novies aside, German troops had been providing the only effective opposition since the invasion of Sicily in any case.

The Canadians continued their advance as the Allies tried to link up the American forces landed at Salerno with General Montgomery's British Eighth Army. There were some hard-fought skirmishes, as at Motta Montecorvino, where the Royal Canadian Regiment and tanks of the Calgary Regiment had a stiff engagement with Germany's 3rd

Parachute Regiment. But it seemed clear that the enemy, still delaying the advancing Allies, was beginning to move into a winter defensive line midway between Naples and Rome, stretching from the Tyrrhenian to the Adriatic Seas. The Adriatic anchor was at a small port called Ortona.

Before the 1st Canadian Division reached Ortona, decisions about the Italian campaign were made in Ottawa and Britain. General McNaughton had wanted his soldiers to return to Britain once Sicily had been liberated, but this made neither military nor logistic sense. Instead, Ottawa decided to despatch the 5th Canadian Armoured Division and I Canadian Corps headquarters to Italy, a major expansion of the Canadian commitment. General Simonds, after demonstrating that he could successfully fight an infantry division, was to command the 5th Armoured. Replacing him was Major-General Chris Vokes, a tough-talking, blustery but not ineffective commander. To direct I Canadian Corps, Ottawa picked Lieutenant-General Harry Crerar, the indispensable man who had been chief of the general staff in Ottawa and a corps commander in Britain. Since McNaughton's fitness to command was in doubt, as his political troubles with his masters in Ottawa increased, everyone understood that Crerar was to be the successor. His time in Italy was to give him some seasoning in battle.

The struggle for Ortona, however, was to be conducted by the 1st Canadian Division and 1st Canadian Armoured Brigade. The enemy, the 90th Light Panzer Grenadier Division, had built its winter line on the Moro River, just south of the town, and General Vokes began his operations on December 6, 1943. A surprise night assault without artillery support across the river by the Princess Patricia's Canadian Light Infantry (PPCLI) worked superbly, many Germans being taken prisoner in their beds. But the Seaforth Highlanders waded across the river into the fire of at least fifteen machine guns, and strong counterattacks soon fell on the PPCLI. With great difficulty and heavy losses, the small Canadian bridgeheads hung on, until a two-brigade attack on December 8 took the

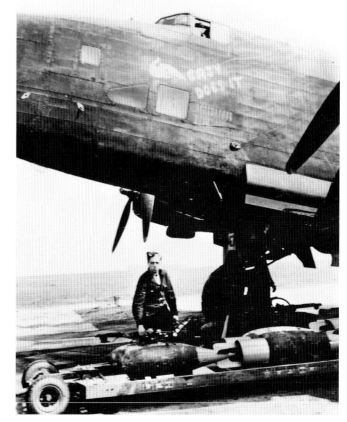

BELOW: Paul Goranson's painting *Marshalling of the Hallies* shows RCAF 419 (Moose) Squadron preparing for a raid on Wuppertal, Germany. (CWM Goranson 11402)

RIGHT: When the aircraft returned, the airfield would be lit up with Sandra lights, as in this painting by Carl Schaefer. (CWM Schaefer 11873)

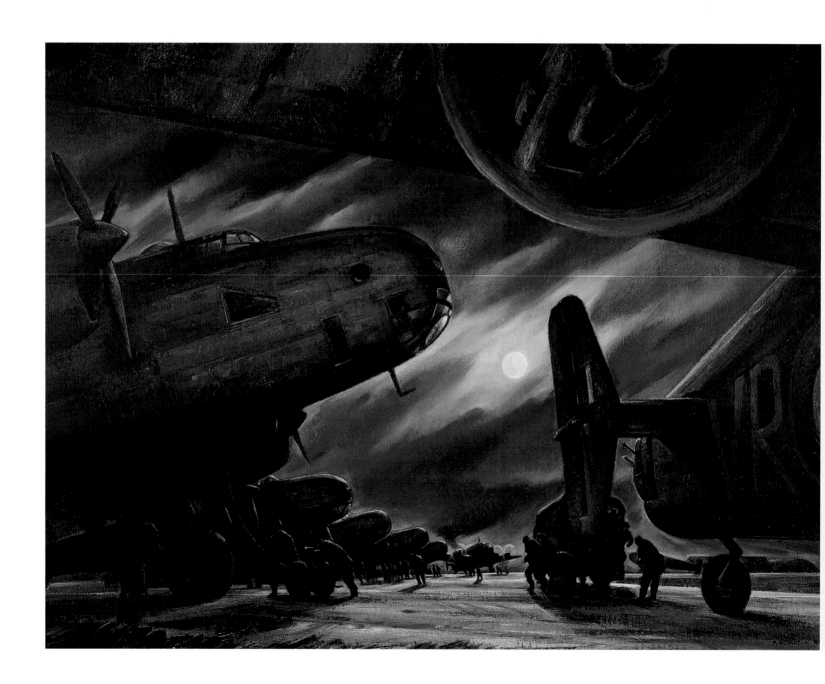

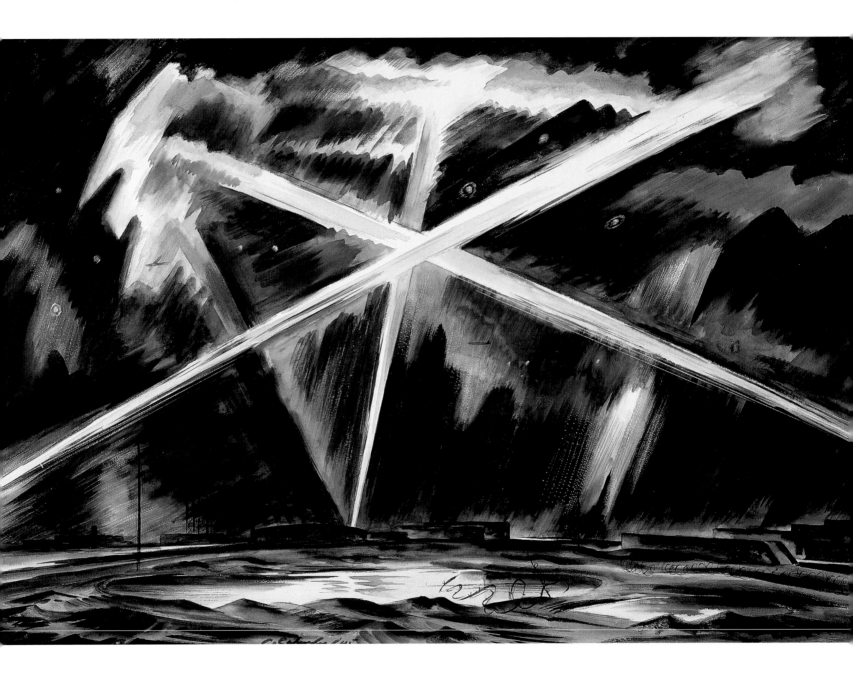

BELOW: The devastation the explosions and fires caused was horrific.
Bomber Command blasted Germany's cities into rubble. (National
Archives of Canada)
RIGHT: The big Lancaster bombers hammered the Third Reich relent-
lessly. This photo shows a Lanc of 405 Squadron. (National Archives
of Canada PA-11370)

hamlet of San Leonardo in the first full-scale divisional battle with the enemy. Further German counterattacks were destroyed by artillery, mortar and machine gun fire, and the enemy pulled back to defensible ground.

The key feature was "The Gully," a long ravine that ran east to west in front of Ortona. The Germans had dug into the forward slope of The Gully, fighting for every bit of cold, muddy ground with extraordinary ferocity. It took several days of bloody fighting and almost a thousand casualties to breach the defences, the way being led by the Royal 22e Régiment (the Van Doos) and the Sherman tanks of the Ontario Regiment, which seized a key group of farm buildings, the Casa Berardi, on December 14 from elements of the German 1st Parachute Division. The Van Doos' company commander, Captain Paul Triquet, led his men towards the farm buildings, his strength dwindling. By the time he reached the Casa Berardi he had only fourteen men and some tanks, and his first objective was to drive the paras out of the buildings. Somehow he succeeded, and Triquet's little band held the fort until reinforcements finally reached them just before midnight. By the time the ground was finally won, well after midnight on the second day of battle, Triquet had just eight men left under his command. He was promoted to major and awarded the Victoria Cross.

Ortona was next. Two battalions of enemy paratroops had fortified the town strongly in response to an order from the führer that it was to be defended to the last. By December 21, the Seaforths and the Loyal Edmonton Regiment from the brigade now led by Brigadier Bert Hoffmeister were struggling in the narrow streets, clearing houses one by one, and using their anti-tank guns or the Sherman tanks of the Three Rivers Regiment to blast enemy strongpoints. The Germans used demolitions to take down houses and pile rubble so that the ways through the jumble became killing zones. They also, as the Three Rivers' Ted Griffiths noted, "would set up prepared charges in a house [and] then, by opening fire on our infantry as they advanced, would drive them into the house selected for demolition before blowing the charges, burying everyone."

The Canadian infantry learned the game quickly, deciding that good sense demanded that they "mousehole" through the walls of row houses. Infantry would dig a hole, toss in grenades, then come through. After throwing grenades into the upstairs and downstairs

BELOW: Albert Cloutier's painting *V for Victory* portrays a Lancaster of 434 Squadron. (CWM Cloutier 11065)

RIGHT: The Sherman tanks of the 1st Canadian Armoured Brigade fought up through Italy. Unfortunately, the stunningly beautiful terrain favoured the defence. (National Archives of Canada PA-114103)

rooms and making liberal use of Sten guns, it was on to the next dwelling. This was slow work and casualties were heavy, not least because the Germans mined houses, setting the explosions off to kill the maximum number of men. One twenty-man platoon of the Loyal Eddies was wiped out in this way.

The fighting continued on Christmas Day, though platoons pulled out of the line in turn for a traditional turkey dinner in the ruins of the Church of Santa Maria di Constantinopoli. One officer played carols on the church organ, and the Seaforths' padre told the weary men, "At last I've got you all in church." The platoons went back into the line. Griffiths remembered that the Germans were firing out the wide-open doors of the Santa Maria delle Grazie Church "until I ordered my gunner [in his Sherman tank] to open fire. In seconds we blew in the front of the church which had stood for hundreds of years, then the infantry went in to do the nasty work in taking out any Germans left alive . . . Every Christmas morning," he added, "I still see Seaforth bodies scattered across that damned square." The CBC's Matthew Halton reported from the town that "in three buildings I looked into there were German and Canadian dead . . . There was smoke here and there, and flames, and the dead. We were in a lost world . . . That was Ortona, and the German death frenzy, not good to de-scribe." The fighting continued to the early hours of December 28, when the surviving paras silently disappeared, retreating to their next defensive line north of the city.

Ortona had been a slaughterhouse. The 1st Canadian Division had lost 2,339 officers and men since its initial attacks on the Moro River on December 8. Another 1,600 had to be evacuated because of sickness or battle exhaustion. One Seaforth Highlander remembered a friend who fell apart from shock during the battles on The Gully. "He is a bundle of nerves, but he never asks for a favour and gives everything he's got until he snaps." The bat-talion medical officer looked him over and concluded that he had to be sent back. "There is deep humiliation in my friend's face as he goes back to join the dead . . . He thinks he has let his friends down. He will be back again and again, shaking like a leaf every time we see

BELOW: The 1st Canadian Division, including these soldiers of the
Royal 22e Régiment, landed in Italy in September 1943. There was some
heavy fighting, as the photo of troops under fire in October 1943
suggests. (National Archives of Canada, *left*: PA-11597, *right*: PA-141306)
RIGHT: For the first few months, however, it was hard marching for
the troops and a struggle against mosquitoes and malaria. (National
Archives of Canada, *left*: PA-115032, *right*: PA-213678)

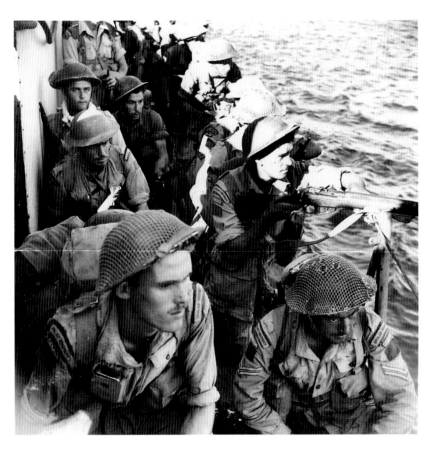

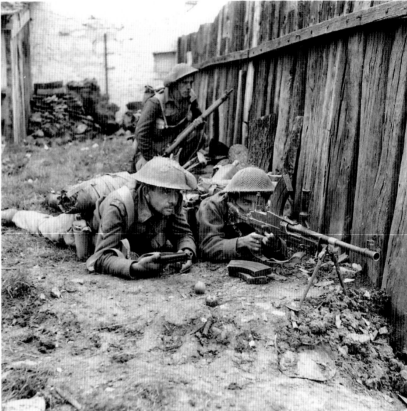

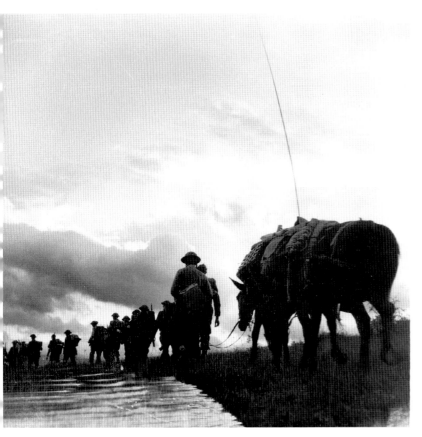

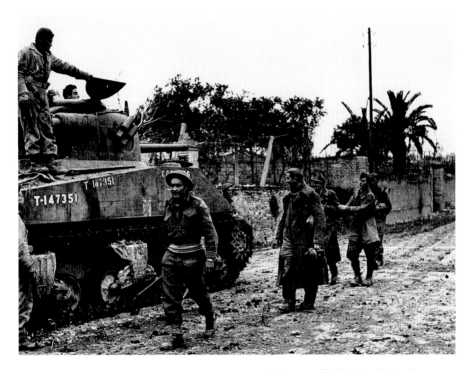

action, going on to the breaking point. He will finish the war unwounded," the Highlander wrote, "and carry a sense of shame for the rest of his life. He is a very brave man."

Bert Hoffmeister was a brave man, too. On one occasion he and the commanding officer of the Saskatoon Light Infantry were well forward under fire from German tanks and self-propelled guns. "It was low velocity stuff," Colonel Tom de Faye of the Saskatoons said, "and we could hear it coming, so there was plenty of time to hug the ground before it burst, and then get up and run again . . . The fire was . . . accurate, and usually missed us by a few yards." The PPCLI had been up on a hill watching "the spectacle of the Brigade Commander . . . doing hundred yard dashes between the shellbursts." The lighter side of war, de Faye called it. But brigade commanders were not often so far forward that they came under direct fire. Hoffmeister was different, but even he was shocked by the casualties his battalions had sustained at Ortona.

The 1st Division, its infantry companies reduced to no more than half-strength, had shot its bolt. But the Canadians, as Matthew Halton reported to Canada, "beat two of the finest divisions that ever marched" and had taken Ortona—if that was a prize worth the awful cost.

Between the New Year and May 1944, the Canadians engaged in endless patrolling and a number of larger actions, though the line scarcely advanced. "The daily routine," Captain Robert Thexton recalled, "included manning all forward positions during the night, withdrawing to rest during the day . . . Outposts and O[bservation] P[osts] would be manned in the daytime, but all personnel would rest with their boots on and weapons loaded, ready to move at short notice to their fire trenches." Any movement in the West

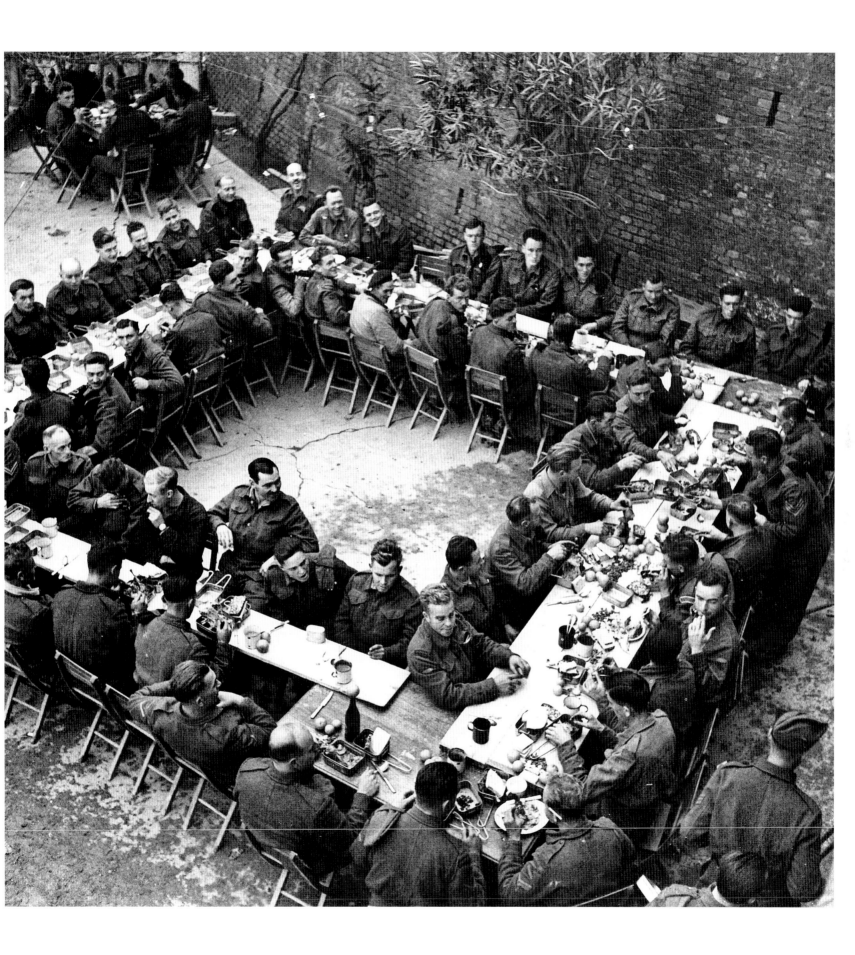

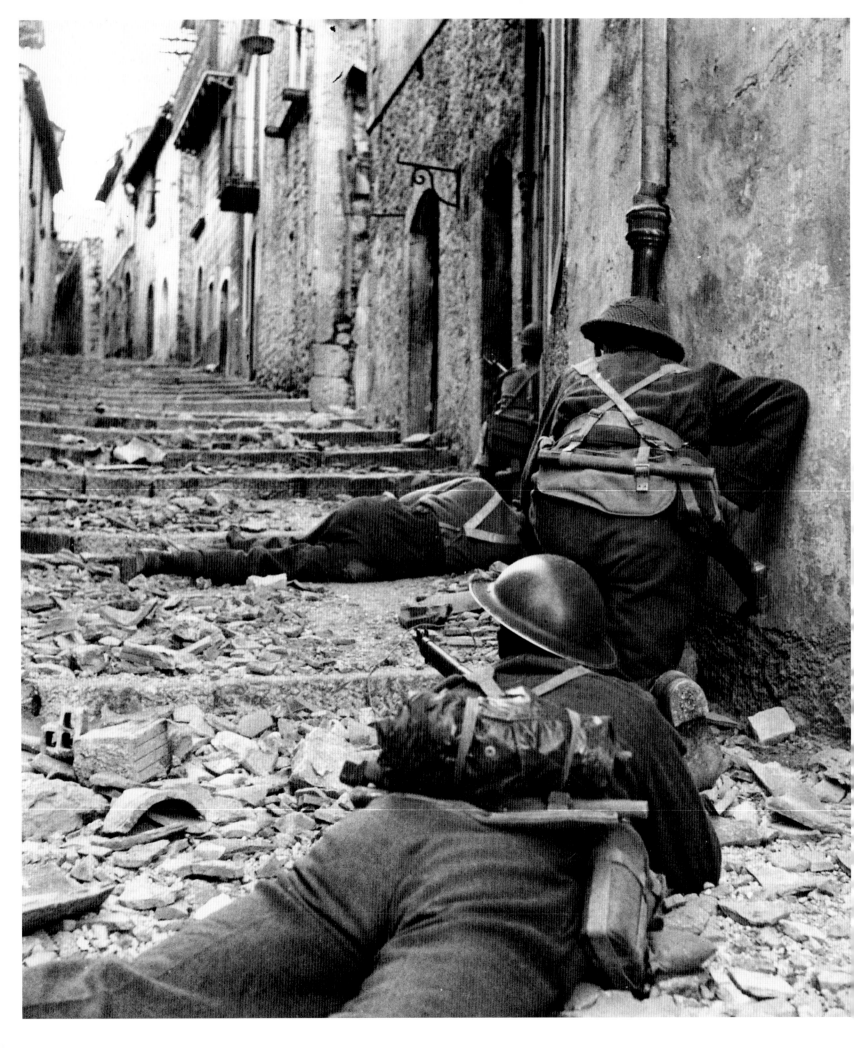

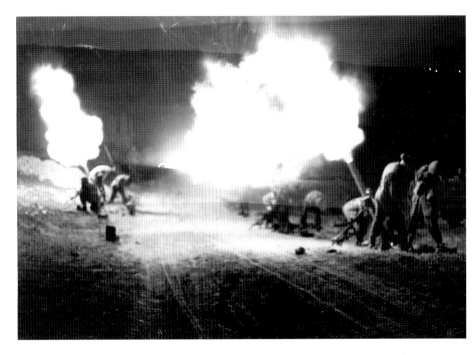

Nova Scotia Regiment's lines, Thexton added, "would be rewarded by a good pounding by [German] mortars or field artillery." General Chris Vokes, commanding the 1st Division, argued against any attacks: "When General Mud allied himself with the defence, an overwhelming tactical advantage was given the enemy," he wrote in his diary.

Vokes also noted that this was a young man's war. When his division had been mobilized in 1939, all the officers holding the rank of lieutenant-colonel or higher, and many other officers and senior non-commissioned officers, had seen Great War service. But now almost none were left, Vokes noted. "None of these held unit command or above. I was 39, the brigade commanders were below 35, and the battalion commanders all below 30 years." These officers, he added, "had risen in rank through ability."

Meanwhile, the 5th Canadian Armoured Division arrived in Italy and settled in, General Simonds returned to England to command II Canadian Corps, and a dour intellectual, Major-General E.L.M. Burns, took command of the armoured division. When Harry Crerar left Italy in March to command the First Canadian Army in Britain and to ready it for the invasion of France, Burns became the corps commander, while Bert Hoffmeister, the Seaforths' commanding officer in Sicily, took his place in command of the 5th Canadian Armoured. Under these commanders, the corps was to play a critical role in smashing through the German army's Gustav and Hitler Lines and opening the way to Rome.

The great battle to crack the enemy's defensive lines began on May 11; the locus of action was in the Liri valley on the western side of the Italian peninsula. The Germans had fortified the ground, stringing wire and planting mines, building concrete bunkers and planting tank turrets into cement. The initial assaults involved British Eighth Army divisions, the only Canadians involved being the 1st Armoured Brigade. Brigadier William Murphy, commanding the 1st Armoured Brigade, told his family in Vancouver that "this was a powerful line, built over five months and which has successfully withstood two major attacks. Of course when the Eighth Army got to work that's all there was to it. The

LEFT: Ortona was streetfighting and house-clearing, a gruelling, deadly game. It is unclear if this photograph shows action in Ortona, but it was taken in a roughly similar Italian town. (National Archives of Canada PA-114482)

ABOVE: After Ortona, the Canadians spent the winter in static positions, but there was a war of mortars. This striking shot shows heavy mortars of the Princess Louise Fusiliers of the 5th Canadian Armoured Division letting loose in April 1944. (National Archives of Canada PA-129764)

THE LAST GOOD WAR

line was busted. My tanks were the first over the river ... " Proud as punch, Murphy added that "to have commanded the B[riga]de that first got its tanks into him [the enemy] is very pleasant."

On May 16, the 1st Canadian Division went into action, clearing the way for the Polish division that finally took the ruins of the great monastery on Monte Cassino. Not until May 23 did I Canadian Corps come fully into the battle, the first operations by a Canadian corps in the war.

In a day-long struggle, the infantry division cracked open a breach through which the armoured division poured, the tanks racing as fast as they could up the valley towards the Melfa River. The Lord Strathcona's Horse and a company of the Westminster Regiment made it across the Melfa and held their ground in the face of repeated counterattacks. Major J.K. Mahony of the Westies led the defence, and though wounded twice, he and his men took fifty prisoners, killed more Germans and knocked out a huge Panther tank and three self-propelled guns. Mahony won the Victoria Cross, and the 5th Canadian Armoured Division began to earn its nickname as the Mighty Maroon Machine. General Hoffmeister, the division's commander always leading from the front, added to his reputation as the finest fighting general of the Second World War Canadian army. For his part, Major-General Chris Vokes of the 1st Division said the Hitler Line "folded like a militia tent in a high wind" and called it "the best battle I ever fought, or organized, even though we suffered so heavily."

The cracking of the Hitler Line opened the road to the capital, and the enemy's retreat turned into a rout. The Americans raced for the Holy City and liberated it on June 4, but the British Eighth Army, lagging behind, found its vehicles stuck in huge traffic jams on the poor roads of the Liri valley. Somehow General Burns and the Canadians took the blame for this, and the Eighth Army commander, Montgomery's successor, Oliver Leese, tried to get him fired. Burns was no Napoleon, no great commander, but his divisions and his untried corps headquarters had performed well and deserved better than the abuse that fell upon them.

Now the Canadians went into reserve for two months. When the Allies landed in France on June 6, Italy almost instantly became a secondary theatre, a sideshow. But the killing there, the suffering and horror, continued.

LEFT: The Hitler Line battles were fierce. This photograph shows Canadian troops caught in the terrible traffic jams that resulted from trying to cram too many divisions onto too few roads. As a consequence, the exploitation towards Rome was delayed. (National Archives of Canada PA-151180)

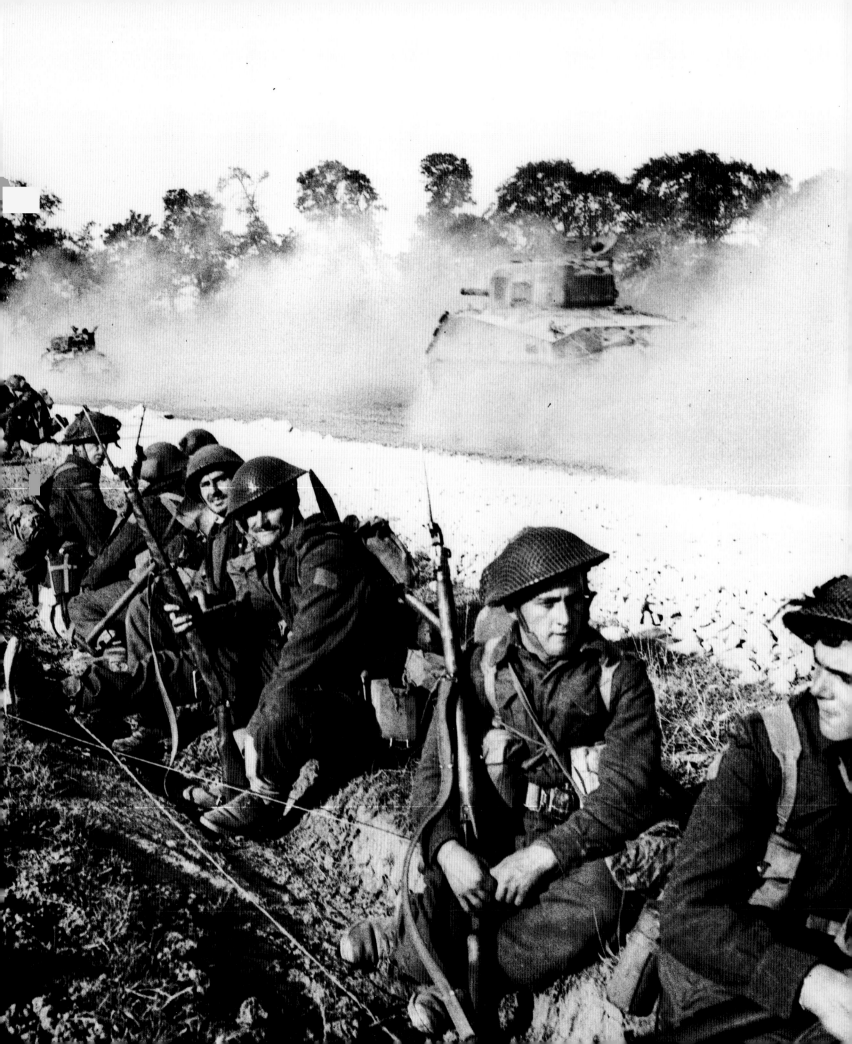

6 | THE STRUGGLE FOR NORTHWEST EUROPE

"OUR JOB," WROTE THE CAPTAIN of the brand-new destroyer HMCS *Algonquin* on June 5, 1944, "was to escort the headquarters ship … to the assault area." On the deck, Lieutenant Commander Desmond Piers wrote, "I could see General Keller, Brigadier Todd, and other familiar faces. We exchanged waves of greetings. It seemed good to us that a Canadian ship should be chosen to escort the staff of the 3rd Canadian Division across the channel to the invasion beaches of Normandy." Overhead, aircraft of the Royal Canadian Air Force attacked enemy positions on the beaches. Canada's three armed services were present in force on D-Day.

THE DIEPPE RAID OF AUGUST 1942 had made all too clear to Allied planners that getting an invading army ashore in France was no simple task. Dieppe had also demonstrated that seizing a fortified port was likely to be impossible, and this meant that an assault over open beaches was preferable. The Germans could figure this out too, and the enemy generals looked at the Pas de Calais area, very close to English ports, and fortified it strongly. As a result the British and American planners looked elsewhere, focusing their gaze on Normandy. The Norman coast was further away, a problem for seasick-prone soldiers in pitching landing craft, but it was not defended as well—or so intelligence reported. Normandy it was.

But when? The Americans had been pressing for an attack on France almost from the day they entered the war. But in addition to the Germans' dispositions, there were other factors like the availability of landing craft. Despite the best efforts of shipyards in the United States, Britain and Canada, the number of ships was limited and the demand for them widespread. LSTs—Landing Ships (Tanks)—were especially scarce, and LSTs were

(Courtesy Directorate of History and Heritage,

National Defence Headquarters, Ottawa)

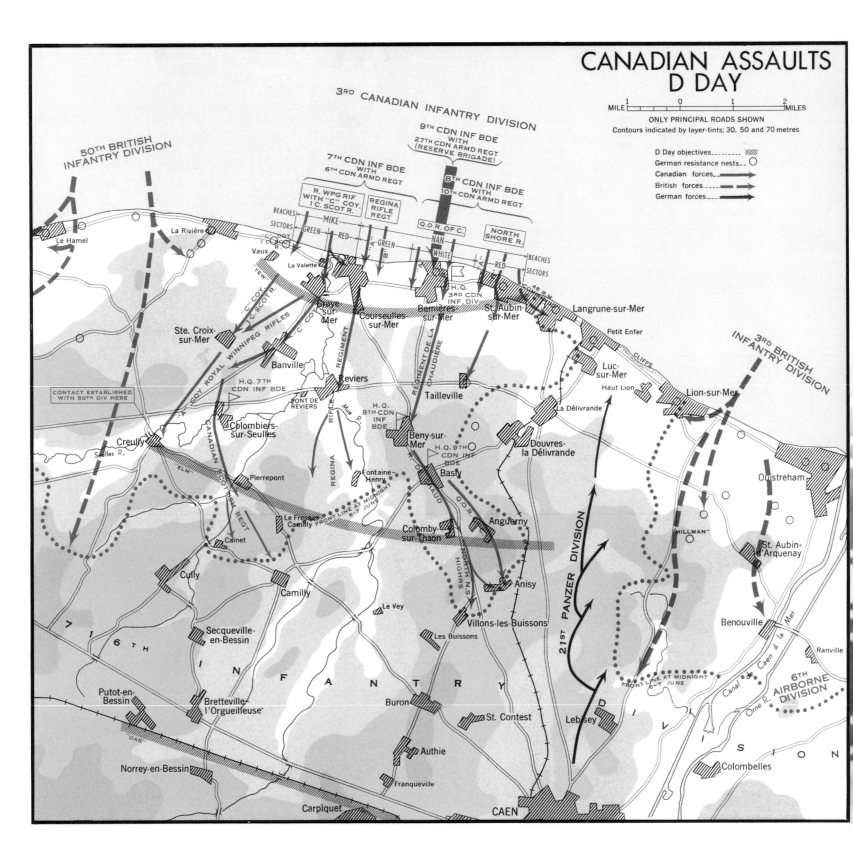

CANADIAN ASSAULTS
D DAY

MILE 1 0 1 2 MILES

ONLY PRINCIPAL ROADS SHOWN
Contours indicated by layer-tints: 30, 50 and 70 metres

D Day objectives..........
German resistance nests... O
Canadian forces.......
British forces.......
German forces.....

3RD CANADIAN INFANTRY DIVISION

9TH CDN INF BDE
WITH
27TH CDN ARMD REGT
(RESERVE BRIGADE)

7TH CDN INF BDE
WITH
6TH CDN ARMD REGT

8TH CDN INF BDE
WITH
10TH CDN ARMD REGT

R. WPG RIF
WITH "C" COY.
1 C. SCOT R.

REGINA
RIFLE
REGT

Q.O.R. OF C.

NORTH
SHORE R.

50TH BRITISH
INFANTRY DIVISION

3RD BRITISH
INFANTRY DIVISION

BEACHES
SECTORS
MIKE
GREEN RED
NAN
GREEN
WHITE
RED
BEACHES
SECTORS

Le Hamel
La Rivière
Vaux
La Valette
Graye-sur-Mer
Courseulles-sur-Mer
Bernières-sur-Mer
St. Aubin-sur-Mer
Langrune-sur-Mer

H.Q.
3RD CDN
INF DIV

Ste. Croix-sur-Mer
Banville
Reviers
Petit Enfer
CLIFFS
Luc-sur-Mer
Haut Lion
Lion-sur-Mer

CONTACT ESTABLISHED
WITH 50TH DIV HERE

H.Q. 7TH
CDN INF BDE

PONT DE
REVIERS

Tailleville
La Délivrande

Creully
Seulles R.
Colombiers-sur-Seulles
Mue R.

H.Q.
8TH CDN
INF BDE

Beny-sur-Mer

Douvres-la Délivrande

Ouistreham

Pierrepont
Fontaine-Henry

H.Q. 9TH
CDN INF
BDE

Basly

Le Fresne
Camilly
FRONT LINE AT MIDNIGHT
6-7 JUNE

St. Aubin-d'Arquenay

Cainet

Colomby-sur-Thaon
Anguerny

"HILLMAN"

Cully
Camilly
Le Vey
Anisy

Benouville

Ranville

7 6TH I N F A N T R Y

Secqueville-en-Bessin
Les Buissons
Villons-les-Buissons

21ST PANZER DIVISION
FRONT LINE AT MIDNIGHT
6-7 JUNE

6TH
AIRBORNE
DIVISION

Putot-en-Bessin
Bretteville-l'Orgueilleuse
Buron
St. Contest
Lebisey

D I V I S I O N

Norrey-en-Bessin
Authie
Colombelles

Franqueville

Carpiquet
CAEN

essential if tanks were to be put on the beaches. The planners' best calculations pointed to the spring of 1944 and to June 5 as the day the tides would be favourable.

And who was to command the invasion? Britain's chief of the imperial general staff, Sir Alan Brooke, had claims for the command. So did General George C. Marshall, the U.S. Army's chief of staff. Both men were deemed indispensable by their country's political leaders. General Dwight "Ike" Eisenhower had commanded "Torch," the Anglo-American invasion of North Africa, and he had led the attack on Sicily. There he had worked with General Bernard Montgomery and his Eighth Army in a sometimes tense but ultimately very productive relationship. The British and Americans settled on the same duo for Operation Overlord, the invasion of France. Ike would be Supreme Allied Commander, in overall command, and Monty would direct the armies in Normandy in the initial phases.

And the Canadians? In Britain, Canada had the First Canadian Army, led by General Harry Crerar. Under him was II Canadian Corps, commanded by Lieutenant-General Guy Simonds, consisting of the 2nd and 3rd Canadian Infantry Divisions and the 4th Canadian Armoured Division. There was also the independent 2nd Canadian Armoured Brigade. Canada wanted a major role in the invasion, and the choice fell on the 3rd Division supported by the tanks of the Armoured Brigade. The rest of the army would follow on, setting up shop in France as the battle developed.

To make up for the lack of a port, some brilliant scientists had devised "artificial harbours" that would be put together from huge concrete caissons and the sunken hulks of old ships. The result, code-named "Mulberry" and covered by a blanket of secrecy, would be a breakwater onto which prefabricated unloading piers could be attached. If Mulberry failed, there would be no way to supply the troops ashore.

The Allied plan called for five divisions to storm ashore in the seaborne assault and for three airborne divisions to land on the flanks. The Americans provided four divisions in all, including two airborne; the British provided three, including one airborne, and the Canadians provided one division and the armoured brigade, as well as a paratroop battalion embedded in the British airborne assault.

To prepare the way, American, British and Canadian bombers had conducted a long, complicated bombing plan to hit rail lines, bridges and enemy concentrations. The first days of the invasion were critical to Allied success, and if the Germans' ability to respond

quickly was hampered, the odds of success increased. At the same time, the Allied navies were aggressively striking out at the German fleet of destroyers and E-boats in and near the English Channel, trying to eliminate the possibility of any attack on the invasion fleet. In late April 1944, for example, the Canadian destroyers HMCS *Athabaskan* and *Haida* went into action against three German destroyers. A torpedo struck *Athabaskan,* and the Canadian ship went down. An accompanying motor torpedo boat withdrew at full speed, and Able Seaman Ted Hewitt, in the water and swimming for his life, recalled: "I will never forget the sound of those engines going away..." But to Hewitt's great relief, *Haida* returned and picked up all the survivors it could, 48 in all, at substantial risk to itself, until it had to turn away to confront the enemy. The Germans took 85 sailors prisoner, and 128 died in the destroyer's sinking, including the captain. For its part, *Haida,* under its captain, Commander "Hard-over Harry" DeWolf (who won three Distinguished Service Crosses and a Distinguished Service Order), had earned and continued to embellish a terrific reputation for its sinking of two destroyers, a minesweeper, a submarine and 14 smaller enemy vessels. The Royal Canadian Navy provided 110 vessels for Operation Overlord, including destroyers, the landing ships HMCS *Prince Henry* and *Prince David,* both converted armed merchant cruisers, 16 Bangor class minesweepers, motor torpedo boats and landing craft.

No one anticipated a cakewalk on the Normandy beaches. Indeed, the planners feared very heavy casualties in the opening attack because Field Marshal Erwin Rommel led the defenders. Rommel had led an armoured division in the blitzkrieg of 1940, and he had commanded the Afrika Korps with great skill. Now his galvanizing energy was devoted to improving the defences of France, and his men strung wire across open fields to impede paratroops, planted concrete tetrahedrons and iron hedgehogs in the water to stop landing craft, and built minefields underwater and on the sands. At the same time, huge concrete bunkers with artillery and machine guns, carefully placed to cover the likely approaches, were fully manned. Behind the beach defences, Rommel had first-rate

LEFT: The invasion of Normandy was as well prepared as it could be. Paratroops of the 1st Canadian Parachute Battalion, tasked with important roles on the eastern flank of the invasion, did sand table exercises as part of their training. (CWM Tinning 13991)

BELOW: An extraordinary array of landing craft gathered in English ports to carry the invaders to Normandy. Note the camouflage netting, which could not have fooled German aerial reconnaissance for very long. (National Archives of Canada PA-137130)

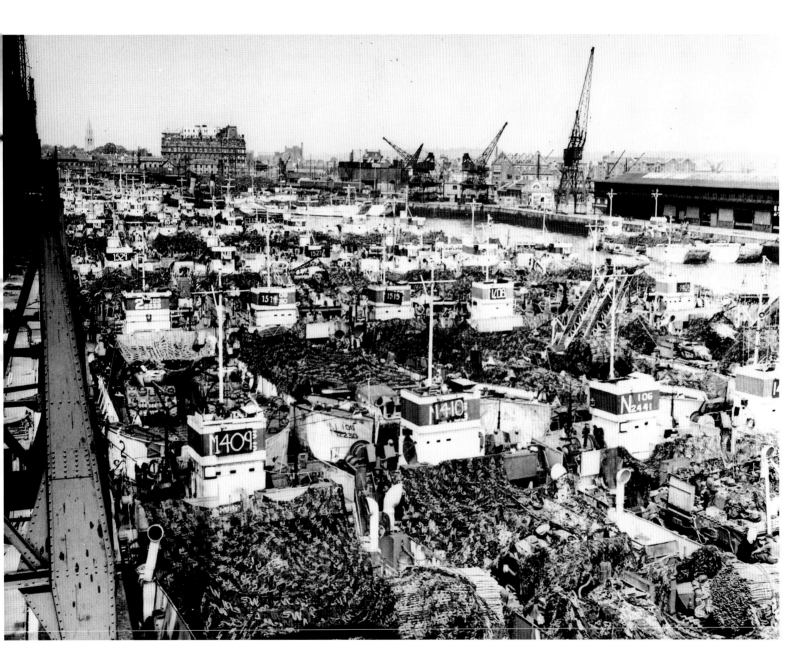

Panzer and Waffen SS divisions. These were the best the Germans had, and they were very good indeed.

The 3rd Canadian Division's beach, labelled "Juno," encompassed a string of small seaside resort and fishing villages, notably Courseulles-sur-Mer, Bernières-sur-Mer, and St. Aubin-sur-Mer. Two infantry brigades, each supported by an armoured regiment, constituted the first wave. The tanks were equipped with Duplex Drive technology, which involved an inflatable canvas screen that gave them the capability to float as well as a propeller to move them through the seas and, once on land, to move on their treads. All the vehicles used by the Canadians had waterproofing applied, just in case they had to wade ashore. The Canadians also had "funnies," specialized tanks that could, among other things, cross ditches over giant fascines or use huge mortars to take out pillboxes.

Ultimately it was to be the men, not the technology, that would determine success or failure. The 3rd Canadian Division had trained hard, carefully focusing its energies on the hard task of getting ashore, overcoming the beach defences, and moving inland to consolidate so that the inevitable counterattacks could be defeated. The soldiers knew that aircraft and battleships would plaster the beach defences, but they also knew that ultimately the poor bloody infantry had to do the job. "For at least two years," wrote Charlie Martin, a company sergeant major in the Queen's Own Rifles, "we'd been training and planning for this; for at least two years the enemy had known we'd be coming." The Canadians were as ready as they could be.

The first setback came when a terrible storm forced General Eisenhower to delay the invasion for a day. Even then, the weather for June 6 was stormy enough to guarantee high waves and nauseous soldiers. At Utah Beach, the Americans landed with success, but at Omaha Beach, they ran into tough German troops holding the high ground. Only with great courage did the attackers manage to get and stay ashore in a day of terrible carnage. At the British beaches, Sword and Gold, the infantry landed without too much difficulty,

but stiffening enemy resistance prevented the seizure of Caen. The airborne assault caused huge confusion to the German defenders, but errant drops and high winds spread the 82nd and 101st U.S. Divisions across the countryside. The British airborne assault had more success.

The Canadians moved in toward Juno Beach, and Martin recalled: "It came as a shock to realize that the assault fleet just behind us had completely disappeared from view." The landing craft touched down late just after 8 AM, the Queen's Own Rifles hitting the beach at a gallop. "Move! Fast! Don't stop for anything," Martin told his platoon. "Go! Go! Go!" He wrote later that "none of us really grasped at that point, spread across such a large beach front, just how thin on the ground we were." The Queen's Own were in five assault boats for each of the two companies in the first wave, and their regimental frontage was 1,500 metres. "Each of the ten boatloads had become an independent fighting unit," separated by a football field of sand. "None had communication with the other."

Worse yet, the riflemen soon discovered that the shells and bombs had not affected the enemy defences, impregnable under one to two metres of concrete. "The entire beach was open to murderous fire from machine guns positioned for a full 180-degree sweep." A German 88mm gun devastated one platoon, and D Company lost almost half its men to fire from a huge bunker in the race for the protection of the seawall. "That first rush," Martin said, "racing across the beach, scaling the wall, crossing the open railway line that ran parallel to the beach, all under heavy MG fire—claimed a lot of us in the first minute or two." But the men rallied, knocked out pillboxes, moved through the enemy's barbed wire and minefields, and slowly began to move off the beach into Bernières-sur-Mer. The problem, wrote Charlie Martin, "was that A Company had now suffered over 50 per cent casualties . . . We had been really fortunate to get off the beach at all."

The North Shore Regiment also had its difficulties, its leading infantry companies faced with a hundred-man bunker stuffed with machine guns. The New Brunswickers managed to knock it out with the assistance of the Sherman tanks of the Fort Garry Horse. The Regina Rifles landed in front of another concrete bunker at Courseulles, its

LEFT: Commander Harry DeWolf, captain of HMCS *Haida*, the RCN destroyer with an extraordinary record in action against the German navy. (National Archives of Canada PA-141695) BELOW: The Allied navies, including the destroyer HMCS *Algonquin*, provided direct fire support for the assault. (Herbert Jessop Nott/DND/National Archives of Canada PA-170770)

BELOW AND RIGHT: Getting ashore in Normandy was a difficult, complicated task. Men were crammed into landing craft with their equipment—and their bicycles, which some staff officer thought would facilitate the advance! Then they had to organize on the beach and begin to trudge forward. (National Archives of Canada, *below*: PA-129053, *right above*: PA-132930, *right below*: PA-132850)

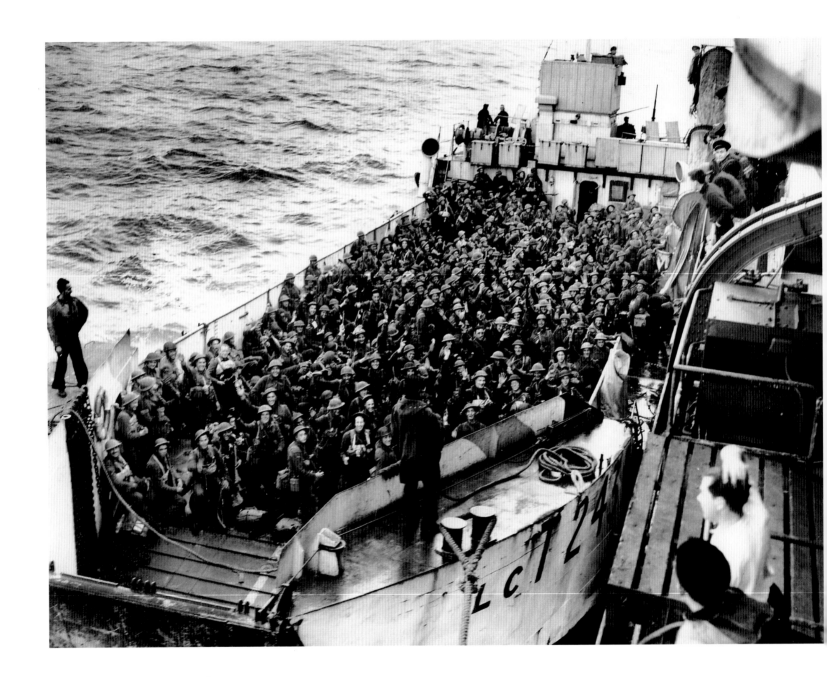

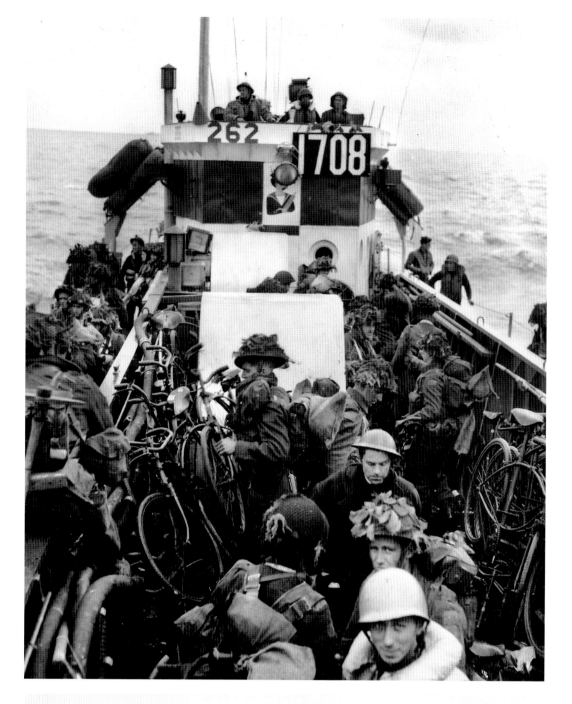

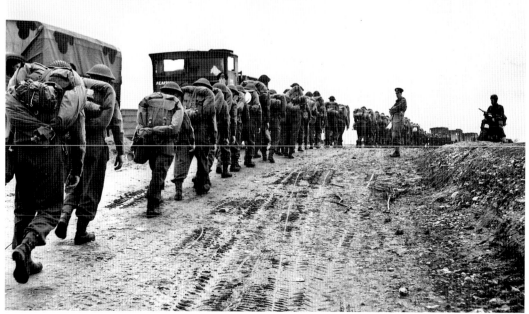

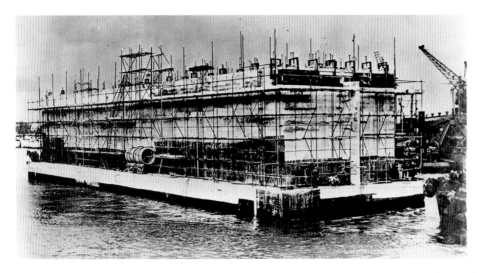

ABOVE: To keep the armies supplied, the Allies brought "Mulberry," their own port, including huge concrete caissons, with them. (York University Archives, *Toronto Telegram* Collection)

RIGHT: They also brought a break-water with piers on which unloading could be done. (York University Archives, *Toronto Telegram* Collection)

defenders equipped with three machine guns and an anti-tank gun. The Reginas overcame its resistance with the help of the 1st Hussars' tanks.

Everywhere there was courage and casualties. Mines in the water blew up landing craft carrying soldiers of Le Régiment de la Chaudière and the Reginas. The Royal Winnipeg Rifles, coming ashore west of Courseulles, found that the preliminary bombardment had "failed to kill a single German soldier or silence one weapon." The Winnipeg regiment suffered grievously from shelling on the way to land and then had the devil of a time getting through minefields before it could take its objectives. But the Rifles did the job, as did all the invading troops.

The Allies had got ashore with fewer casualties than feared. Omaha Beach had nearly been a disaster—the much-vaunted shelling had left the enemy defences untouched almost everywhere—but the courage and training of the American, British and Canadian soldiers had overcome the Wehrmacht. Reinforcements poured in, and by the close of D-Day, June 6, the Allies had 150,000 men ashore. Canadian losses in the first day of the invasion were 340 killed and 574 wounded—terrible enough, but only half the toll the planners had predicted.

The German counterattacks had yet to materialize, however. The enemy believed that the Normandy landings were a feint, a diversion designed to draw attention from the Pas de Calais. The Germans, moreover, had run into Allied airpower as they tried to move towards the landing areas; and bombers and Typhoons, the latter shooting up tanks and trucks with three-inch rockets, slowed them down. This greatly assisted the Allies both in moving forward and in providing the time to sort out the inevitable confusion of men, vehicles and supplies on the beaches.

But the Germans were there soon enough. On the night of June 6, the North Nova Scotia Highlanders and the Chaudières faced attacks from mechanized infantry. The next morning, as the Canadians advanced towards the airfield at Carpiquet, infantry and armour from the 12th SS Panzer Division fell upon them at Buron and Authie. The Germans were *Hitler Jugend* teenagers, led by experienced officers, both commissioned and noncommissioned, and they fought with extraordinary ferocity. The SS overran a company of

the North Novas, and the Canadian Shermans, facing heavily armoured German Tigers and Panthers, found that their shells bounced off the panzers, while their Shermans almost always "brewed up" at once if hit by German shells—"Tommy cookers," the Germans called them. The losses were heavy in men and tanks, and the 12th ss murdered most of the prisoners it took that day and for the next several days. In all, at least 106 Canadians died behind the lines, victims of Nazi fanaticism.

The next few days were a confused, costly struggle. The Canadian infantry and armour banged heads with the 12th ss; the fighting was extraordinarily fierce. The Germans had hoped to drive the Allies into the sea, but the Canadians, like the British and Americans, staggered under the force of the enemy assault but held on. Overconfidence drove the ss forward in a succession of badly coordinated engagements, and the Canadian artillery hammered them. The 3rd Division beat off the attacks. But Canadian advances similarly were too often hasty and ill-prepared. Infantry mounted on tanks ran into the prepared positions of the 12th ss at Rots and Le Mesnil-Patry on June 11, and, as Charlie Martin recalled, the Queen's Own riflemen riding the Shermans "were sitting ducks" and so were the tanks: "Firing from dug-in positions about 800 yards away" with their 88mm guns, "they had easy targets." The 1st Hussars lost 37 tanks and 60 men, the Queen's Own 87 killed and wounded. There were no gains made that day.

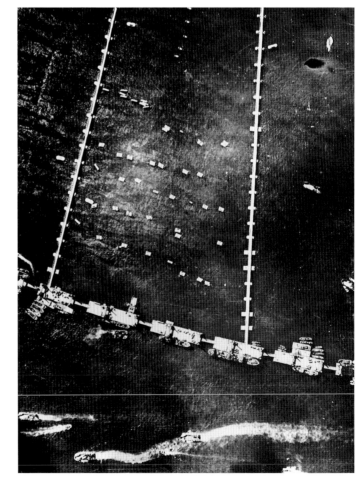

This was the last engagement for the 3rd Division until July, as British divisions took over the line. The Canadians had been in action for six gruelling days, and they had sustained the loss of 1,017 men killed and more than 1,800 wounded. Most of the killed and wounded were infantrymen, and the losses approached or exceeded those in any comparable period in the trench warfare of 1914–18. The advance inland had not proceeded the way the planners had hoped, but the beachhead—all the landing beaches now linked into a continuous front—was secure. Canadians had played their full part in this achievement.

BELOW: War artist T.C. Wood offered an artist's impression of D-Day
at Courseulles-sur-Mer. (CWM Wood 10544)
RIGHT: Although the Allied invasion liberated French villages and towns,
the fighting forced many out of their homes, as Paul Goranson showed
in this painting. (CWM Goranson 11439)

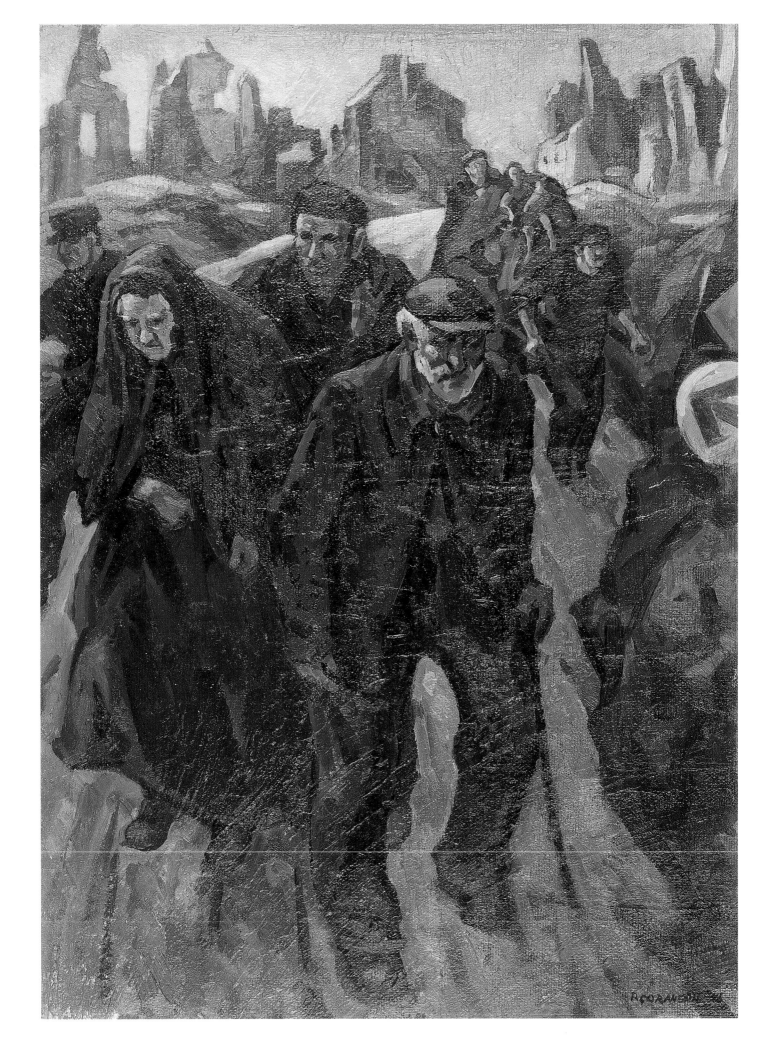

WHILE THE 3RD CANADIAN DIVISION recovered from its hard introduction to battle and absorbed reinforcements into its depleted ranks, the First Canadian Army and II Canadian Corps headquarters arrived in Normandy. They did not come into operation at once, however; the bridgehead was still too crowded. Also arriving was 2nd Canadian Division, which joined the 3rd Division in General Simonds's corps.

General Montgomery's plan was to force the enemy to stay on the British–Canadian front with most of their panzers. This, it was hoped, might make it easier for the U.S. forces trapped in the *bocage,* the hedges that cut up fields and offered ideal defensive country. Montgomery's plan, rather clearer in his memoirs than in July 1944, required a series of heavy assaults on Caen, the centre of the area's road network, to force the Germans to hold there.

As part of this process, the 8th Brigade of 3rd Division attacked Carpiquet airfield on July 4, an objective the division had come close to seizing in the immediate aftermath of D-Day. The airfield, defended by 150 men of the 12th SS, faced a four-battalion assault, the whole brigade plus the Royal Winnipeg Rifles and the tanks of the Fort Garry Horse. But it was not enough. Fighting from well-sited concrete bunkers, the young SS soldiers poured machine gun fire into the Canadians while German artillery, further back, hammered at the attackers. After they had inflicted heavy casualties, the 12th SS counterattacked and did more damage. The North Nova Scotia Highlanders lost 132 men, their worst losses of the war; the North Shore Regiment also lost 132, a company of Chaudières was overrun and many POWs were murdered, and in all the Canadian losses were 371. But somehow, parts of the airfield were in the 3rd Division's hands.

Captain Harold MacDonald of the North Shores wrote to his wife after Carpiquet that the enemy were "all bastards, rotten, sneaking, back-shooting, double-crossing devils. Only one good thing for them." Later, he wrote about his dress at the front. "Want to know what I wear in action? Well, my vermin-proof battle dress, dark pips [his rank badges], a

pair of binoculars round my neck, helmet, skeleton web with mess tins, water bottle, gas cape, compass and ammo. Always carry a Sten and extra mag[azine]s and a knife (big 'un). Then smokes and matches." Then, he went on, "You want a day at war with a Rifle Company ... Starts in the evening. Threatened tank attack, didn't materialize. Constant shelling and mortaring. Platoon well dug in and Jerry 300 to 400 yards away. Co[mpan]y HQ in an old barn; lost most of the building that night—only four casualties though."

Unusually, MacDonald, a company second-in-command, talked about soldiers getting "windy," or hyper-anxious. "Took over platoon and came under a barrage. Men were windy, nerves at breaking point. Checked all trenches while Jerry knocked out parts of wall. Was buried partially three times ... Dug out one man. Three men went windy and one nuts entirely. Got two pacified and two evacuated, using strenuous methods." MacDonald knew that he was not unbreakable. "Wondering how long nerves will last," he said to his wife, "trying to plan the next move. It's all in a day's work, but now it all seems like a dream, a nightmare."

Caen was next for the Canadians. The Royal Air Force and Royal Canadian Air Force's Bomber Command plastered the city, almost destroying the centre. The Germans unfortunately were sited on the outskirts, and the casualties regrettably were mainly civilians. Now the Canadians had to take the ruins, and this proved extraordinarily costly. The Highland Light Infantry lost 262 men, or two thirds of its attacking strength, at Buron (another hamlet the Canadians had reached and lost on D-Day), but they took the village. The North Novas took Authie (again), and the Regina Rifles liberated the Abbaye d'Ardenne, a 12th SS headquarters, after a stiff fight and a charge that, Major Gordon

Brown wrote, "overwhelmed the remaining dazed enemy troops." Brown wrote that one of his officers found a room in the Abbaye protected by a German shepherd. He had "killed the dog and found an enormous supply of wines, champagne and liquor," which Brown and his friend dipped into, along with a basket of cherries discovered in another room. Another of the Reginas noticed a hidden machine gun and then suddenly fired into the pit. There was, wrote Lieutenant J. Robert Cameron of the 3rd Canadian Anti-Tank Regiment, his guns ready to resist a counterattack, "a wail and cry from the hole. Two young German soldiers came tumbling out . . . yelling, 'Kamerad, Kamerad.' They were 12th ss Hitler Youth machine gunners" who had been unable to get away. One was wounded, Cameron said, and when stretcher-bearers carried him away, "the German kid raised himself to a sitting position, extended his right arm fully . . . and loudly declared

'Heil Hitler.'" The Canadians laughed and shouted "several jocular and unprintable comments," and the troop sergeant "summed it up for the group when he said, 'Cheeky bastard.'" The hard-fought advance continued, and on July 9, at last, Caen was Canadian.

The casualties, if they were lucky, made it to the army's superb medical system. John Hilsman, a surgeon, recalled that at his field surgical unit the struggle for Caen turned his team into "war-wise veterans . . . We saw the tragic sights from which we were never to be free for ten months. Men with heads shattered and grey, dirty brains oozing out . . . Youngsters with holes in their chests fighting for air . . . Soldiers with intestines draining feces into their belly walls and with their guts churned into a bloody mess by high explosive . . ." Hilsman added: "We became the possessors of bitter knowledge that no man has ever been able to describe. Only by going through it do you possess it." The fatality rate among the wounded who reached the field surgical unit was almost 20 per cent, but that meant that four in five wounded survived.

Now Montgomery's plan was to move south. A British attack on July 18 cut two armoured divisions to pieces. Supporting this effort, II Canadian Corps fought its first battle, Operation Atlantic,

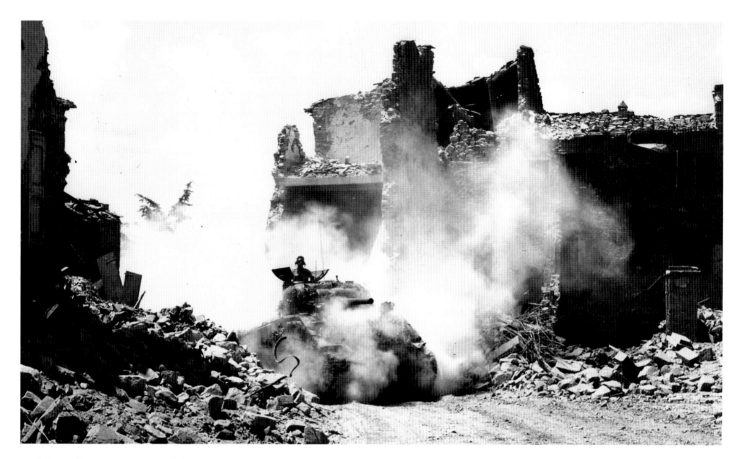

and the 3rd Division crossed the River Orne and entered the Caen suburbs of Colombelles, Cormelles and Faubourg de Vaucelles. The 2nd Division, commanded by Charles Foulkes, made a good start by seizing Ifs and Fleury-sur-Orne.

The dominant geographic feature on the road south from Caen was the low Verrières Ridge, controlled by the Germans, who thus had good visibility, ideal fields of fire and a reverse slope into which they could carve their bunkers. The enemy had fewer men than did the Allies, but their good ground and ample supply of tank-killing 88s gave them the advantage. So too did the Germans' powerful tanks, the skilled generalship of their field commanders and the fanaticism and skill of their soldiers. The Canadians were fated to bang their heads against the ridge for the next few weeks.

The first crack at Verrières Ridge came on July 20, when the 2nd Canadian Division and tanks of the British 7th Armoured scored a small success but nonetheless suffered a shattering overall defeat. The South Saskatchewan Regiment, aiming for Verrières village, ran smack into two battle groups of panzers, fought desperately, but was overwhelmed. The surviving South Sasks retreated through the lines of the Essex Scottish, sowing panic, and two companies broke and ran. Fortunately, two companies of the southwestern Ontario regiment held their ground and drove off the enemy. Verrières Ridge remained in German hands, and the Canadians had lost almost two thousand men.

LEFT: Major-General Rod Keller (*left*) led the 3rd Canadian Division on D-Day. His boss, Lieutenant-General Harry Crerar, commanded the First Canadian Army. (National Archives of Canada PA-132916)

ABOVE: Sherman tanks were not as good as the best German panzers, but the Allies had more Shermans than the Germans had panzers. (National Archives of Canada PA-115031)

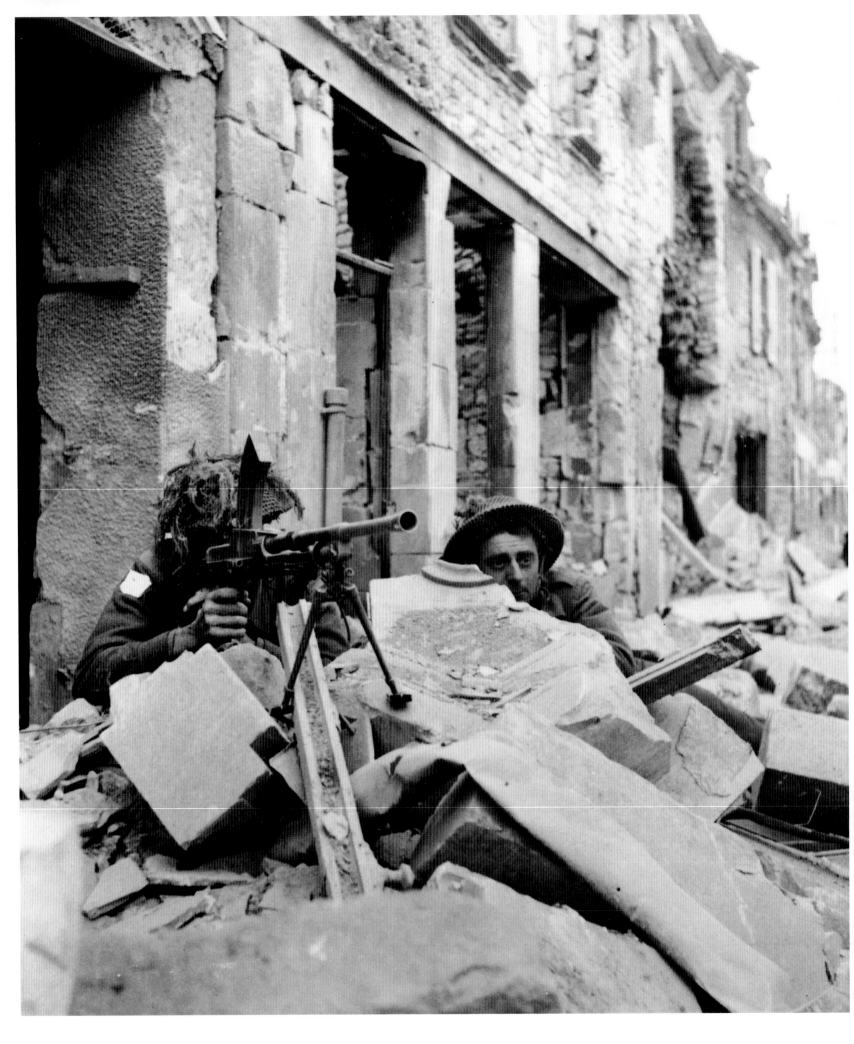

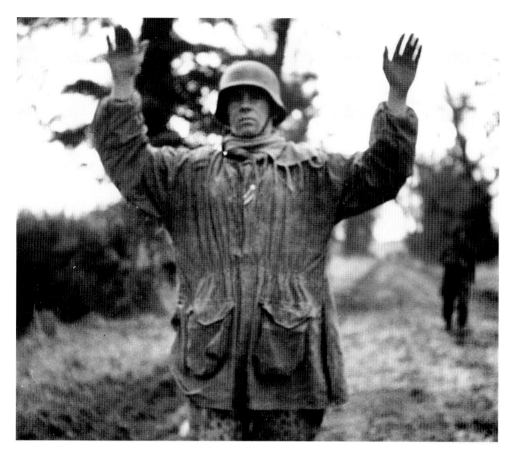

The fighting to take Caen and to move south of the city was fierce.

FAR LEFT: The Bren gunners, their shoulder flashes whited out by censors, looked for sentries in the ruins of Caen. (National Archives of Canada PA-131404)

NEAR LEFT: The SS troopers resisted the Canadians with skill and tenacity, but the weight of Allied firepower eventually wore them down. (M.M. Dean/DND/National Archives of Canada PA-132726)

BELOW: Canadian casualties were heavy, but the medical services were excellent, and the wounded sometimes could be flown back to England within hours. (National Archives of Canada PA-131427)

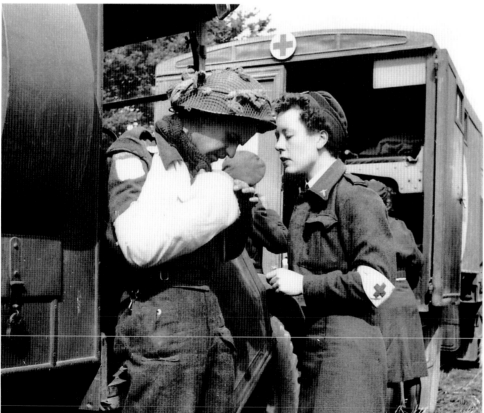

The American breakout to the west had yet to come, and the British and Canadians, desperately trying to hold the enemy on their front, launched yet another attack, Operation Spring, on July 25. General Simonds's plan called for the two Canadian divisions, supported by the 7th Armoured, to attack the ridge once more. The advance began at 3:30 AM, the men finding their way by "artificial moonlight" created by bouncing searchlights off the clouds. This innovation unfortunately backfired, the North Novas finding themselves silhouetted and hence cut to pieces at Tilly. The 3rd Division assault ground to a halt in confusion and terror. The 2nd Division, inexperienced in night attacks, fared no better. Only the Royal Hamilton Light Infantry, also known as "the Rileys," after the RHLI's initials, seized its objective of Verrières on time. But the Calgary Highlanders lost heavily, and Montreal's Black Watch, its commanding officer killed, launched a gallant but hopeless charge up the ridge into the teeth of a battalion of infantry and a battle group of armour. The regiment lost 324 men. The Germans now set out to smash the Hamilton battalion at Verrières, but the Rileys' commanding officer, Lieutenant-Colonel John Rockingham, a superb field commander, drove off the panzers that at one point rolled over his positions and held his ground. The battalion lost two hundred men in doing so.

Guy Simonds now created a new plan, Operation Totalize, to proceed on August 8, the anniversary of the great Canadian attack in 1918 that smashed the Germans. Simonds understood that the Germans, driving to the west in an effort to smash the Americans at last breaking out, had created a pocket that, if the trap could be closed, might deal them a shattering blow. The key to the trap was the road junction of Falaise, a few kilometres down the road. But how to get there? How to get over Verrières Ridge?

An innovative thinker (if a cold man), Simonds recognized that the Germans' anti-tank defences had killed his previous efforts. To overcome them this time, he would use a heavy bomber attack at night followed by a night assault. And to give the vulnerable

infantry some cover from small-arms fire, his fertile mind dreamed up the armoured personnel carrier. Canadian artillery had landed in Normandy with self-propelled 105mm guns, dubbed Priests. The corps commander proposed to take out the gun, cover the top with armour and use the "defrocked Priests" or Kangaroos, as they came to be called, to carry infantrymen into action. (Later, Canadian-made Ram tanks were converted into Kangaroos, each capable of carrying eleven men and a crew of two.) Moreover, Simonds proposed to group the attacking forces in regiment-sized columns, each with a battalion of infantry in Kangaroos. Armour was to lead the way, and the force would keep direction by following radio beams, watching tracers on the flanks or relying on artificial moonlight.

This was a brilliant, complex scheme—perhaps too complex. The 4th Canadian Armoured Division, now added to II Canadian Corps, was new to battle. So too was the Polish Armoured Division, and when the bombers dropped their payloads on the Germans, leaving stunned, shattered defenders, the armoured columns set off into the dark and dust. The first phase proceeded well, but another bombing attack, this time by the U.S. Army Air Force, fell partly short, smashing Canadians and Poles. General Rod Keller of the 3rd Division was wounded, and two companies of the North Shores and the 4th Medium Regiment of artillery were smashed. That hurt the launch of the second phase of Totalize, and now the Germans fought back. Small units of the 12th SS, all that remained of that division two months after D-Day, used their 88s to slow the attack. The tanks of the 1st SS were formidable, and German infantry, their ranks much reduced, still fought hard. The Shermans of the British Columbia Regiment and the Algonquin Regiment's infantry got lost on the night of August 8 and were slaughtered by enemy tanks the next morning. Simonds called off Totalize, well short of his objectives.

General Montgomery urged Simonds, the sole Canadian commander for whom he had high regard, to press on. Simonds's response was Operation Tractable, a second great attempt to close the Falaise Gap. The plan this time was for a daylight attack by two huge squares of armour, one based on the 4th Armoured, the other on the 2nd Armoured Brigade and the 3rd Division. They would go directly at the enemy defences, their flanks covered by bombing and huge smokescreens. The attack jumped off on August 14, immediately running into trouble when RAF and RCAF bombs again fell short, killing at least

sixty-five. The enemy killed more, pumping fire into the armoured boxes. Rivers marked on the maps as streams turned into major obstacles and slowed the attack, but the Germans, simply overwhelmed by the size of the attacking force, gave ground.

Simonds's new orders directed the 4th and Polish Armoured Divisions to cut off the Germans who were trying to escape through the Falaise Gap. This they tried to do, facing the enemy, who were moving eastward, and under attack from Germans trying to keep the gap open by attack from the west. Meanwhile, Allied air forces were shooting up the enemy columns, killing the horses that were drawing guns and carts, destroying tanks and half-tracks. With complete air superiority, the fighter-bombers could roam at will. The Typhoons, which were especially feared by the Germans for their devastating effect, had a field day of destruction, and pilots soon reported that they could smell death from their cockpits. In addition, the "Tiffies" answered calls for support from units under attack. "If I ever run into Typhoon pilots," Captain Harold MacDonald of the North Shore Regiment wrote, "I shall go down on my knees before them. They've given us an awful lot of support and saved us from some bad attacks."

But for the Canadians on the ground, facing the desperate German efforts to break out, the war was utter hell. The Poles, on a mace-shaped ridge they dubbed *Maczuga*, had 80 tanks and 1,600 men, but without supplies and low on ammunition, they took 6,000 prisoners, killed 50 tanks and 700 other vehicles and suffered 1,400 casualties. A squadron of the South Alberta Regiment and a company of the Argyll and Sutherland Highlanders, both from the 4th Armoured, held the village of St. Lambert-sur-Dives on the only route with a bridge across the River Dives able to carry tanks. The enemy threw everything it had at them; Major David Currie of the South Albertas and Major Ivan Martin of the Argylls rallied their troops and cleared the town. Currie killed a Tiger tank and took six POWs himself, and Martin took out enemy snipers until a shellburst killed him. But Currie held, his tiny band capturing 3,000 prisoners, destroying 7 tanks, a dozen 88s and 40 trucks. Currie was awarded the Victoria Cross.

Arthur Bridge, a rifleman in the Argylls, recalled entering St. Lambert and seeing a host of German prisoners. "The South Albertas had several tanks well sited to cover the prisoners, who seemed to be quite content to be out of the fight. One of them," he added, "had a concertina and as we passed he was playing the hauntingly beautiful 'La Paloma.' To this day," Bridge went on, "whenever I hear that tune the memory of that evening comes flooding back."

The Falaise Gap was never completely plugged, and many Germans escaped to continue the war. But the toll had been staggering, at least half the 100,000 men in the pocket either dead or prisoners. The 12th SS no longer existed as an effective formation, its ranks now down to a hundred prematurely aged teenagers; other Wehrmacht divisions were no better off. For their part, the Canadians lost some 5,600 killed, wounded or captured between August 8 and 21, a casualty rate per thousand men engaged that was higher than that of the slaughterhouse of Passchendaele a quarter-century before.

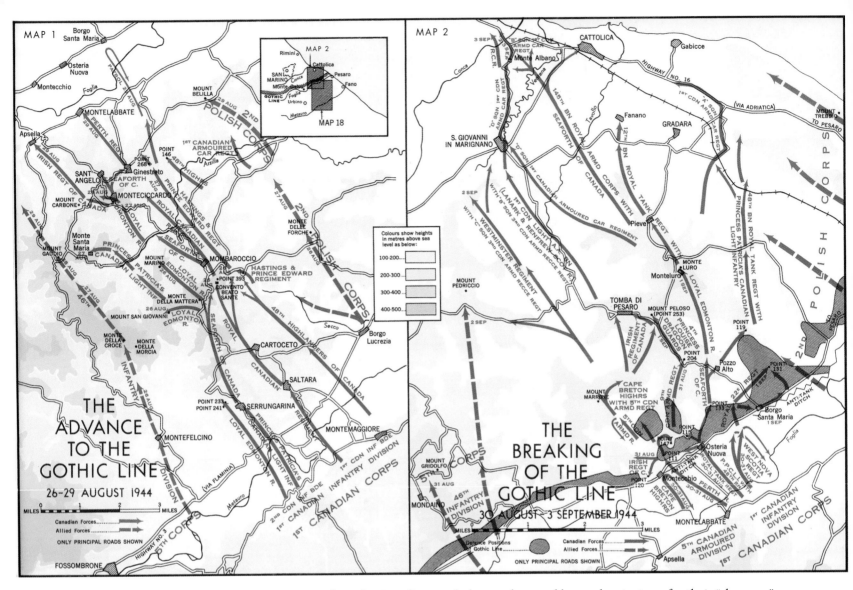

MAP 1

THE
ADVANCE
TO THE
GOTHIC LINE
26–29 AUGUST 1944

MAP 2

THE
BREAKING
OF THE
GOTHIC LINE
30 AUGUST – 3 SEPTEMBER 1944

(Courtesy Directorate of History and Heritage, National Defence Headquarters, Ottawa)

And yet the Canadians took the rap then, and have taken it since, for their "slowness" in closing the gap. If only they had moved faster, the argument goes, more Germans could have been trapped and the war shortened. Most of the critics underestimate the strength of the Verrières Ridge defences and neglect to factor in the greenness of the Canadian Corps' two armoured divisions and the battered condition of its infantry. Simonds's elaborate plans might have been beyond the skills of his men, as well. Even so, there is some truth to the complaints. The Canadians were less aggressive, less hard-charging than they might have been and too tied to their artillery support. Those who have not fought, those who have not walked the ground, however, can never understand the difficulties and the terror of battle.

WHILE THE CANADIANS in Normandy fought to close the Falaise Gap, I Canadian Corps in Italy was readying itself to score the greatest Canadian army victory of the war. After their part in breaking through the Adolf Hitler Line, the Canadians got the time to recover

and absorb replacements. The Germans, meanwhile, abandoned Rome and Florence, fighting a long retreat northward to new defensive lines in the Apennines. The Gothic Line, their main defensive barrier, protected northern Italy with 100,000 land mines, at least 2,300 machine guns, 479 anti-tank guns and 3,500 shell-proof dugouts. The Canadians, back on the Adriatic coast, had the task of cracking the Gothic Line to open the road to Rimini and the Po valley. "It'll be a piece of cake," Sergeant Fred Cederberg reported one senior officer as saying. "We won't even use the artillery until the river crossing has been pulled off—silently and at night."

The main attack was to go in on the night of September 1–2, 1944, but after fifteen months in action, the Canadian Corps was a smoothly functioning machine. When Major-General Bert Hoffmeister, forward on a reconnaissance, observed that the German lines were almost empty, he passed the word to General E.L.M. Burns, the corps commander. Quick as a flash, the generals altered the attack timings and the first Canadian infantry units moved off on August 26 on a two-division front. The enemy soon reacted, but Hoffmeister saw an opportunity, made a "gutsy" decision and sent his tanks through the gap his riflemen had opened up.

The battle was bloody, as far from being a piece of cake as it could be. The West Nova Scotia Regiment suffered terrible losses when it was caught in a minefield covered by German machine guns. The British Columbia Dragoons on August 31 took Point 204, a critical hill behind the main German line, but there the armoured regiment was hammered by German fire and reduced to eighteen tanks. The commanding officer, Fred Vokes, the brother of the 1st Canadian Division's commander, was among the forty-nine men killed and wounded. The Perth Regiment played a major role in the battle, and Lieutenant Fred Egener was exultant in a letter he wrote to his wife more than two weeks later. But Egener remarked that a shell had fallen on his platoon, "catching nearly eleven in a standing position... The effect of the morning's trials on the men was all too apparent. They were nervous, hesitant, reluctant to go on." But the company commander took hold, "the platoons moved in closer and individuals found better spots of ground" to shelter in. Fifteen minutes later, the Perths moved forward once more.

The Germans had been out-thought and out-fought on the Gothic Line, one of their divisions was in danger of being encircled, and they began yet another withdrawal on

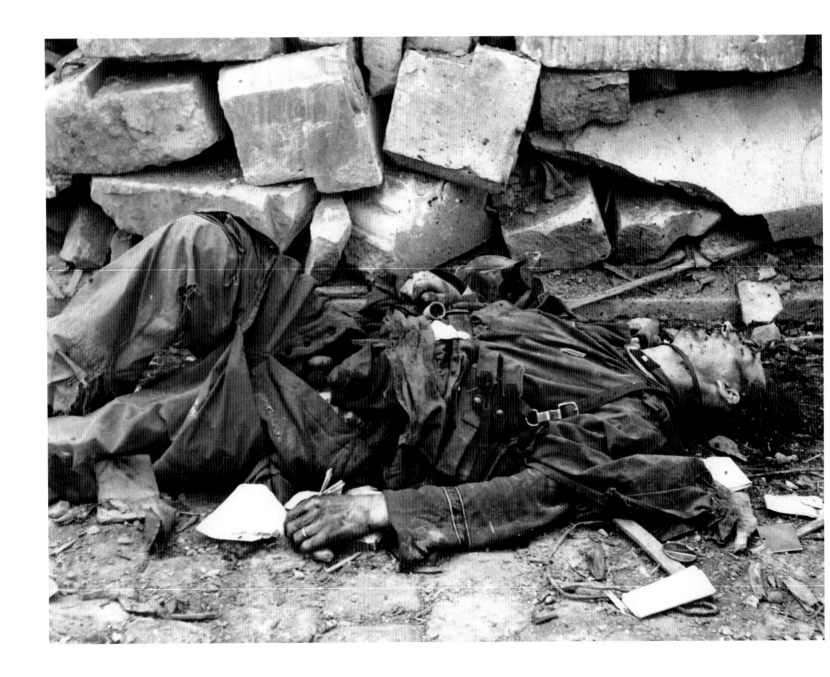

THE LAST GOOD WAR

September 1. The Eighth Army commander, General Sir Oliver Leese, gave the 5th Canadian Armoured Division its due, telling Montgomery that "This Div, led by Bert Hoffmeister, has the terrific dash of 7th Arm[oure]d [the Desert Rats] in the old days. They really have done very well."

The war in Italy was far from over. The terrain, with rivers and hills always seeming to offer good defensive positions, let the enemy reform its positions, and the rainy weather also hampered the Allies. It took the Canadians three weeks to liberate the city of Rimini, fifty kilometres north of the Gothic Line, but the cost of the Gothic Line operations and their aftermath was terrible. The 1st Division had more than 2,500 battle casualties and an additional thousand men evacuated for illness or battle exhaustion; the 5th Armoured, Hoffmeister's Mighty Maroon Machine, lost almost 1,400.

Despite the victory, General Burns was sacked. His British superiors and his own senior commanders had lost confidence in him, greatly resenting his dour attitude. The soldiers called Burns "Smiler"—because he never did; the generals liked him no better, and he had to go. His replacement, Lieutenant-General Charles Foulkes, who had commanded the 2nd Canadian Division in Normandy, was not much more popular, but he did well commanding the corps.

Into October, the Canadian troops continued to press forward. In one attack across the River Savio on October 21, the Seaforth Highlanders anti-tank platoon, using PIATs (Projector Infantry Anti-Tank), faced an enemy counterattack with three Panther tanks, two self-propelled guns and thirty infantry. Private Ernest Smith took out one Panther with his PIAT, and then killed four of the ten infantry riding on it. The rest scattered, and Smith, getting a fresh supply of ammunition for his tommy gun from a wounded Seaforth, fought off more panzer grenadiers. The rest of his platoon killed another tank, two self-propelled guns, a half-track and a scout car. Smith and his comrades had defeated a small army, and the thirty-year-old private won the Victoria Cross. He is Canada's only surviving V.C. winner.

LEFT AND ABOVE: The war's cost in life was terrible. A Wehrmacht soldier in Falaise (*left*) and a Canadian infantryman at Tilly (*above*) paid the price of war. (National Archives of Canada, *left*: PA-132819, *above*: PA-132906)

The struggle to close the Falaise Gap put small units of the 4th Canadian Armoured Division against Germans desperately seeking a way out of the cauldron.
BELOW: The wreckage of the enemy armies was everywhere. Will Ogilvie's painting suggests the carnage of men, horses and machines. (CWM Ogilvie 13328)
RIGHT ABOVE: The infantry and armour worked closely together, and tens of thousands of Germans became POWs. (CWM 19900198-076)
RIGHT BELOW: At last the Canadians moved into Falaise. (National Archives of Canada PA-129135)

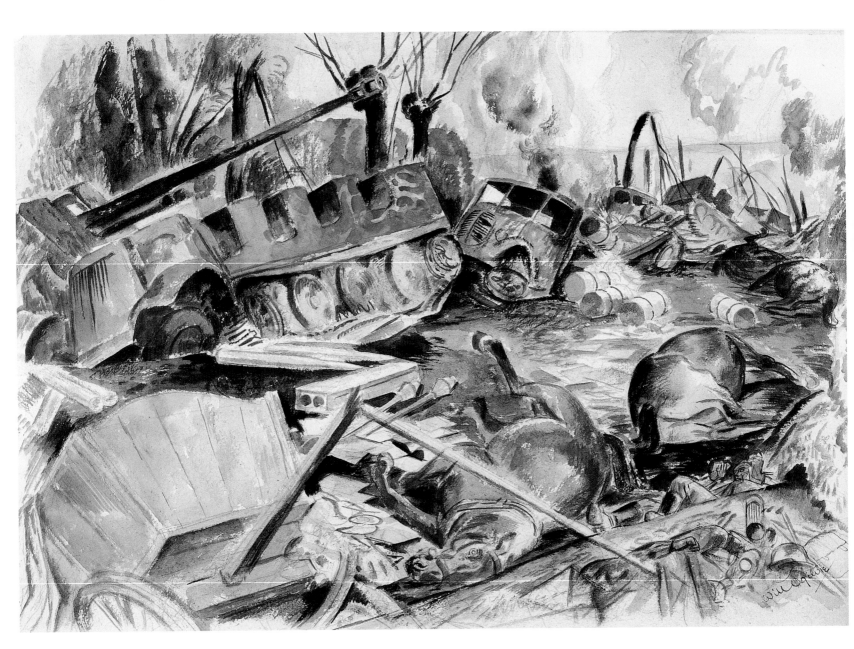

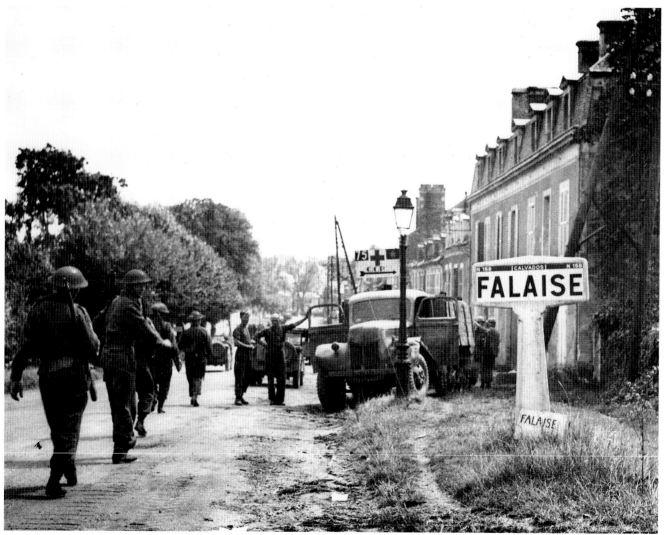

While the fighting in France dominated reportage, I Canadian Corps won Canada's greatest victory of the war, smashing through the Gothic Line in northern Italy.

BELOW: Armour crossing a bridge near Rimini. (National Archives of Canada PA-173514)

RIGHT: Campbell Tinning's painting suggests the ideal defensive terrain held by the Germans. (CWM Tinning 13903)

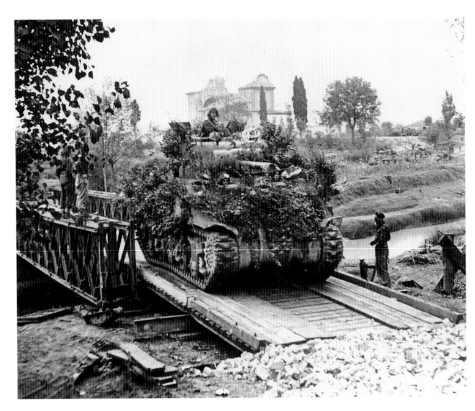

Not everything went right. On December 4, the 1st Division's 1st Brigade tried to cross the Lamone River in assault boats and over temporary bridges. The Germans were ready, and they hit the Royal Canadian Regiment (RCR) very hard. Mortars wiped out one platoon, and a counterattack by tanks destroyed two RCR companies. There was much bitterness in the RCR and in the neighbouring Hastings and Prince Edward Regiment, which were also hard hit.

The problem of casualties was compounded by a shortfall in reinforcements. Army headquarters in London and Ottawa had made their reinforcement calculations using a complicated formula that factored in German airpower and expected enemy resistance. But the enemy aircraft had been driven from the skies in Italy and in Northwest Europe, and the casualties overwhelmingly fell on the infantry as the Germans always fought harder—and longer—than anticipated. The training system in Canada, geared to produce "x" truck drivers, "y" supply clerks and "z" riflemen, suddenly discovered that it required a third as many reinforcements for support roles and twice as many infantry. The system could not adjust quickly, and the army thus found itself forced to send wounded men back into the line after the minimum recovery period. Another method was the "conversion" of drivers and cooks to infantry, an unsatisfactory method at best. Compounding the difficulty, sixty thousand home defence conscripts, mostly infantrymen, remained in Canada refusing to volunteer for overseas service. The army's projections of casualties into 1945 foresaw a large need for infantry that could only be met with the use of the "Zombies," as conscripts were derisively known in Canada (after the soulless living dead of horror films).

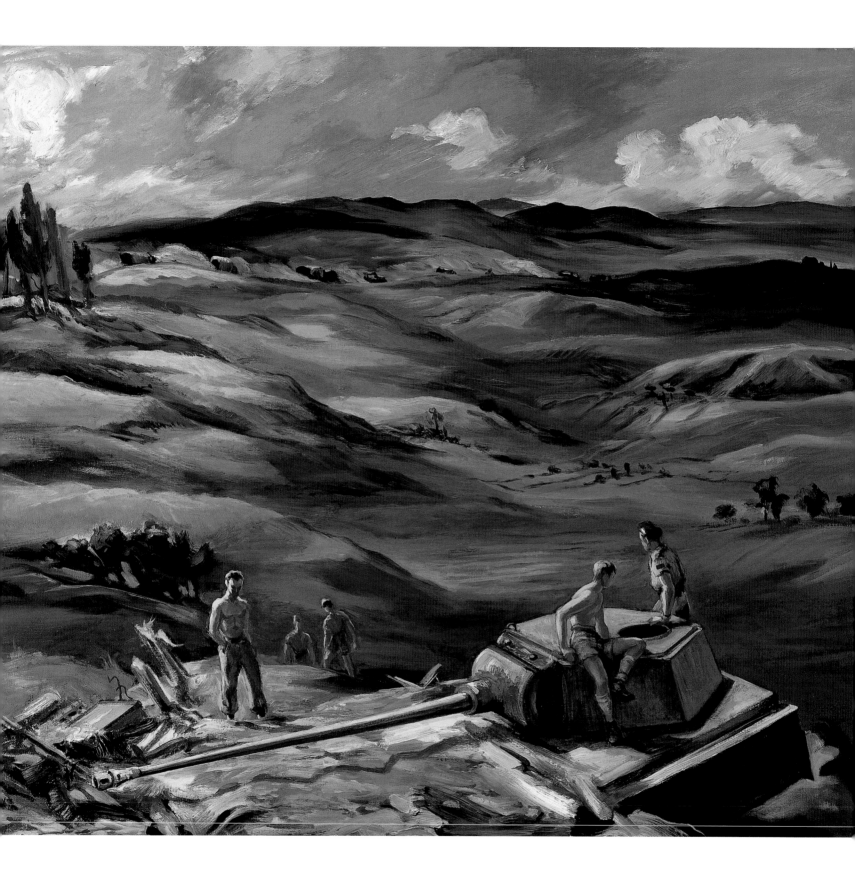

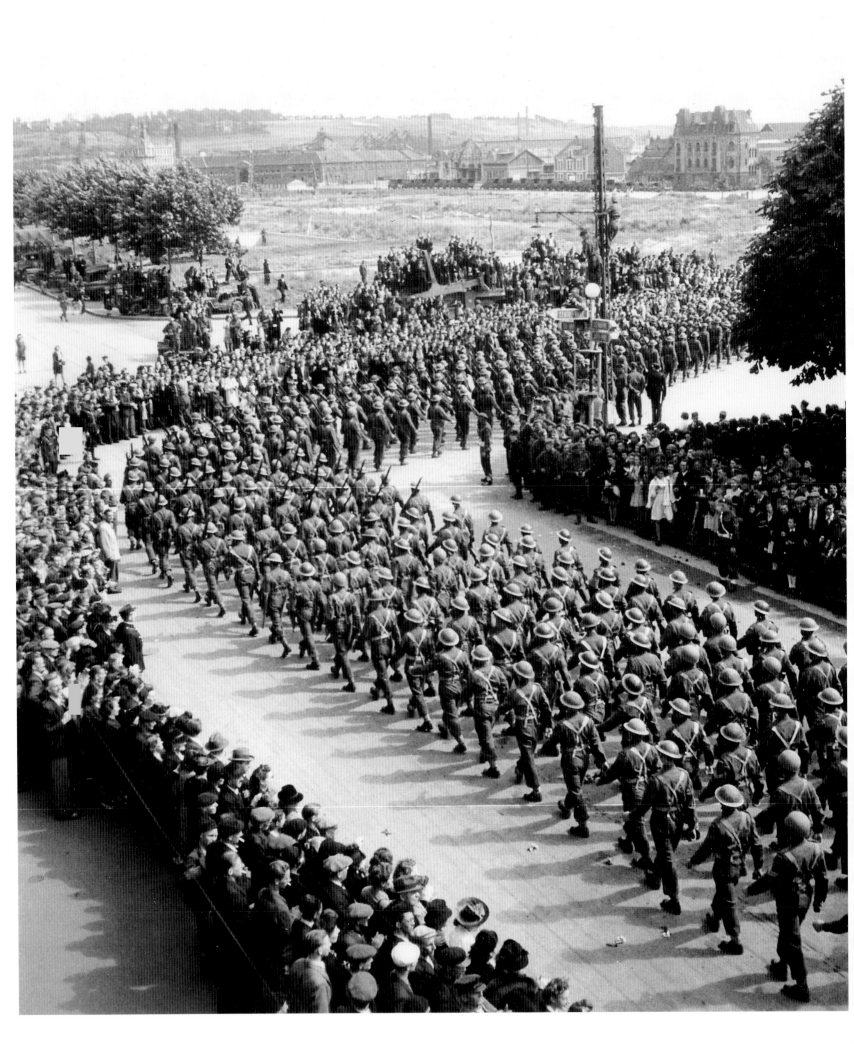

The conscription crisis of 1944 erupted in October and November. The defence minister, J. Layton Ralston, had returned from a visit to the Italian and Northwest European fronts ready to demand that the home defence conscripts be sent overseas. The prime minister in 1942 had said, "Conscription if necessary," and now, Ralston argued, was the time. But Mackenzie King said that he had meant "necessary to win the war," promptly firing Ralston and replacing him with General Andrew McNaughton, the former commander of the First Canadian Army. The general tried to persuade the conscripts to volunteer, using every inducement possible. One soldier wrote that sergeants were promised five days leave for each Zombie they persuaded to volunteer for overseas service. Another, Major Harry Robinson, serving in Prince Rupert, B.C., argued that the home defence conscripts were not "no-good cowards. Eighty percent of them will go, & go willingly, when the Gov't tells them to … " The real issue, he said, "is that the Gov't is the no-good collection of cowards in asking men to lay their lives on the line when it is not even prepared to lay its political future there."

In such circumstances, McNaughton's efforts failed, the army chiefs told him they could not find sufficient volunteers to meet the need, and a desperate Mackenzie King, convincing himself that he faced a generals' revolt, had to accept the dispatch of sixteen thousand conscripts overseas. Public opinion in Quebec was restive but appeared to agree that King had held off the inevitable to the last moment. English Canadians were furious with the government, but relieved that reinforcements could now reach the front. Curiously, the projections of a shortage of infantry vanished like mist under a hot sun, and very few Zombies made it to the front lines. By all reports, those who did, fought well. A South Saskatchewan Regiment officer noted later that "to our surprise" the conscripts were "well trained and good soldiers."

THE ARMY'S SALVATION in part came about in Italy. The new defence minister wanted all the Canadian divisions to fight together, and he arranged for I Canadian Corps to be pulled out of the line in January 1945 and moved through France to join up with the First Canadian Army at the front in the Netherlands. The weeks of respite from battle let the reinforcement system catch up, and the reinforcement crisis disappeared.

The Canadians who had fought in Italy, like their comrades in Northwest Europe, were disgusted by the political manoeuvring at home. They had suffered more than 25,000 casualties, and they had little time for politicians who left them understrength. But any settling of political scores had to await the war's end.

AFTER THE GERMANS' DEFEAT in Normandy, the end of the war seemed close at hand. The Germans retreated from France, and Paris was liberated by General Charles de Gaulle's troops in an extravaganza of emotion. General Montgomery pressed his columns forward quickly, and British troops liberated Antwerp, Belgium, on September 4. Two

THE LAST GOOD WAR

LEFT: Orville Fisher's painting *Scheldt Crossing* shows soldiers of the 7th Brigade, 3rd Canadian Division. (CWM Fisher 12601)
BELOW: The advance sped up as the Germans pulled back. George Pepper painted German fortifications near Ostend, Belgium, which were captured by the Essex Scottish on September 12, 1944. (CWM Pepper 13651)

weeks later, a further great leap forward, Operation Market Garden, intended to seize bridgeheads in the Netherlands, at Arnhem and Nijmegen on the Rivers Maas and Waal, was smashed. The Germans had great recuperative powers.

The First Canadian Army knew this all too well. Assigned the task of moving eastwards along the English Channel coast (and destroying the huge launching ramps from which the Nazis were sending V-1 "buzz bombs" aimed at London), the army's spearheads units of the 2nd Division had been mauled by German rearguards in the Forêt de la Londe on the River Seine at the end of August. Canadian casualties numbered 577 in the three-day struggle, and the enemy withdrew at a time of its choosing and after large numbers of retreating troops had crossed the Seine. Slightly shaken by this experience, the 2nd Division nonetheless had the distinct pleasure of liberating Dieppe on September 1, a bittersweet day for the division that had suffered so severely two years earlier. *"Nous sommes heureux d'être delivrés par des Canadiens,"* one Dieppois told a reporter from the town newspaper.

Now the remaining channel ports—Le Havre, Boulogne, Calais and Dunkirk—had to be seized, all vital objectives if the Allied armies were to be supplied. The Germans fought hard, destroying port facilities when they finally gave up. The Royal Hamilton Light Infantry of the 2nd Division liberated Bruges, Belgium, on September 12 to scenes of jubilation: "The people on seeing the vehicles became delirious," the regimental war diary recorded, "and literally thousands of people swarmed about and prevented the vehicles from moving for close to an hour." Liberation had its joys.

But armies needed supplies, and the channel ports, undamaged or not, could not easily sustain the Allied host. Although Montgomery had seized Antwerp, he had somehow neglected to clear the shaken Germans out of the Scheldt estuary. The great docks at Antwerp thus sat empty, access blocked until the enemy, quickly recovering its strength and spirit, could be driven out. The task went to the First Canadian Army.

This was no simple chore. The weather in October 1944 was cold and wet, the ground muddy. Centuries of reclamation efforts had created polders, land below sea level that was protected by high dikes. Too often the only way forward was atop the dikes, and the Germans invariably had their machine guns and mortars carefully registered. In charge of the army was Lieutenant-General Guy Simonds, replacing Harry Crerar, who was ill. Simonds was equal to the task.

The Canadian plan called for three divisions to clear the south bank of the Scheldt, an area dubbed the Breskens Pocket. Then the 2nd Division would free South Beveland, and finally, Walcheren Island, controlling access to the Scheldt estuary, would be attacked over the causeway joining it to South Beveland and from the sea.

The German 64th Division, a good fighting formation hunkered down behind the broad Leopold Canal, defended the Breskens Pocket. Leading the charge behind the fire of massed flamethrowers was the 3rd Division, which seized a bridgehead on October 6. For the next eight days, the soldiers fought hand-to-hand in the mud, and helped by air

support that prevented daytime movement and forced enemy guns to limit their firing, the Canadians finally forced the enemy to retreat. "All the actions in the polders, at the dikes and in the farm buildings or towns were an infantryman's fight," Charlie Martin of the Queen's Own Rifles wrote. "A section of men below the dike would slog along waist deep in water, watching their lead man near the top of the dike. He is the bait, the point man, as they sought to find the enemy. Sometimes he made it safely, sometimes he took a wound, often a bad one, and sometimes he was killed."

Never was he comfortable. The soldier lived in his dirty clothes, always wet and muddy or hot and sweaty (and sometimes, if he was digging in hard ground, both at once). He frequently had lice or scabies, and he ordinarily ate on the run or, if he was lucky, out of greasy mess-tins, sharing food with his mates and usually cooking his rations with them. A hot drink was comfort, but in action, it was not to be found. The soldier drank heavily chlorinated water out of a water-bottle and wine or spirits of any kind out of the bottle, and the odd, delicate soul who could simply not bear to drink from a bottle passed from hand to hand somehow managed to carry a glass in his knapsack, to the jeers of his friends. The army tried to get mobile bath and laundry units forward far enough to let the men have an occasional shower and a change of clothes, but these comforts were dependent on the military situation. Above all, there was no privacy. The trooper in a tank lived with his crew, the infantryman with his section. Too often, they died with them too.

The slogging match continued, and Canadian casualties were severe. On October 24, Captain Harold MacDonald of the North Shores wrote home to say that "my Gawd we see terrific sights

and yet we're so hardened to them— Horses tangled in wire & starving, animals badly wounded & necessitating shooting. Dead Huns in the ditches, groups of once well-kept farms now a mass of burnt-out rubble. Yes, what we're fighting for is always clear in our minds."

Were the war's aims clear for all the Canadians? Perhaps for some, but most soldiers likely cared less about the rightness of the cause than they did for other things. As one American writing about a later war put it, "They care about being too hot or cold, afraid and tired. They know the bullets will penetrate their skin and that they might mess their pants when the guy next to them gets his head blown off." Above all, they cared for their friends, the men they had trained and fought with, men to whom they had become closer than brothers. They would do anything not to let them down. Many died for their comrades.

Not until early November was the last resistance in the Breskens Pocket overcome. The Germans fought hard, most surely knowing the war was lost. With their backs to the wall—and, in the pocket, to the water—they resisted to the end. But even the Germans cracked. One POW told his interrogator from the Stormont Dundas and Glengarry Regiment that air attacks by Typhoons destroyed his company's field kitchen. This hurt morale because, the interrogation report noted, "as a result they got cold food as a steady diet."

While the pocket was being cleared, the 2nd Division was wading into Beveland. The soldiers faced a hard choice—wade through waist-deep water or move along the dikes exposed to fire. The gains from October 6 to 16 were limited, the losses high. On October 16, the Royal Hamilton Light Infantry attacked successfully but soon struggled to drive off a

heavy counterattack. Major Joe Pigott, one of the Rileys' company commanders, called down artillery on his own position. More than four thousand shells fell on the exposed enemy in a matter of moments, and Pigott's men, sheltered in their trenches, cheered as the Germans were decimated. The Hamilton regiment nonetheless had only 163 men left standing after twelve hours of battle. The battle for Beveland was not yet concluded, and it was only on October 24 that the Canadians cut the isthmus. A few days later, resistance ended.

Now, it was Walcheren's turn. Simonds had decided that the key to freeing the island was to bomb the dikes, sink the island, isolate the Germans on the few patches of high ground and attack them from the sea behind a massive bombardment. Overcoming opposition from the Dutch government-in-exile, which hated the thought

of returning land to the sea, and from Bomber Command, Simonds prevailed. British commandos and soldiers, serving under the First Canadian Army, cleared Walcheren by November 8.

Regrettably, to maintain pressure on the Germans and to divert attention from the commando landings, the Canadian attacks over the Beveland–Walcheren causeway had to go forward. The causeway was 1,200 metres long and forty metres wide, a death trap well protected by enemy artillery and machine guns. The first Canadian attack came on October 31, the Black Watch losing heavily. Another attack that night by the Calgary Highlanders failed at first but, behind a massive artillery barrage and air bombardment, it succeeded the next morning, until a German counterattack with flamethrowers forced the Highlanders back. Further assaults by the Régiment de Maisonneuve followed on November 2—another gallant, costly failure. The struggle continued until November 8, when the seaborne attacks on Walcheren made the causeway redundant and the enemy capitulated.

The Scheldt battles had been horrid, a gruelling test of wills in utterly impossible conditions. The First Canadian Army had prevailed, losing almost thirteen thousand men, half of them Canadian and the rest British. But the Scheldt was open, and supply vessels soon reached Antwerp.

The outcome of the war against Hitler could no longer be in doubt.

7 | LIBERATION

"I HAVE JUST SEEN BELSEN and am ashamed," wrote Squadron Leader Ted Alpin to his wife in Toronto. "Over the whole place is the still of death, and the sweet sickly scent of human flesh. When the Army arrived here there were 10,000 unburied bodies on the ground and 13,000 more have died since then." The dead had been interred "in huge rectangular graves, giving the date and numbers," Alpin continued. "They read: May 12, 5000—5000—1000—800 and so on. No one will ever know the true numbers that this fiendish place has really accounted for." Belsen was not a death camp like Auschwitz or Treblinka, where millions died, but it was horrible enough that all who saw it truly understood the evil of Nazism.

AFTER THE DREADFUL STRUGGLE in the Scheldt estuary, the First Canadian Army needed a respite, and it received one. For three months, the soldiers and their units had a chance to recover their strength and integrate reinforcements. Holding a winter line along the Rivers Waal and Maas in the friendly Netherlands, there were few actions of a major kind. The Germans' Ardennes offensive, the Battle of the Bulge, fell on the U.S. Army in December, though the 1st Canadian Parachute Battalion, serving in Britain's 6th Airborne Division, played a role. Had Hitler's last throw of the dice succeeded, however—had his armies reached Brussels—the First Canadian Army might have ended up in the bag. But the Nazis failed, thanks to stout U.S. resistance, and an added "benefit" was a delay in the next Canadian offensive until February.

This offensive, code-named Veritable, threw the Canadians at the Rhineland, and General Harry Crerar's First Canadian Army was huge. Thirteen divisions in all—British,

THE LAST GOOD WAR

American, Polish and Canadian, and contingents of Belgians and Dutch—had the objective of clearing the ground between the Maas and Rhine Rivers. The Germans had to defend their own homeland now, and they honeycombed the Rhineland with the Siegfried Line's strong concrete fortifications set into two huge forests, the Reichswald and the Hochwald. As seemed to be the norm for the Canadians, the weather was cold, the ground flooded and muddy.

Veritable began on February 8, 1945, the first tanks following closely on a massive heavy bombing attack and artillery and rocket fire. Gunner J.P. Brady of the 4th Medium Regiment wrote in his diary, "Our unit kept up a steady and sustained barrage for 13½ hours." The outpost line, manned by weak troops impressed into service, fell at once, but the good Wehrmacht divisions fighting in the Siegfried Line bunkers resisted fiercely. Some Canadian units had to use rowboats to get their men near the enemy; others breasted the cold water, frequently under fire, and supplying the troops was a nightmare. The Royal Canadian Army Service Corps, carrying ammunition, food and water forward, had to use DUKWs—amphibious tracked vehicles—when trucks could find no passage. Troop-carrying amphibious vehicles known as Buffaloes were used to reach units cut off by high water. Astonishingly, after two days of horror, the 3rd Canadian Division and British units had cracked the Siegfried Line; three days later, they had swept the Reichswald clean. The 3rd Division's commander, Major-General Dan Spry, had been a lieutenant in 1939, and he was all of thirty-two years old.

The army's next objective was the Hochwald, a task assigned to units of the 2nd and 3rd Divisions. First, however, the 3rd Division tackled the enemy paratroopers holding Moyland Wood. The Germans, Spry told his unit commanders, "are experts at forest fighting. The troops will find it tough going; it will be up to the junior officers and NCOs to keep them moving." They tried, but the ground was so wet, so heavily mined or covered by fire, that there were limits to what men could do. The Canadian Scottish were pounded by enemy mortars and then pushed forward in a disastrous attack that saw one company slaughtered in less than an hour. Only 5 men remained standing; 16 had been killed and 48 surrendered to the Germans. The regiment lost 11 stretcher-bearers in the fighting. Another of Spry's battalions, the Royal Winnipeg Rifles, used flamethrowers called Wasps to force the Germans back, but then had to fight ferociously to repel repeated attacks by the

LEFT: The winter of 1944–45 found the First Canadian Army in the Netherlands, hunkered down and waiting for the war's end. In the interim, soldiers went on patrol, like these Queen's Own Rifles near Nijmegen. It might have been a Canadian winter. (Barney J. Gloster/National Archives of Canada PA-192022)

BELOW AND RIGHT: War artist Alex Colville found his style
in Northwest Europe. These two paintings from the Nijmegen
front show an armoured car and a light anti-aircraft gun.
(CWM Colville, *below*: 12113, *right*: 12131)

6th Parachute Division. The Winnipeg unit lost 105 men on February 21. Moyland Wood, however, was finally freed.

The 2nd Division then struck down the Goch–Calcar road. The Royal Hamilton Light Infantry and the Essex Scottish, riding in Kangaroos and supported by the Fort Garry Horse's Sherman tanks, ran into 88mm guns and a sudden armoured counterattack. Casualties mounted, and the two regiments, soon bolstered with the Royal Regiment of Canada, barely hung on. "It took my men just two hours to get on their objectives," Lieutenant-Colonel Denis Whitaker of the Rileys said, "but it took another seven days to fend off the determined enemy counterattacks." Whitaker added, "We called down target after target of artillery fire, trying to knock out the tanks and enemy paratroopers; we sent our men to attack the counter-attackers until I had no more men to send. One by one my top officers were wounded or killed." The enemy suffered heavy losses too, and the Canadians finally cleared the route. By now, some units were at the breaking point from the combined shock of combat and the cold.

The Hochwald itself was the next objective. An attack by German paratroopers on the 2nd Division's start line just before "H-Hour" caused major difficulties but was repulsed, and the Canadians moved forward at 3:45 AM on February 26. Using artificial moonlight to see and following tracers for direction, the carrier-mounted troops moved as quickly as they could. But villages had to be cleared, and the Queen's Own Rifles at Mooshof ran into a strongpoint at a farm. Sergeant Aubrey Cosens, most of his platoon killed or wounded, led the survivors forward, found a 1st Hussars tank and, staying fully exposed, guided it towards the enemy. With the Sherman acting as a battering ram, Cosens cleared the farmhouse and two more buildings. Cosens himself killed at least twenty Germans and took even more prisoner. Then he told his four surviving riflemen, "OK, take up defensive positions. I'm going to find the company commander and report to him." One of his soldiers said, "I guess he got about 8 or 10 feet from me and plink! Down he went—that was it." Sergeant Cosens, twenty-three years old, won a posthumous Victoria Cross and was one of the 101 Queen's Own to be killed or wounded that day.

The enemy's tactics were devilishly effective. The Germans defended strongpoints as long as they could, then fell back to the next one. The advancing Canadians invariably faced a barrage of pre-registered artillery and mortar fire, and all too often fierce counterattacks

LIBERATION

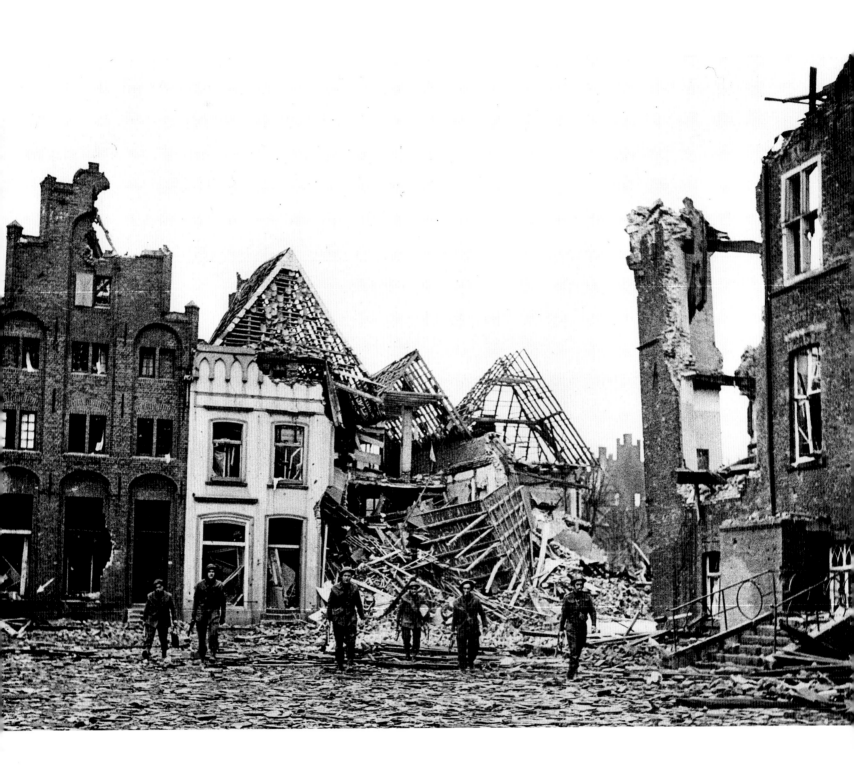

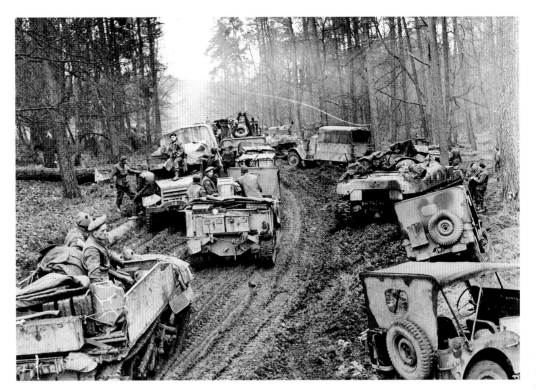

by fresh troops hit the weary Canadians before they could consolidate their just-won positions. It was the weight of Canadian artillery and armour that kept the advance going when the courage of the infantry could do no more. The complete Allied air superiority, the ability of the leading infantry companies to whistle up Typhoons to blast a fortification, saved many situations as well.

Now the 4th Armoured Division set out to take the Calcar–Udem ridge. Formed into two battle groups, the division moved quickly. Brigadier Robert Moncel's Tiger Group had three regiments of tanks, a motorized infantry battalion and two infantry battalions, as well as flamethrowers and anti-tank guns. The sheer power of the assault overran the heavy enemy resistance in a classic demonstration of good planning and armour–infantry coordination. Lion Group, formed from the South Alberta Regiment and the infantry of the Algonquin Regiment, had a harder job in seizing and holding a commanding hill. The initial dawn attack through the heavy mud caught the Germans by surprise, but the enemy artillery and mortar fire inflicted heavy losses and the advance stalled for three days. German paratroopers, three battalions strong, supported by panzers and massive concentrations of artillery fire, fought Lion Group to a standstill, even though two additional infantry battalions were thrown, one by one, against the enemy. Twenty years later, the commanding officer of the Lincoln and Welland Regiment remembered the shellfire as of unbelievable intensity.

The fighting to clear the way to the Rhine continued. The Essex Scottish on March 1 had the task of advancing across six hundred metres of open ground. Major Fred Tilston led his company forward and was shot in the head, but he carried on into the German line, where he eliminated a machine gun with a hand grenade. Tilston was wounded again but led his company to the second enemy line and cleared it. He and his troops had eliminated two enemy company headquarters, but his own strength was now only twenty-six men. Hit a third time, the major refused to accept medical treatment until he had passed on his

The First Canadian Army went into action again in February 1945, its troops smashing into German defences in the Rhineland.

LEFT: By the end of the month, the Canadians had taken the ruins of Calcar. (Ken Bell/DND/National Archives of Canada PA-170460)

ABOVE: The Reichswald and Hochwald, two large and well-defended forests, tested the Canadians to the limit. The enemy lines were fortified, the roads narrow, the mud everywhere. (National Archives of Canada PA-138353)

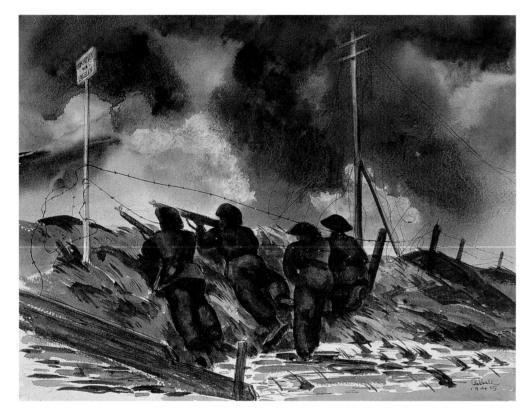

orders to his sole surviving officer, who held the position against counterattacks. A pharmacist in civilian life, Tilston lost both legs but was awarded the Victoria Cross. The Rhineland finally fell on March 8. The Canadians had lost 5,300 killed, wounded and captured. The Germans' ten divisions had lost an estimated 45,000.

There is a Commonwealth War Graves Commission cemetery in the Reichswald Forest, and it has 706 Canadian graves in it. Only one grave is army; the rest are RCAF. General Crerar, the First Canadian Army's commander and one who had fought two world wars, against the kaiser and the führer, decreed that none of his men would be buried in German soil. Somehow, one soldier was buried there. The other Canadian soldiers killed in Germany were moved to the friendlier soil of the Netherlands.

NOW, AT LAST, THE MEN of the 1st Canadian Corps joined up with the First Canadian Army. Everyone, generals and soldiers alike, gaped at the profusion of equipment in Northwest Europe that made the Italian campaign look like the Allies' poor relation. There was air support on demand, specialist units to generate smokescreens, and Shermans, Buffaloes, DUKWS and Kangaroos everywhere. The Germans, however, remained the same good soldiers they had been at Ortona and on the Gothic Line.

The crossing of the Rhine, Operation Plunder, which began on March 23, had relatively little Canadian involvement. The 1st Canadian Parachute Battalion jumped ahead of the river crossing and suffered heavy losses. Using the standard wartime parachutes—much less accurate than those used today, which can give pinpoint accuracy—soldiers overshot

War artists Bruno Bobak and George Pepper moved with the troops.
LEFT: Bobak sketched men of the Lake Superior Regiment trying to pick
off an enemy mortar crew. (CWM Bobak 11956)
BELOW: Pepper painted *Dead German Paratroopers* at Den Heuvel,
the Netherlands. (CWM Pepper 13676)

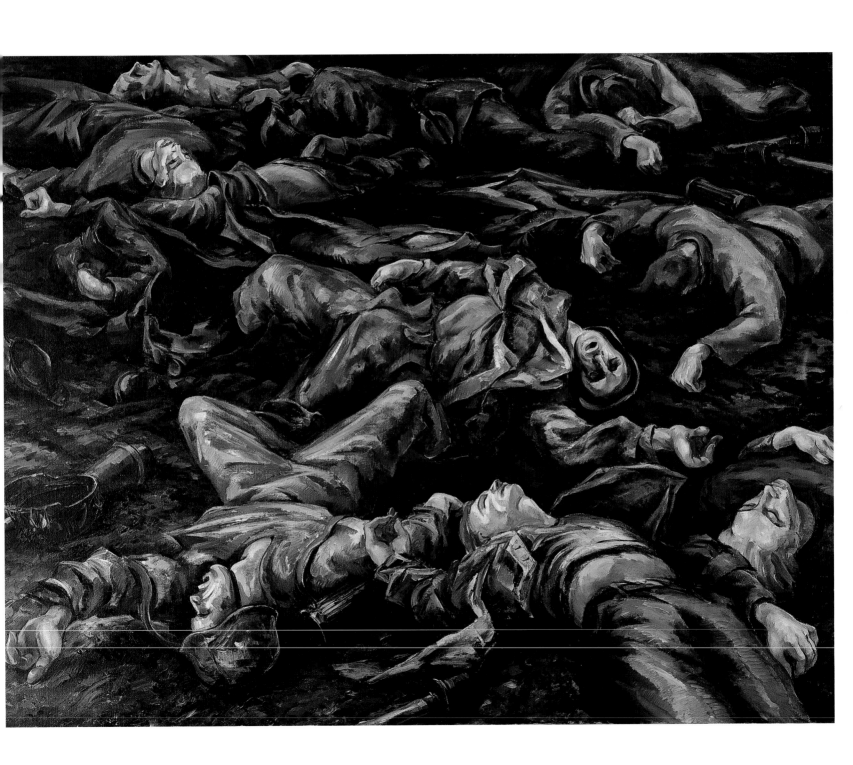

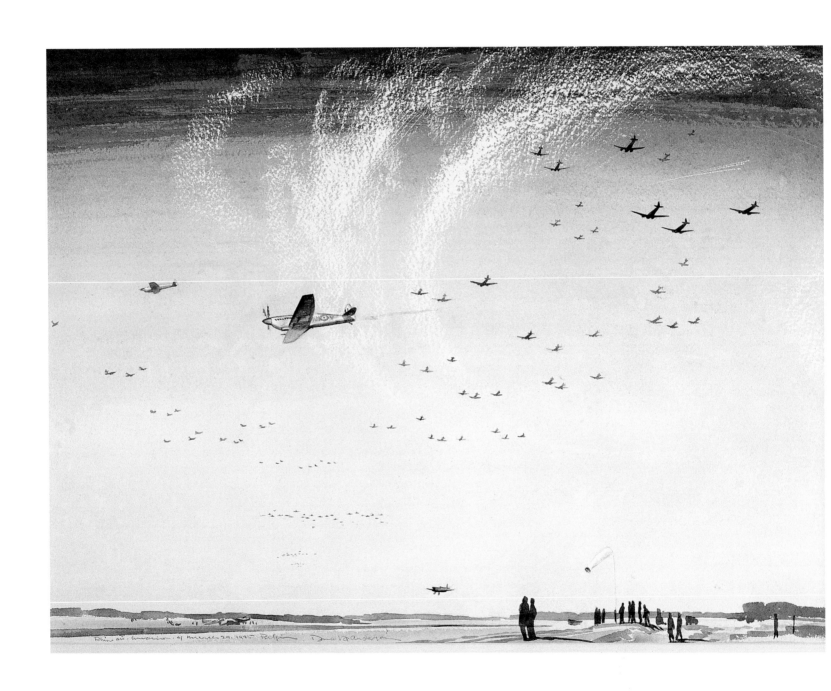

THE LAST GOOD WAR

the drop zones or found themselves caught in trees. The battalion's commanding officer was killed on landing, but the troopers rallied and took their objectives. Corporal George Topham, a medical orderly with the unit, won the Victoria Cross for carrying wounded men to safety despite a gunshot wound in his face. The 3rd Division's 9th Brigade crossed the Rhine aboard Buffaloes on March 24, the Highland Light Infantry being the first Canadian unit across the river. The enemy resisted fiercely, and it took heavy artillery fire and flamethrowers to subdue the Germans. Within a few days, the entire division was across the Rhine, and Canadian engineers began building huge bridges over the great river to facilitate the advance.

At recently liberated Cleve in the last days of March, Lieutenant Elliott Gluck, serving with 2nd Armoured Brigade, went to a Passover service, presided over by Jewish chaplain Sam Cass. "Our destination proved to be a bombed-out building which contained a considerable crowd," Gluck said. Padre Cass added that "a work gang of German labour was provided," something that all commented on with some satisfaction. Journalist Ralph Allen reported that everyone present believed that "until today the feast had not been observed publicly in Germany since 1939, but in Cleve there was no one who could say for sure. In the entire community, not a single Jew was left to testify ... " Word of the huge death camps that the Red Army had captured in Poland and Czechoslovakia had begun to reach the West, and the ironies of a Seder on German soil struck everyone.

The First Canadian Army then turned north into the Netherlands. II Canadian Corps was to liberate the northeastern part of the country and get into the northwest of Germany, while I Corps freed the western portion of Holland. The objective, as one report put it, was to drive the Germans "into the [POW] cage, into the grave, or into the North Sea." The advance jumped off on April 1, town after town turning out its entire population to cheer the Canadians, to point out enemy strongholds—some manned by Dutch SS troops—and to finger collaborators. The Dutch had endured four years of occupation, and the winter of 1944–45 had seen them living on starvation rations, little more than 350 calories a day. The joy of liberation was intense, the press of jubilant civilians so great that tanks could frequently not advance.

Often there was hard fighting. Henk Dykman, a young Dutch boy, was in Leesten when the Canadians, soldiers of the Stormont Dundas and Glengarry regiment, arrived

LEFT: In March 1945, a huge Allied airborne assault leapt across the Rhine. Artist D.K. Anderson painted the scene. (CWM Anderson 10814)

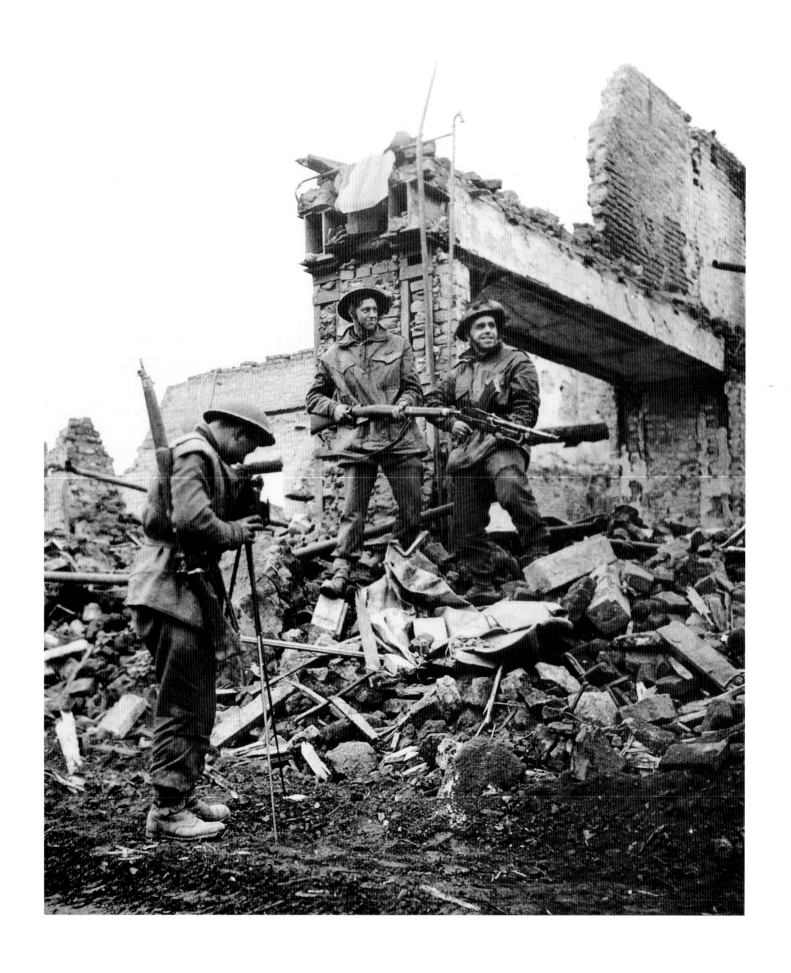

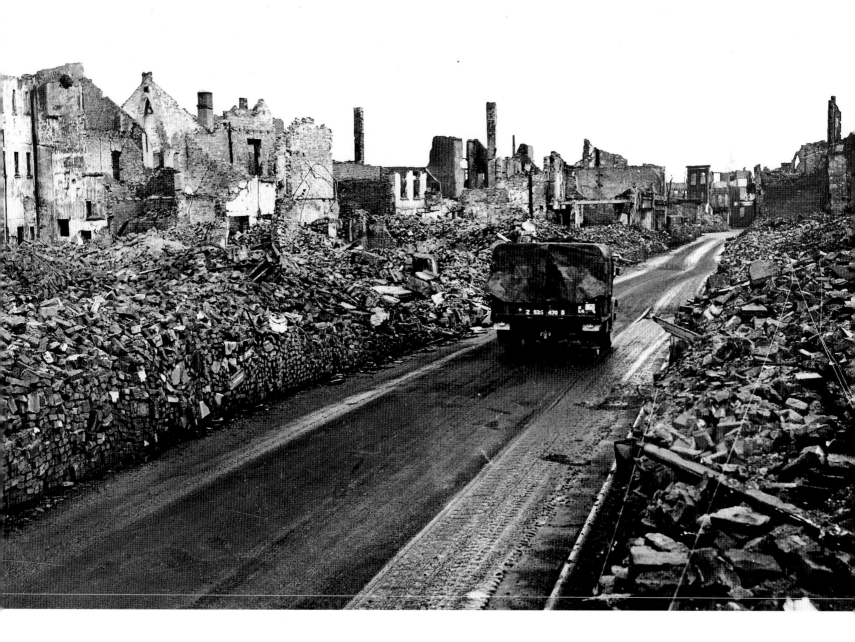

The First Canadian Army had the task of liberating the Netherlands.

BELOW: The soldiers crossed the rivers in rubber boats. (Donald I. Grant/ National Archives of Canada PA-133331)

RIGHT: These men of the South Saskatchewan Regiment engaged in stiff firefights as they beat back the defending Germans. (National Archives of Canada)

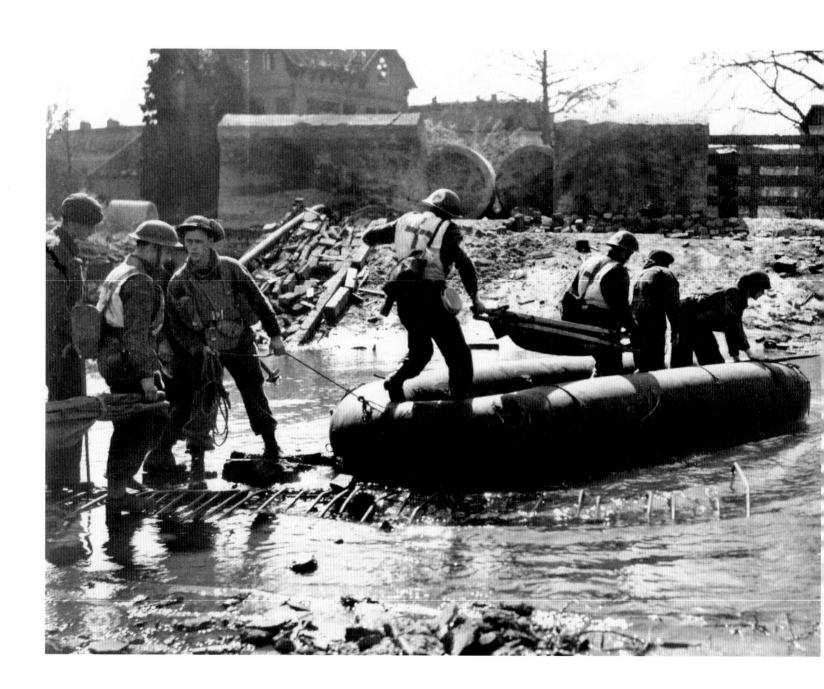

on Easter Monday, April 2. The locals gave the Canadians information on the enemy dispositions, and the village was liberated after a stiff engagement that cost eleven of the Glens their lives. The Dutch suffered too, many losing their possessions and homes. One woman later wrote that as her family fled the fighting, her father turned back to see "our family farm of many generations burn furiously and listened to the bawling of our dying cows. Then Father cried and cried, like a baby." In the midst of the action, Dykman's family confronted a German soldier whose rifle was clogged with sand and who asked to use their tools. The German then gave them good advice on where best to take shelter in their house. "He was not a fanatic. He was looking to save his own skin," Dykman recalled. "He very likely saved ours." Whether this soldier survived is unknown; many German defenders of their position did not. Leesten's liberation was complete on April 8.

Others of the Wehrmacht continued to resist strongly. On April 17 at Otterloo, a German effort to break through the Canadian lines ran over the 17th Field Artillery Regiment of the 5th Canadian Division. The fighting was fierce, the losses high. A much-quoted and possibly apocryphal story had it that General Hoffmeister led a counterattack in his pyjamas. At Zutphen, the 8th Brigade had to use Crocodiles, flamethrowing half-tracks, to smash the resistance of young Nazi soldiers. At Friesoythe in Germany in mid-April, Major-General Chris Vokes, commanding the 4th Armoured Division, heard that one of his battalion commanders had been killed by a civilian. In a fury, Vokes ordered the town razed. "We used the rubble to make traversable roads for our tanks," he wrote. As it turned out, the commanding officer had been killed by a soldier. "I confess now to a feeling still of great loss" over the officer, Vokes said in his memoirs, "and a feeling of no great remorse over the elimination of Friesoythe."

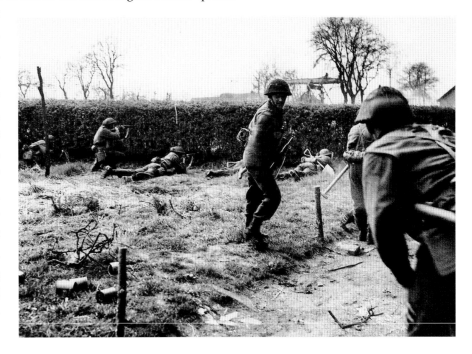

Other experiences solidified the sense that the Nazis were truly evil. On April 12, the South Saskatchewan Regiment came upon a place called Westerbork in Holland. This was a transit camp through which 107,000 Dutch Jews had been processed for transfer to the death camps in the east. When the South Sasks arrived, only 876 inmates remained. One of the survivors, Robert Engel, later wrote that he heard the shout "They are coming, they are coming," and saw Canadian Wasp carriers. "A soldier looked over the top," Engel wrote, "and I grabbed his hand and all I could say was 'Thank you, thank you.' He grinned and said 'It's okay, it's okay.'" The liberated Jews began to sing the Dutch national anthem and every other anthem they knew. Then "Our Liberators started singing. We didn't know the song, had never heard it, but . . . they sang it with such pride, standing there with their dirty faces beaming . . . they sang . . . 'O Canada' . . . and we were free."

Experiences like that at Westerbork made Canadians unforgiving of the Germans. Captain John Gray, an intelligence officer with the First Canadian Army, recalled passing a big house near Rotterdam full of German soldiers "waving and yelling excitedly, as joyously as the liberated Dutch. This we weren't quite in a mood for yet," he wrote in his memoirs, "and we hurried by with only a perfunctory acknowledgement of this for-give-and-forget gesture. It wasn't just a rough hockey game we had all been playing," and "they could not expect us to stop thinking them loathsome just because pieces of paper had been signed saying the shooting would stop."

But the war was in its last moments nonetheless. The Nazi Reichskommissar in Holland, Arthur Seyss-Inquart, opened talks with the Allies for a truce to permit food to be sent to the starving Dutch still under his control. On April 28, fighting ceased on the Netherlands fronts, and trucked-in food and air-dropped supplies fell like manna from heaven to the people. On May 1, Hitler killed himself, and his

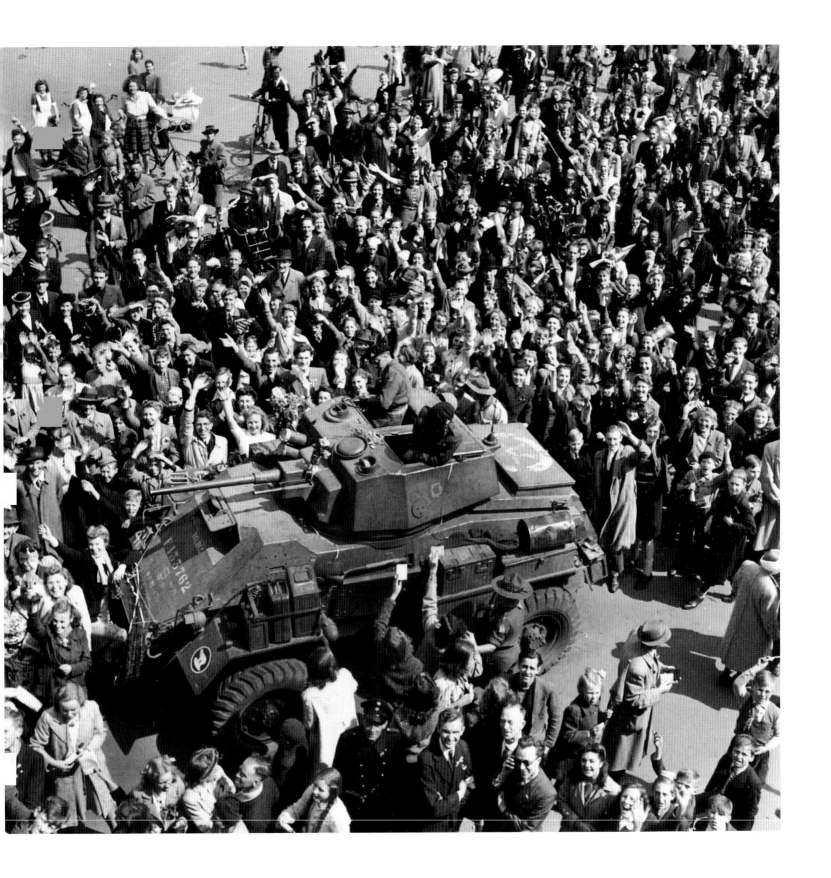

There was no welcome for Canadian troops in Germany.
BELOW: On April 29, 1945, the troopers of the Fort Garry Horse and the
infantry of the Fusiliers Mont-Royal just hoped not to die in the last days
of battle. (Daniel Guravich/National Archives of Canada PA-166806)
RIGHT: German children too, as with these in Sogel, hoped to survive.
(National Archives of Canada PA-113697)

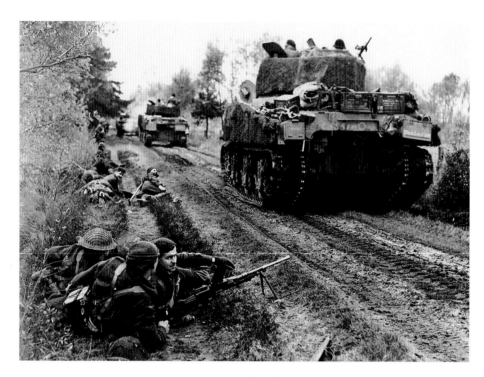

satraps fled or tried to strike deals with the Allies. The 1st Canadian Parachute Battalion, racing east as part of the British 6th Airborne Division, met up with soldiers of the Red Army at Wismar on the Baltic Sea on May 2. Their aim, successfully achieved, was to stop the Soviets from liberating Denmark, a clear sign that suspicion between the victorious Allies was increasing. There were some tense moments between the Canadians and Russians, masked by superficial bonhomie and many vodka toasts.

Some Germans continued to resist. At Delfzijl in the northeastern Netherlands, units of the 5th Canadian Armoured Division attacked the four thousand Germans defending the port and surrounding areas. Brigadier Ian Johnston, commanding the 11th Infantry Brigade, later noted that "there was little cover, the weather was miserable, and the enemy shelling was taking its toll of casualties." The decision, therefore, was made "to push forward to at least reduce the pocket immediately." The attack began on April 23, proceeding slowly and at heavy cost. On April 29, the Canadians fired psychological warfare leaflets into the German lines, telling the enemy that Gestapo chief Heinrich Himmler "has today offered unconditional surrender to the Allies ... We Canadians assume that up to now you don't know about this. The war is practically over. You have done your duty." But the enemy continued to fight, and on April 30, one day before Hitler killed himself, the Cape Breton Highlanders and the tanks of the New Brunswick Hussars launched the final assault on the town. In a stiff action, in taking Delfzijl, with the end of the war in sight, twenty Capes died. Brigadier Johnston observed that "victory was in our hands and life once more was precious" when his units freed the port. The tragedy of war continued to the last minute.

But on May 7, Grand Admiral Karl Dönitz, the führer's successor, surrendered all German forces. U-boats rose from the depths and sailed to Allied ports. U-889 arrived at Shelburne, Nova Scotia, its smiling captain "full of goodwill and charm," or so Commander Anthony Griffin wrote, posing happily for the photographers. The soldiers in the Netherlands laid down their arms, their officers maintaining discipline until the Canadians could take over. Lieutenant-General Charles Foulkes, commanding I Canadian Corps, had accepted the German surrender in the Netherlands at Wageningen's "The World" Hotel on May 5. The Germans, Foulkes wrote later, were upset at the terms. "In the first place they thought that they would be accepted as prisoners-of-war and therefore would be fed by us ... However, as the stocks of food available were very short" and the needs of the Dutch very great, "I decided that the Germans would have to fend for themselves and that if there was any further shortage of food it would be the Germans who had to go short."

Soon, long columns of disarmed German troops were on the march, returning to camps in Germany. V-E Day, May 8, 1945, officially marked the end of the war against Hitler's Germany, the end of his thousand-year Third Reich. At the front, the celebrations were muted. Gunner J.P. Brady wrote: "Our crew are silent and thoughtful. Anti-climax. There is no feeling of exultation nothing but a quiet satisfaction that the job has been done." The struggle had been too long, the horror too much, for soldiers to celebrate wildly. Units had memorial services, and the long lists of names of the killed were read out. Now, everyone wanted only to go back to Canada.

AT HOME, THE V-E DAY jubilation was wilder. In Ottawa, a huge gathering on Parliament Hill cheered the victory to the echo. In Vancouver, Toronto and Winnipeg, parades and banners, flags and confetti marked the end of the European conflict. In Halifax, however, the celebrations turned into a debauchery of rioting and looting, as drunken sailors and soldiers smashed the downtown shops. Commander Anthony Griffin, who was in town in his civvies, asked one rioter "what possessed these men ... He naturally assumed I was a

LEFT: D.K. Anderson called this watercolour *The Last Days of the Third Reich*. (CWM Anderson 10792)
ABOVE: At Wismar, Germany, the 1st Canadian Parachute Battalion met up with Russian troops. The Soviets look less than pleased that their westward advance has been checked. (Charles H. Richer/National Archives of Canada PA-150930)

NEAR RIGHT: The Germans handed over supplies and weapons to Canadians in Amsterdam. (Michael M. Dean/ National Archives of Canada PA-134394)
BELOW: The disarmed enemy forces began their march back to camps in Germany. (National Archives of Canada)
FAR RIGHT: George Pepper's painting *German Prisoners of War in Cage.* (CWM Pepper 13697)

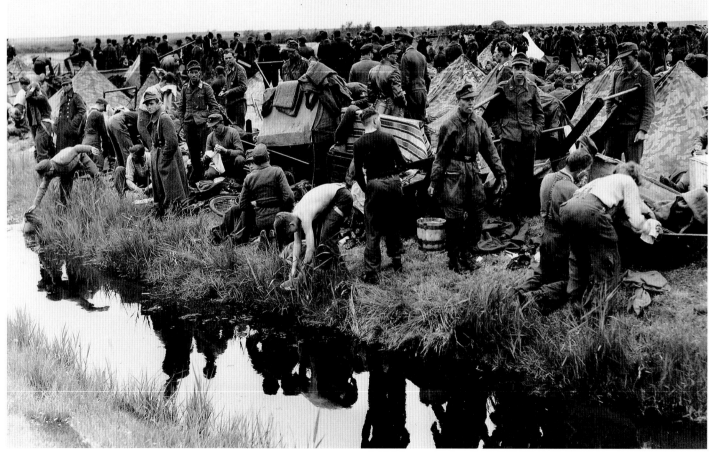

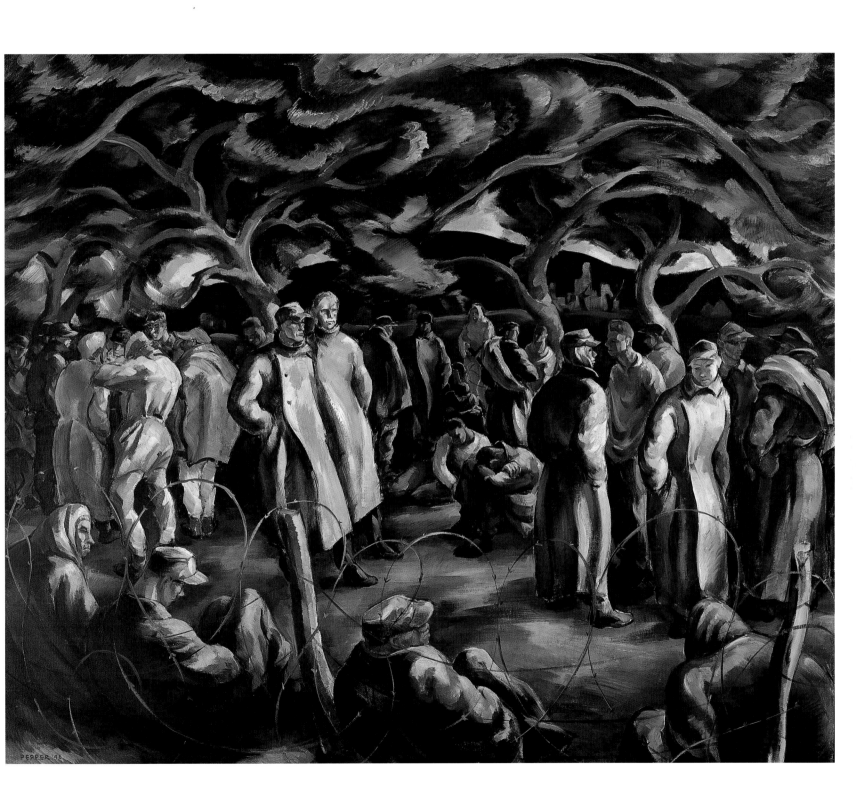

BELOW: In Ottawa, V-E Day was marked by a huge parade on Parliament Hill. (National Archives of Canada PA-114618)

RIGHT ABOVE: V-E Day was celebrated quietly at the front, the carefully staged celebration around a Bren gun carrier notwithstanding. (National Archives of Canada PA-134450)

RIGHT BELOW: Back in Canada, there was a dance at HMCS *Avalon*. (National Archives of Canada PA-204583)

native Haligonian and said, 'We're going to repay you bastards for the way you've treated us over six years.'" The next morning, Griffin saw civilians looting stores. "I asked one citizen what he thought of such behaviour and he merely shrugged and said, 'Everybody's doing it.'" The scapegoat for the riot was Admiral Leonard Murray, the naval commander in Halifax. He was all but blameless, but someone had to take the rap. Sensibly, Griffin said that terrible amusement facilities, a lack of legal opportunities to drink and gouging landlords had been at fault. "To put all the blame on Murray seemed to many of us a most lamentable example of political cowardice."

Politicians had their own battles to fight. Mackenzie King had called his general election for June 11, and went to the voters as both the prime minister who had won the war and the leader to guide Canada into the future. And that future? The Liberals promised a system of social security, jobs for all and the reintegration of the veterans into society with the concrete thanks of the nation. The Progressive Conservatives, led by former Manitoba premier John Bracken, pledged to conscript men for the war in the Pacific, while the Co-operative Commonwealth Federation (CCF) promised a social democratic Canada. The Liberals seemed most in tune with the public. The war in the Pacific was important, but few wanted to fight another domestic battle over compulsory service. A vicious anti-CCF campaign that painted the party as "national socialists" frightened voters who had come to resent the wartime controls and who feared the CCF might continue them forever. And King and the Liberals, with much of their reconstruction planning already enacted into legislation, held the high

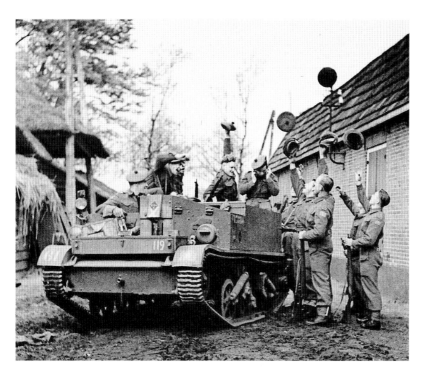

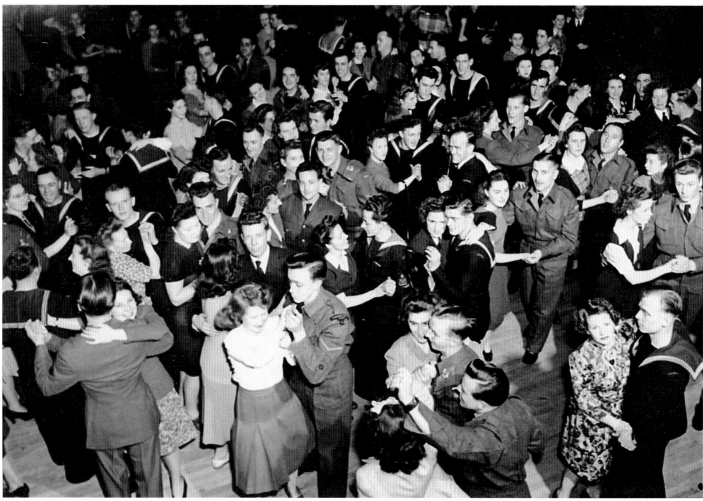

THE LAST GOOD WAR

ground. Servicemen and women overseas agreed, giving King's party a plurality of votes; domestically King won 41.3 per cent of the popular vote and 127 seats in a House of 245. The Conservatives took only 67 seats and the CCF 28. This was a narrow win, but a victory nonetheless—an endorsement of King's leadership and the country's extraordinary war effort. Canadians didn't like King, but they seemed to agree that compared with the other possibilities, he would do. Winston Churchill, the saviour of the world, could not replicate King's feat. His government in Britain was roundly defeated by Clement Attlee's Labour Party.

Meanwhile, the First Canadian Army—*onze Canadezen,* "our Canadians," the Dutch called them—were busy helping in the rebuilding of the Netherlands and enjoying the role of liberators. The army also created a composite division to serve in defeated Germany as the Canadian Army Occupation Force. One battalion went to Berlin to represent Canada at the Potsdam conference, where the victorious Allies met, schemed with and against each other, and staged a victory parade. Other Canadians worked for the Allied Control Commission that effectively ruled Germany, and the RCAF's Stanley Winfield entered the defeated country on May 25. "I felt that I was entering a land of the dead," he

LEFT: The British certainly deserved to celebrate. This is Paul Goranson's painting *V-E Night London.* (CWM Goranson 11474)
ABOVE: In Groningen, the Netherlands, the 5th Canadian Armoured Division staged a parade. General Bert Hoffmeister is shown leading his troops. (National Archives of Canada PA-138047)

BELOW: In Halifax, sailors, soldiers and civilians disgraced themselves by rioting on V-E Day, looting the shops and liquor stores. (National Archives of Canada)

RIGHT: Canadians liberated no Nazi death camps, but Alex Colville did travel to Belsen. There he drew *Bodies in a Grave, Belsen, Germany.* (National Gallery of Canada 12123/CWM neg. no. WA 1090)

THE LAST GOOD WAR

Alex Colville

SPRING '45

BUY VICTORY BONDS

wrote, noticing in particular "the attitudes and reactions of the former 'super race.' When passing us... they either looked to the ground, sideways or straight ahead. Some just stood at the side of the road, watching in a sort of stupor while endless streams of Army vehicles of all types and descriptions rolled by. 'Could this really be happening to us?' was what their stunned expressions seemed to say." The occupying troops had been ordered not to fraternize with the Germans, but that order did not last very long in a country where a pack of cigarettes could buy anything and anyone. Winfield noted that a good Leica camera could be secured for 500 to 1,500 cigarettes. Senior officers and sergeants alike soon had mistresses. And one member of the Canadian Berlin Battalion observed dryly that "Troops evacuated by our Medical Officer generally suffered, not from shrapnel, but from VD."

But Winfield, working with Squadron Leader Ted Alpin, "decided that no one else was thinking about the welfare of the children at Belsen, other than feeding them 3 meagre meals a day." The two Canadians collected chocolate bars from their men and held a picnic the next Sunday: "One hundred and fifty chocolate bars, sandwiches, milk and three trucks to convey them into the country for the afternoon." The children had a good time, Winfield wrote. "The older ones who had been at Auschwitz had the inevitable numbers tattooed... What memories these people must have." Alpin soon set in train a wide-reaching program to bring help to concentration camp survivors.

THE WAR IN THE PACIFIC still had to be won, and, just as the Germans had, the Japanese resisted with fanatical courage. The United States, China, Britain and Australia carried the burden of the war in Asia, but Canada's government in 1944 decided that the Dominion

would do its share. In September of that year, the Cabinet War Committee agreed that an appropriate contribution would be an infantry division, a substantial naval flotilla led by the cruisers HMCS *Uganda* and *Ontario* and twenty-two RCAF squadrons, including a dozen heavy bomber squadrons. In all, Canada was to provide close to a hundred thousand men, all men who volunteered to fight against Japan—or so the government decreed.

This decision led to one of the war's great embarrassments for Canada. The cruiser *Uganda* was already in the Pacific, serving with a Royal Navy flotilla. Did the nine hundred members of the ship's crew wish to volunteer for service in the Pacific? the government asked. Although the cruiser had participated in the invasion of Okinawa and taken part in operations in Japanese waters, although the captain and some of his officers tried hard to persuade the ratings to agree, 576 ratings and 29 officers opted not to volunteer and decided that their war was over. "Why should we volunteer again?" Able Seaman Andrew Lawson wondered. "We volunteered once to get out here . . . I was prepared to stay," he said, "but if they were going through this nonsense of volunteering . . . I wasn't going to volunteer again."

HMCS *Uganda* left the fleet on July 27, 1945. An official at the U.S. Embassy in Ottawa reported to Washington that naval officers in Ottawa felt "real resentment at the requirement that the men re-volunteer for service in the Pacific when they had already volunteered for service anywhere." The official continued: "I hate to say it, but it begins to look as though the Canadians, who prided themselves on the magnificent war effort they made in the European theatre of operations, are going to have to eat dirt in the Pacific . . . They will give lip service to the Pacific phase, but their hearts are not in it."

The other services had no trouble finding volunteers, but their preparations to participate in the invasion of Japan ended on August 6 and 9, when B-29s of the U.S. Army Air Force dropped atomic bombs on Hiroshima and Nagasaki. Stunned, the Japanese surrendered, their nation

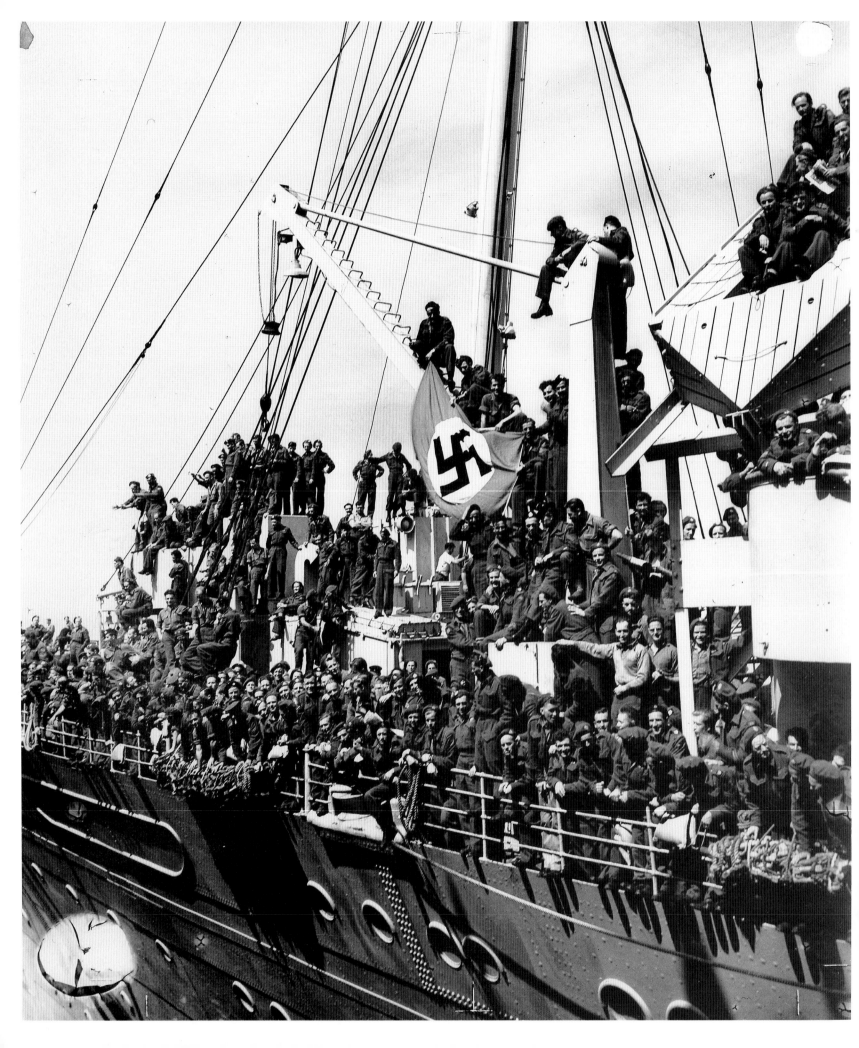

the first—and to date the only—victims of the military use of atomic power. Almost no Canadians realized that their country's mines and scientists had played a role in developing the bomb, a role that encompassed the provision of uranium and a major research effort led by the National Research Council.

Few of the soldiers, sailors or airmen training for Japan grieved the use of atom bombs. It meant their release from the military, for one thing. Moreover, the memory of Pearl Harbor was strong, the brutality of the Japanese to prisoners and civilians fresh in their minds. Had not the Canadians at Hong Kong been butchered and brutalized? And an argument could be— and was—made that an invasion of Japan would have cost hundreds of thousands of

Allied and Japanese lives, certainly more than the atom bombs killed. Still, the horrible new weapons, scarcely imaginable in 1939, were widely believed to have altered the way future wars would be fought.

The way the Second World War had been fought was horrible enough for Canada. Of the nation's 1.05 million men and 50,000 women who put on a uniform, 1,533 serving in the navy were killed in action and 491 died from other causes. In the air force, 13,498 were killed in operations and 3,603, a very large number that includes training deaths, died. The army lost 17,682 in battle and another 5,203 dead off the battlefield. Of those who died in the three services, eight were women. The total of just over 42,000 was a very high price for a small country to pay. There were, in addition, more than 54,000 wounded and 9,000 taken prisoner, all of whom bore scars from their experiences. Canada's merchant sailors, civilians all, suffered 1,600 killed of the 12,000 who worked the sea routes. For years,

THE LAST GOOD WAR

long after their repatriation to Canada, they and the military veterans frequently woke screaming from terrible nightmares. The war changed all who fought it.

MOST CANADIANS TODAY know very little of the Second World War or the extraordinary part played by Canada. They assume their country was always a weak military power, a nation of peacekeepers. But as the veterans pass away, Remembrance Day ceremonies each year paradoxically become better attended. Great-grandfathers are telling more of what they did in the war to their families, and old men and their offspring still go to Europe in the spring, in search of graves in the Canadian war cemeteries in Italy, France and the Netherlands. Tears are shed, and memories flood to the surface.

Many of those killed have no known grave, however; the identity of many more remains unknown. But over time, some of the missing Canadian dead have been recovered. In Wilnis, the Netherlands, on March 30, 2003, hundreds of citizens turned out to unveil a monument to three RCAF aircrew. Their Wellington bomber, returning from a raid on Dortmund in the Ruhr, had been shot down on May 5, 1943. Two of the aircrew escaped the burning bomber, but Flight Sergeants Adrien Thibaudeau and Joseph White and Warrant Officer Robert Moulton were killed when the Wellington crashed into a bog. The remains of the men and their aircraft were not recovered until the autumn of 2002. The Canadian ambassador to the Netherlands unveiled the monument and said that of all those monuments commemorating Canadian servicemen, Wilnis's was the most beautiful.

The Dutch clearly have not forgotten *"onze Canadezen,"* who fought and died for their liberation. That all Canadians do not remember and honour the deeds of their soldiers, sailors and airmen who fought for freedom is a crime against their nation's history. The last good war, the struggle against Nazism, fascism and Japanese militarism, must never be forgotten.

LEFT: After the men arrived, the war brides came, many with children born in Britain or Holland. These families look slightly apprehensive, hoping that both Canada and their husbands will be welcoming. Most were not disappointed. (City of Toronto Archives G&M 102055)

ABOVE: Demobilizing the armed forces was a major task that was well handled. These men collected their money, signed the requisite forms and went off to start their lives again. The war was over at last. (National Archives of Canada C-49391)

INDEX